Painting Men's Portraits

Painting Men's Portraits

BY JOE SINGER

WATSON-GUPTILL PUBLICATIONS/NEW YORK
PITMAN PUBLISHING/LONDON

Copyright © 1977 by Watson-Guptill Publications

First published in the United States and Canada by Watson-Guptill Publications,
a division of Billboard Publications, Inc.
1515 Broadway, New York, New York 10036

Library of Congress Cataloging in Publication Data
Singer, Joe, 1923–
 Painting men's portraits.
 Bibliography: p.
 Includes index.
 1. Men—Portraits. 2. Portrait painting—Technique.
I. Title.
ND1329.3.M45S56 751.4'5 77-6398
ISBN 0-8230-3795-9

Published in Great Britain by Pitman Publishing, Ltd.
39 Parker Street, London WC2B 5PB
ISBN 0-273-01150-2

Manufactured in U.S.A.

First printing, 1977

To my brother, Jacob

Contents

COLOR GALLERY

ARTISTS AT WORK

Introduction

Although science informs us that men and women aren't so much different as they are alike, physiological variations definitely do exist. In addition, most commissioned portraits of men today fall into the more formal or institutional category, while those of women tend to be more personal. These and other factors made it apparent to me that a separate book on painting each of the sexes would be artistically helpful to aspiring portraitists. Therefore, this is the companion volume to *Painting Women's Portraits* which is already in print.

In this book, as in the book on painting women, I deal with every aspect of portrait painting, but the emphasis here is always on how these aspects affect the male portrait. Pose, lighting, color, design, costume, accessories, hands, viewing angles, tools, and materials are all discussed in specific terms so that you may apply these suggestions to particular situations.

Having painted hundreds of portraits myself, I'm fully aware of the many problems and decisions attending each one. I hope this book makes this process much easier and more enjoyable for you.

PROBLEMS
AND
SOLUTIONS

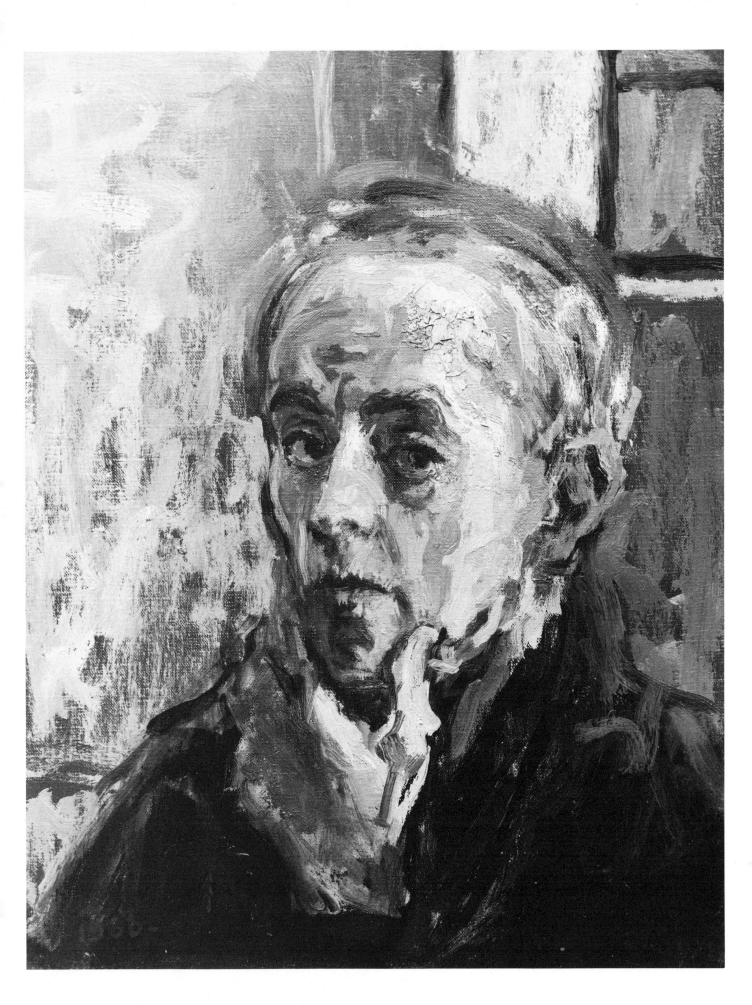

CHAPTER ONE
Analyzing the Portrait

From my own experience and a long association with professional painters, one factor has become abundantly clear—that the planning stage of a portrait is as vital as the execution. The time that you actually devote to each of these stages is a matter of personal preference, but neither should take precedence. A well-planned portrait may still turn out badly, but a poorly planned portrait is almost certainly doomed to failure.

BREAKING DOWN THE PROBLEM

As in every problem — artistic, personal, or scientific—in order to solve it you must first thoroughly weigh and consider all of its ramifications. The first step in analyzing a problem is to break it down into components so that the brain doesn't skip randomly about from point to point. This involves making up a checklist, which can be either mental or written, and considering each aspect in turn. More about this checklist in a moment.

PURPOSE OF THE PORTRAIT

A portrait — any portrait — fulfills a definite purpose. If it's commissioned, it serves to gratify certain demands of those who have ordered it. If non-commissioned, it meets certain specifics laid down by the artist. Even if the painter asks a friend or relative to pose simply because he feels like painting a

portrait, a need is being fulfilled. It's vital that the artist acknowledge this factor of purpose so that he can use it to his advantage.

THE COMMISSIONED PORTRAIT

The artist who decides to paint commissioned portraits must approach his task with the dedication of a monk. If he is flighty, cynical, or lackadaisical, he belongs in a different profession. Painting a commissioned portrait entails a solemn commitment between two persons. On the one hand, the sitter promises to pay a fee for a well-executed product. On the other, the painter is honor-bound to give the best that is in him to satisfy or exceed his client's expectations; additionally, he is obligated not to compromise his integrity and to advance (or at least not to impede) the cause of art. As you see, most of the burden falls on the artist.

THE INSTITUTIONAL PORTRAIT

There are two basic types of commissioned portraits —the personal and the institutional. The latter includes paintings for boardrooms, schools, churches, government offices, military installations, and the like. Men's portraits tend to fall heavily into the institutional category; this entails a calculated appoach since this kind of portrait often produces the problem of how to create an interesting picture out of a man sitting at a desk in a traditional dark business suit. Another problem is that an institutional portrait is often hung high up in some large hall; therefore the problem of size must be resolved, since the viewer may ultimately be seeing it from many yards away.

There are additional considerations. When painting a commissioned portrait, the artist must frequently work on location where conditions are less than perfect. This may entail problems of illumination or the need to employ artificial lights, since few homes or offices are equipped to admit enough, or the right kind of, daylight by which to paint. It might prove necessary to do a quick color sketch on the spot and take photographs for reference material

Self-portrait (opposite page) by Moses Soyer, oil on canvas, collection Mr. and Mrs. Louis Friedenthal. The artist is expected to be as honest with himself as he is with his other subjects. Here, Soyer presents a far-from-pretty rendition of his own face, complete with tension, self-doubt, and anxiety. Painted broadly, with extensive use of the palette knife, it provides remarkable insight into the subject's personality. Few persons are as conscious of their less positive traits as is shown here, but it's incumbent upon the artist—and particularly the portrait painter—to let nothing divert him from truth, especially within himself.

to be used in the studio. Another factor is that a man who is important enough to be painted is often a busy executive who has little time to spare for posing. This again imposes hardships upon the artist.

There are other limitations. Likely as not, the artist is confined to a certain size and shape of canvas and is often restrained from straying from conventional poses, lighting, and composition. Obviously the person who elects to paint commissioned portraits — particularly the institutional kind — must possess the stamina of a bullfighter, the patience of Job, and the tact and humor of a career diplomat.

As we stop to consider all these factors, it becomes more and more evident that the *purpose* of a portrait is a vital aspect of the process of analyzing its individual problems and arriving at some meaningful solutions. Therefore, before you even contemplate painting a commissioned portrait, check off the following points:

1. Where will it hang — in his home, his office, a boardroom, a gallery, a large hall or auditorium? Will it hang high up or at eye level? Will it hang by itself or in the company of other portraits?

2. What kind of costume is he to wear — a business suit; a military uniform; medical, academic, or clerical robes; a costume defining his hobby or profession, such as a football player, a hunter, a sailor, an astronaut?

3. Are you to be confined to any particular size or shape for the portrait?

4. In what setting is he to be painted — the artist's studio, the subject's home or office, the operating room, the battlefield, the sporting arena, aboard ship, etc.?

5. Who is commissioning the portrait — the subject himself, his family, his business, his club members, the government, a school, an institution?

THE NONCOMMISSIONED PORTRAIT

Obviously in the noncommissioned portrait it's assumed that you control all these considerations, and your latitude is therefore considerably wider. But even here the purpose of the portrait — be it primarily to please you rather than your sitter — must be established beforehand. Otherwise an aimless hit-or-miss product is the prospect.

GETTING TO KNOW YOUR SITTER

Once you have learned some of the pertinent facts concerning the purpose of the portrait, it's time to get to know your sitter. Considering that they haven't met the subject before, some artists arrange an initial meeting as early as two to four weeks prior to the actual sitting. This allows them to get to know the subject, to gain an impression of him, and to begin visualizing how he will fit into the painting they will be constructing around him.

Often this initial meeting isn't possible. In such instances the artist may sacrifice the first sitting and do little or no painting and lots of looking. Because subjects tend to be nervous or rigid about this usually strange experience, the wise painter will not appear to be consciously studying the subject and will chat about inconsequential topics that have nothing to do with the portrait or about art in general. Some, such as John Sanden, will have done research on aspects of the sitter's life and will know in advance what his interests and hobbies are. A clever portraitist knows that much of the process of portraiture is a theatrical event, and that a great degree of showmanship enters into it. He will seek to draw out his sitter, to relax him, and to keep him animated and talking about *himself*. With a few astute remarks the artist will encourage the sitter to verbalize his feelings about life and the world while he keeps his chatter to a minimum and busily contemplates the person he's about to paint.

Unless a person genuinely enjoys people and is curious about them, he will have trouble painting portraits professionally. The somber, moody individual is best off sticking to inanimate subjects — still lifes and landscapes. Please don't ascribe anything sinister to this investigative process. Surely you *are* manipulating another human being, but to a good purpose. Unless you can make your subject open up, he will remain a closed book to you, and your portrait may suffer; getting to know your sitter involves not only his physical, but his emotional traits as well. You are painting the total human being — not his outer shell alone.

THE FIRST IMPRESSION

Many portrait painters look for that first impression the sitter projects during the initial encounter. This first impression often serves as the basis for the finished portrait. It's said that every human being produces a stark visual impact the moment he first enters our presence. I subscribe to this concept to a point. The first impression is only as valuable as the artist's ability to *read* the visual and emotional image the sitter projects. A painter must develop this facility to its maximum. His perception must be so concentrated and sensitized that it absorbs every nuance of the person's face, figure, and personality. We all possess this sense to some degree, but in most of us it has been allowed to atrophy. A veteran policeman walking a dangerous beat uses this same sense to stay alive. Experience has taught him to quickly scan and interpret seemingly innocuous sights so that he can just about discern who is innocent and who is potentially threatening.

Fortunately this is an instinct that can be re-

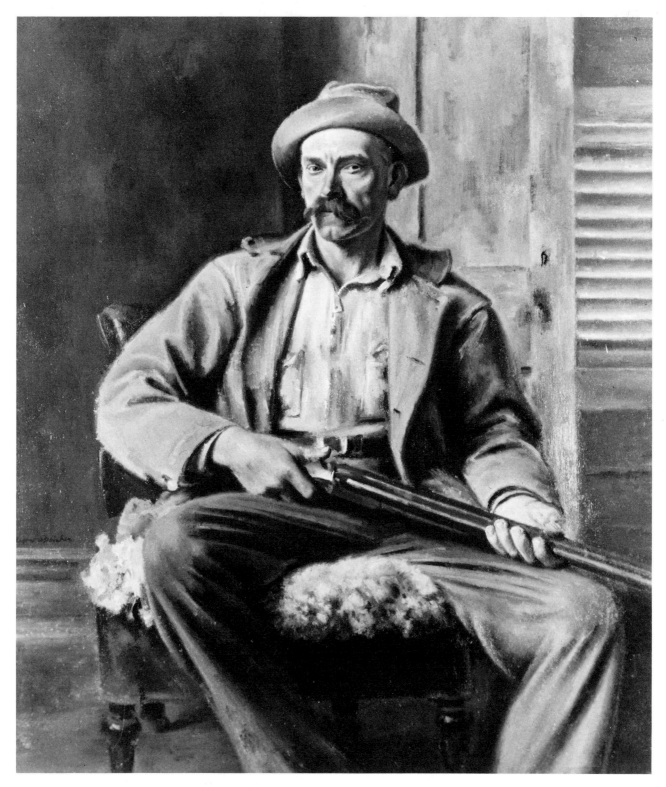

Red Moore, Hunter *by Eugene Speicher, oil on canvas, courtesy Frank Rehn Gallery. A marvelous character study by one of America's leading artists, there is nothing reticent about this crabby rustic. The artist has wisely chosen not to make any mollifying statement—he simply painted the gun-toting old rascal for what he was. Good art only reports, it never editorializes. If your subject is vicious, bullying, or just plain ornery, it's your responsibility to include some of this information in the portrait—assuming you can get away with it.*

vitalized and developed. Train yourself to glance at a person; then, without looking at him again, draw him as accurately as possible. You may miss some of the individual features, but if you have captured his particular stature, gait, bearing, and configuration, you have succeeded in absorbing his essential and individual impact. Do this again and again and again. Years ago every art student and many experienced artists carried sketchbooks and drew constantly. Drawing one-minute poses from the model is equally helpful. Both these exercises help develop a kind of photographic memory and sharpen one's ability to quickly receive and retain a person's special essence. Portraitists look for this essence in the first meeting and often exaggerate its impact to accentuate their initial reaction to the sitter.

PHYSICAL ATTRIBUTES

Regardless of how perceptive or intuitive we may be, our main impressions of people we are meeting for the first time are still those of their physical presence. Given enough time we come to know their inner traits as well, but this may be a slow and complicated process. In most portrait situations decisions must be made on the basis of face, figure, stance, dress, bearing, and pose—the external manifestations.

Every person is essentially *something* first. This something — be it tall, alert, erect, hunched — is what initially separates him in our minds from the thousands of other people we see in our daily lives. If not for this innate sense of recognition, think of the problems a world of four billion human beings, all of them more or less alike, would present! Fortunately our eye is instinctively trained to transmit to the brain certain shortcut impressions which enable us to identify an individual through some brief marks of classification which separate him from the mob. This may be a shock of gray hair, an outsized pair of ears, a particularly underslung jaw — something. Fortunately few of us are perfectly symmetrical in form or feature. I say fortunately, because as esthetically ideal as it would be to live in a world of perfectly made men and women, it would be nearly impossible to distinguish between them. It's that slight or not-so-slight deviation from perfection that marks us apart. It's nature's way (considered by some a dirty trick) that lends each of us our own individuality and identity. The wise portraitist glories in this deviation, for it serves as his guideline for the portrait.

When the artist meets his sitter for the first time, he looks for these differences and carefully files them away in his mind. They are the characteristics by which his family, friends, and associates identify him, and they must be not only indicated, but even *slightly exaggerated*, in the portrait. The reason they must be stressed is that while a person is ani-

mate and strikes perhaps a thousand different poses and expressions within an hour, a painting hangs absolutely still. In its inanimate form it must represent a living being who never remains exactly the same from second to second. The solution, therefore, is, to indicate the distinct identifying marks that characterize the person, just as a caricature identifies an individual with a few lines accenting the obvious and most apparent.

Thus a painter doesn't look at his subject as a being with two eyes, ears, arms, and legs; he probes for those distinguishing features that characterize the sitter and set him apart—big hands, freckles, a wide mouth, piercing eyes, an arched eyebrow, sharp nostrils, deep jowls, hunched shoulders — anything that arrests the eye to the individuality of the person. These are the factors that will be incorporated into his portrait in such a way that they strike the eye of the viewer at first glance. If the initial thing the sitter projects is a snub nose and thick lips, and if the portrait does the same, chances are that it will work. But if the artist consciously or unconsciously conceals or minimizes these features, he is opening himself to trouble. However, it's vital that it's the subject's attractive rather than negative individual features that are accentuated.

So get to know your sitter's physical aspects by marking and cataloging his most striking features in order of importance; then make absolutely sure that you pose and light him in such a way that the same order of importance prevails in the portrait as well.

EMOTIONAL TRAITS

A portrait doesn't merely show light falling softly on skin, flesh, and bone—a portrait probes deeply inside the man, or it's no portrait: it's a painting of a head. All of us are composed of body, mind, and soul, and it's the interpretation of these three factors together that portraiture is all about. No one expects you to conduct psychiatric evaluations of your sitter. But you *are* obligated to do a little digging into your partner in the portrait experience. Likeness is fine, but likeness without character or expression is like marriage without love—flat and unrewarding.

In the brief time you may have to confront your sitter, strive to read his character to the best of your ability. The signs are all there—the way he speaks, sits, gesticulates, dresses, looks at you — his every word and gesture are a clue to his personality. Even though he may be on his best behavior and guarded in manner, he can't really hide everything about himself, and it's up to you to decipher those little foibles and mannerisms we all project.

Once you have gained some of this insight, use it in the portrait in the same exaggerated fashion that you exploited your sitter's more obvious physical traits. If he's aggressive, don't paint him in a placid, pensive pose. Have him lean forward, looking the

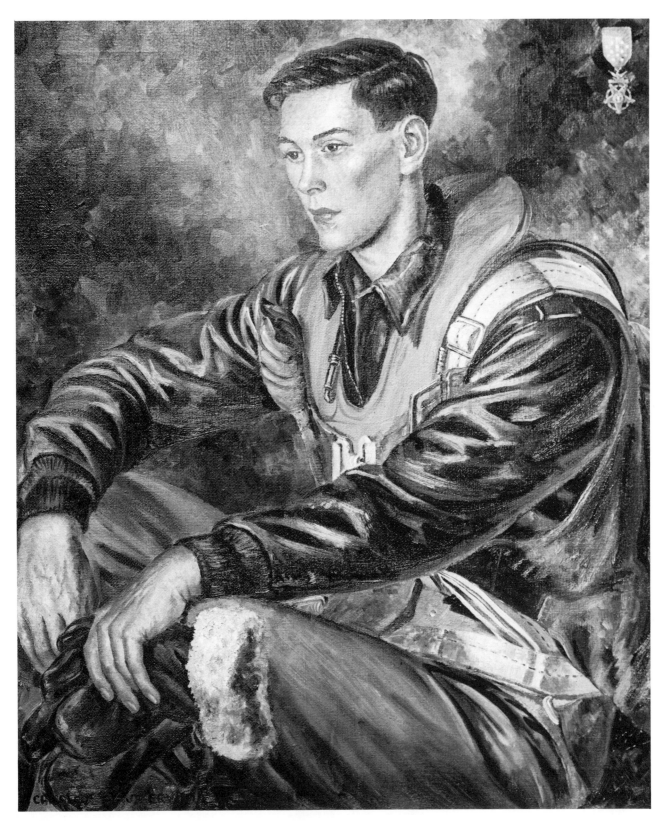

Technical Sergeant Forrest L. Vosler by *Charles Baskerville, oil on canvas. In this moving study of a young airman who won the nation's highest military award, the Congressional Medal of Honor, Charles Baskerville has captured all the horror and futility of war as expressed in the vulnerable, pensive expression of the boy forced to perform a man's job under the most trying conditions. This is a perfect demonstration of how the experienced artist assesses the emotional status of his subject and employs it to advantage in the portrait. The averted gaze heightens our response to the effect of war on a sensitive, undeveloped personality. Note how the powerful hands contrast with the immature face.*

viewer straight in the eye. If he's timid, show some of this introspective character. Naturally you are obligated to show your man at his best—that's part of the covenant struck between artist and sitter—but you can delineate a person's character in a positive sense. In this you must follow Will Rogers' dictum and take the attitude that you have never met a sitter you didn't like. Even though this may not be the absolute truth, pretend that it is and paint accordingly.

If you are a person who has trouble getting clues to peoples' character, read some books on psychology and body language which might help you discern and interpret what makes others tick and how they unconsciously demonstrate these inner feelings.

WHAT IS HE LOOKING FOR?

A most important consideration in every portrait is the sitter's reason for having himself painted. This naturally excludes professional models. Artists tend to forget that sitting for a portrait can be a traumatic experience. Few of us are completely secure about the way we look, as witness the shock we experience when we glimpse ourselves in a three-way mirror.

Besides being physically tiring and tedious, posing is often a threatening situation as well. The sitter may feel that opposite him stands a stranger whose eyes seem to be looking right through him. He suddenly becomes overly conscious of his receding chin, his rather close-set eyes. And the painter's eyes keep boring in, boring in. You, the artist, must put yourself in the sitter's shoes. *Why* is he sitting for the portrait? *What* does he expect out of the effort? There is only one way to find out—ask him.

Contempt is not conducive to portraiture. Nothing is more tiresome than the smirking, supercilious painter who treats his sitter as some nuisance whose presence he must endure and whose views, opinions, and preferences are of no consequence to him—the Man with the Brush. The sitter's needs and expectations regarding his portrait are of utmost importance.

There is, however, a delicate point which touches on this. This is the aspect of flattery. Flattery is not, as some might think, a problem that crops up often in the painter-client relationship. Most sitters, artists tell me, go the other way—they demand the absolute truth and object when they feel the artist has been too kind to them! Still, an occasional man might ask—or hint—that he be prettified. What do you do?

You firmly and absolutely refuse, basing your refusal on the grounds that any deviation from fact will result in a dishonest, inaccurate portrait. If this explanation doesn't suffice, suggest to the sitter that he look for another artist. Every one of the painters I've interviewed over the years has been adamant on this point, and I tend to agree with them. Fortunately this will come up rarely, if at all, and if it happens, be content to have disposed of a potentially troublesome commission.

A portrait may be considered the ultimate ego trip. Keeping this aspect in mind and remaining firm in your resolve not to flatter (which in this context means to alter), do acknowledge that in every other area you are obliged to satisfy the needs, aspirations, and expectations of the sitter. Does he desire to emerge noble, commanding, inspiring, interesting, provocative, wise, masculine, regal, disarming, righteous, sexy?

Some or all of these requirements may be at least partially fulfilled without resorting to dishonesty or deception, since every man reflects *some of these qualities at some time in his life.* It's merely up to the discerning artist to determine what the sitter is looking for, and then — remaining firmly fixed within the bounds of honesty—to give him what he is paying for.

If this sounds like a sellout, ask yourself the reason you're painting the commissioned portrait in the first place. Is it not for the money? And if you're not ashamed to accept payment for performing your job, don't act hypocritically by refusing to give the client what he wants, so long as the request is reasonable and doesn't compromise your personal or artistic integrity.

WHAT DO YOU HOPE TO ACCOMPLISH?

You, as an artist, have (or should have) set certain goals and standards for yourself. You also realize that professional portraiture entails commercial considerations and that if you are lucky enough to get a commission, you will have to reevaluate these standards and accommodate them to practical considerations. Regardless of whether your portrait is to be commissioned or not, it dictates certain goals. Let me list a dozen I consider important:

1. Achieving a perfect likeness.

2. Creating a good work of art regardless of subject.

3. Capturing the character of the sitter.

4. Obtaining a feeling of life in the painting.

5. Avoiding the repetitive or formula portrait.

6. Experimenting, innovating, daring to try something new and different.

7. Varying the size, setting, lighting, pose, composition, and color so that each new portrait is a fresh and exciting challenge.

8. Accepting no more portraits than you can comfortably handle.

9. Interspersing portraits with still lifes, nudes, landscapes, etc.

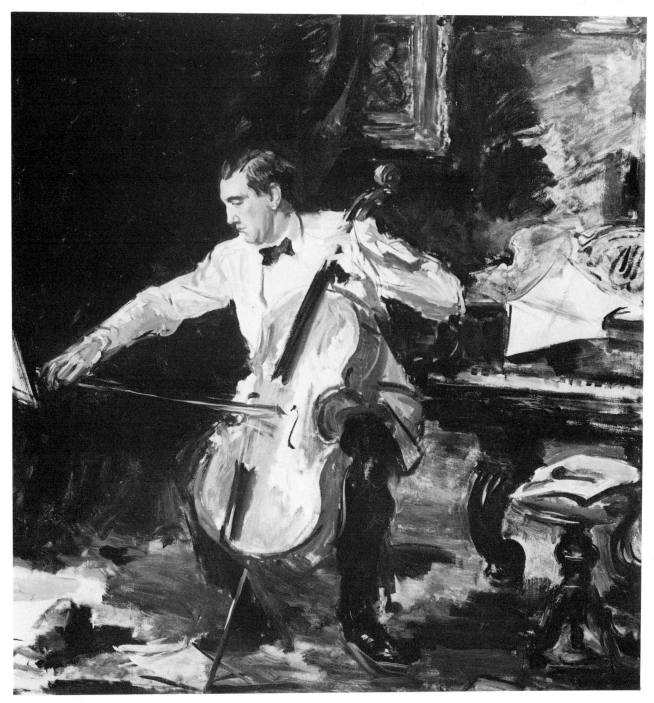

Gregor Piatigorsky *by Wayman Adams, oil on canvas. This vigorous, forceful study of one of the world's most distinguished cellists won first prize in the Carnegie Institute Exhibition "Painting in the United States" in 1943. That the painter was one of America's foremost masters is evident from the nervous, direct technique which sacrifices all extraneous detail to its single goal of showing a dedicated musician absorbed in his art. Note how daringly Adams almost slashed in the left arm in a series of seemingly careless strokes. Yet the total effect is unmistakably alive, dynamic, and powerful.*

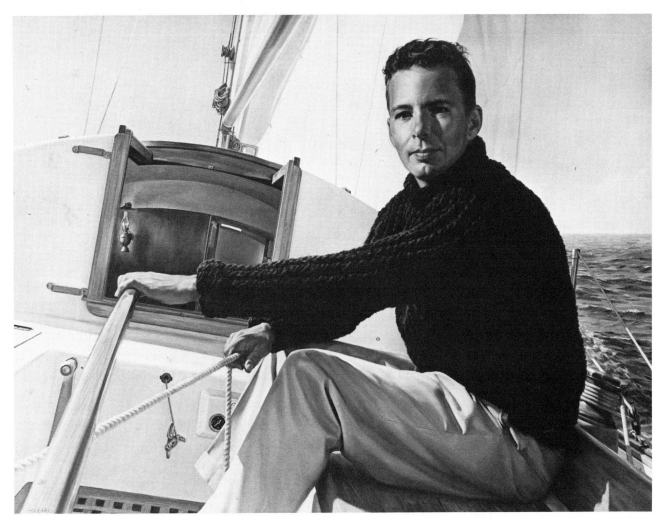

William Hatfield by Hananiah Harari, oil on canvas, 30" x 40" (51 x 76 cm), collection Mrs. W. A. Hatfield. What was the purpose of this portrait? Obviously to show Mr. Hatfield's love for the sea and skill as a sailor. This could have been accomplished in a number of ways, such as posing the subject in his study wearing a sailing cap and surrounded by his trophies. However, the artist chose to avoid subtleties and to achieve the goal directly. The technique is tight and controlled, and the treatment of texture is detailed. It's interesting to contrast this work with the Adams painting. There are many, many ways of painting a portrait successfully.

10. Having the courage to turn down those portraits that don't inspire you.

11. Constantly learning and expanding your skills and knowledge.

12. Keeping yourself at fever pitch—always!

Now let me say a bit more about each of these twelve points.

Achieving a Perfect Likeness. A portrait must closely resemble the sitter, or it ceases to be what it purports to be. The elongated necks of Modigliani may be superb art, but portraits they're not. Physical resemblance is a must, and unless you're prepared to accept this condition, go into some other line of work.

Creating a Good Work of Art. A portrait is first of all a painting, and either a painting aspires to be a great work of art, or else it loses all meaning and purpose. To separate portraiture from art is to be snide, sophomoric, and venal. A portrait that achieves perfect likeness but is poorly painted should be consigned to the fires of hell.

Capturing Character. As already stated, what's inside a person is as important as what's outside, and

showing one without the other is an exercise in futility. You're painting a complete human being, not a mannequin.

Getting Life into the Painting. Life is that spark of animation that separates us from chairs, dressers, and tables. Unless this is evident in the painting, it's only canvas, paint, and medium—not a portrait. *How* to evoke this quality is a question artists have been pondering for centuries. One possible solution lies in painting as honestly and passionately as possible. Life issues from life!

Avoiding Repetitive or Formula Portraits. After you have painted some dozen or so portraits to splendid response, you're headed for serious trouble unless you seize yourself by the throat and seriously ponder your artistic future. Are they all beginning to look the same? Are you falling into little manneristic traps, such as a finger crooked around a pipestem? This is the time to take stock and decide if you're going to follow the easy road and spend your life painting portraits by rote, or if you're going to take the hard road and seek new directions. It's at this stage in their lives that most portrait painters sell their souls and go to their artistic graves without even a whimper.

Experimenting and Innovating. Unless you are willing to tackle new and difficult challenges, your progress as both artist and human being will be permanently stalled. Try painting a portrait all in shadow or with the head halfway out the canvas. Go all the way to the bizarre, the untested. Try new mediums, new surfaces—invent techniques of your own. Unless you are willing to risk serious failure, you atrophy and die. A magnificent error is better than a mediocre success.

Varying Elements to Create Challenge. Study your last few portraits and see how they might have been painted from other angles, in other poses, perhaps outdoors, perhaps in full-length size, or perhaps very small, round, or long and narrow. By varying the elements in a portrait, each can become a fresh and exciting challenge.

Accepting What You Can Handle Comfortably. Don't overload yourself with more work than you can handle. Tight schedules turn painting into a burden rather than fun, and then you'll start grinding out one job after another and quickly slip into routine and mediocrity. Even if it entails some financial sacrifice, take on only as many portraits as will keep you interested and alert.

Changing Pace. Allow yourself time to do other painting than portraits. Go outdoors into the fresh air and do some landscapes or seascapes. Try a nude or a still life. Then when you return to the portrait, you'll be amazed at how fresh it will emerge.

Rejecting the Uninspiring. If you've painted six consecutive portraits of bank presidents and a seventh is looming, have the courage to turn it down. Unless a portrait offers a challenge, a chance to do something different and fresh, you might be better off skipping it. At the very least, postpone it for later.

Learning and Expanding Constantly. Don't ever feel you've reached a point when you have stopped learning about both art and life. Go to exhibitions and see what other artists are doing; read, discuss, listen, and learn. No one lifetime is enough to absorb even one-half of one percent of what's available to the inquisitive mind.

Maintaining Fever Pitch! Never, never approach a portrait with a weary, jaded attitude! Psyche yourself up for every job, as if it were a life-or-death struggle — which in some sense it is. A bored painter paints boring portraits. If you can't recharge your enthusiasm, take a long vacation or go into some other line of work.

SETTING SPECIFIC GOALS

The 12 principles just discussed constitute a universal tablet of commandments for the portrait painter. But there is something else: Approach each new portrait with knowledge and experience secure but *with no preconceived ideas*, since each new portrait will — through its own peculiar and individual aspects — entail specific and precise goals. These goals will be predicated upon the exact purpose the portrait is expected to fulfill, the special demands imposed by the sitter, the place it will be displayed, its size (if this is rigidly prescribed), the location where it must be painted, and any special costume, pose, lighting, or background indicated.

Running this data through your mental computer will spell out your *specific* goals for that particular job. Since the combination of such possibilities is vast, I can't tell you how you should resolve each situation. I can tell you, however, that by acknowledging the fact that every portrait is a totally new and different experience, you are gearing yourself mentally to resolve specific goals for a specific job.

The best way to do this is to prepare a checklist enumerating the conditions, restrictions, and requirements the portrait presents, then tackle each until you've resolved every problem and challenge in turn. This way, you stand a better chance of coming up with a fresh, exciting, *different* portrait, instead of another tired and stale rendering.

At Sea by Robert Philipp, oil on canvas, collection Walter Wanger. This is a powerful study of the actor Ian Hunter portraying a brooding sailor in John Ford's film The Long Voyage Home. Hunter played a doomed soul trying to forget his past, who is ultimately killed at sea. Although he was allowed only two sittings, Philipp managed to capture the ominous mood the actor was projecting. Such elements as clothing, pose, and direction of gaze were emphasized to represent the grim character of the portrait. Mood is a vital aspect of any portrait and must be carefully planned.

CHAPTER TWO
Visualizing the Portrait

While some artists envision the total portrait in their minds down to the last details of pose, composition, and color, others merely conceive a rough idea of what it will subsequently look like; however, almost all experienced artists visualize the portrait to some extent prior to placing the first brushstroke.

Without this visualization the painter — particularly one who is inexperienced — faces a chaos of changes, revisions, wasted effort, false starts, and only a rough chance of ending up with his goals fulfilled. At best painting is an imprecise process. Things go wrong even for the grizzled veteran who has stormed the barricades victoriously many, many times. Visualizing the portrait merely *increases* the chance of success — it doesn't assure it.

Visualizing the portrait entails assembling the data gathered in the first analytical stage and transforming it into visual terms — whether in one's mind, in line or tone drawings, or in color studies. It is important, however, that at this stage you have the following factors about the portrait firmly fixed in mind:

1. Its type and purpose.
2. Its restrictions and special conditions.
3. The sitter's needs and expectations.
4. Your own goals.

SIZE AND SHAPE OF THE PORTRAIT

Unless you are severely and irrevocably limited to a specific size and shape for the portrait, this consideration merits careful thought. Portraits in our uninhibited culture run from tiny conversation pieces to mural-sized curtain drops. In an era in which everything is permissible the artist rides the crest of license. This allows you to vary the size and shape of your portrait unless your fee is firmly fixed to the dimensions of the canvas. If this is the case, it's a problem you'll have to resolve on your own. But, barring this restriction, take the following aspects into consideration when deciding the size and shape of your portrait.

Where Will It Hang? If it's to be a personal portrait for the home, you can usually paint somewhat smaller in light of the limited space the average wall presents these days. If it's to hang over a fireplace or a bed, you might consider a horizontal rather than a vertical shape. In a radically ultramodern house you might consider a round canvas or a long, thin one in keeping with the overall avant-garde concept. For a cluttered, overdecorated room, you might paint a little 10″ x 14″ (25 x 36 cm) gem that will stand on one of the tables or rest in a small niche all its own.

If it's to be an institutional portrait, again seek to find out specifically where it will be displayed. Visit the location if at all possible and determine at what angle and how far from the viewer's eyes it will hang. This will help you determine how big you'll have to paint the portrait to retain the illusion of reality. The farther away the picture hangs from the viewer, the larger the figure will have to be painted, thus expanding the size of the portrait.

The Sitter's Physical Makeup. This is another consideration that should bear on the size and shape of the finished portrait. If the man is short, it would be best not to show him standing, since this would merely accent his diminutive stature. He'd be best shown seated, since the distance from the head to the waist is fairly constant in most people, and it's the length of the legs that generally separates the runt from the giant. This situation might, therefore, call for a square or a horizontal picture or one excluding the legs.

Conversely, a tall model might be shown to better advantage standing in a long, rectangular portrait which would play up his height. Also, if the man possesses an unattractive or asymmetrical figure, it might be best to do a head-and-shoulder study only.

Study your subject's hands. Are they handsome, nondescript, repulsive? The inclusion or exclusion of hands plays a vital part in selecting the size for the portrait. If you do elect to show the hands, they must be posed naturally. Also remember that including hands requires a picture showing at least

Robert Hardy by Clyde Smith, oil on canvas, 40" x 27" (102 x 69 cm), collection Mrs. Fitzgerald S. Hudson. Smith chose a long, narrow canvas to accommodate the standing pose and the subject's tall, lean physique. Had the portrait been painted on a wide, horizontal canvas, some of its impact may have been lost. There are artists who never vary the shape of their portraits, regardless of subject, pose, or other considerations. This narrow attitude leads to triteness, tedium, and repetition. The portrait painter must consider each portrait a fresh challenge to be resolved with insight, style, and originality.

three-quarters of the figure, with correspondingly larger dimensions for the overall painting.

Including Objects or Actions. Another factor dictating the size of the portrait is the amount of action or accoutrements it's required to represent. To show a surgeon in his operating room necessitates the inclusion of figures or objects naturally found in such an environment. This immediately calls for a larger painting. Or, if a favorite pet is to be included, the same conditions obtain. Also, if you wish to give some indication of your subject's hobby or profession—such as a minister's lectern or a yachtsman's boat—again you must expand the size of the portrait.

But suppose you want to focus on your subject's intellectual or spiritual qualities. You might consciously eliminate all extraneous matter and concentrate on the man's head, leaving little "air" and seeking to fix the viewer's attention on a lofty forehead, piercing eyes, or firm jaw. Thus you might deliberately constrict the size of your canvas to confine it to the subject exclusively. This same principle might be employed for any famous individual who is so easily recognized that he needs no accompanying "text" to identify him.

Costume. A fourth consideration affecting the choice of size for a portrait might be the costume the sitter will be wearing. Clerical or academic robes would be poorly served by a small, head-and-shoulders study. Their very sweep and swirl call for a larger painting. What the subject is wearing might well sway you to show him full length, or nearly so. This might include an ethnic or native costume such as a Scottish or Irish kilt, a particularly splendid military uniform which includes spectacular boots or leggings, a dancer's costume, or anything so extraordinary that it makes us curious to see the figure in toto. All this, of course, is predicated upon the principle of painting the head and figure more or less lifesize. Abandoning this concept opens up a whole new realm of possibilities.

LIFESIZE, OVER LIFESIZE, UNDER LIFESIZE

The alternative to varying the size of the portrait is adjusting the size you paint the figure itself. This can run from the head painted the approximately normal 9" (23 cm), to one 14" (36 cm) or 4" (10 cm) high. Most portraits are painted lifesize, or nearly so. This is a size in which most artists feel most comfortable and one which, to most viewers, represents reality.

There are exceptions, however. Some of the old masters, including Rembrandt, Titian, and Rubens, consciously sought a majestic effect for their portraits, which served to elevate man and lift him out of his mundane surroundings. This resulted in

paintings in which heads ran as large as twice their normal size and did, in fact, endow man with seemingly divine attributes. In defense of these masters (as if they needed it), their portraits were often hung in lofty perches so that they were seen from far below and did require their heroic size to present them to fullest advantage.

As castles and palaces disappeared and walls shrank to more manageable dimensions, portraits began to be displayed at eye level and no longer required the mystique of exaggerated size. At the same time, cynical man stopped seeking to endow his fellowman with false grandeur and began to see him with a more realistic, if slightly jaundiced, eye.

Both these factors contributed to the practice of painting portraits in approximately lifesize proportions, a condition that prevails to the present. Yet, in former times as well as today, some artists have deliberately elected to work *below* lifesize for reasons of their own. The miniature portrait, usually painted on ivory, was all the rage in the 1800s, particularly until the rise of photography. Some of these portraits were executed down to the very last meticulous detail, yet were no larger than 1″ x 2″ (2.5 x 5 cm).

Holbein, Vermeer, Terborch, the Van Eycks, and Breughel were some of the artists who painted smaller-than-life heads. Among present-day artists, Andrew Wyeth, John Koch, Charles Pfahl, David Leffel, and Charles Baskerville have been known to paint diminutive portraits. Thomas Eakins could execute a magnificent full figure no bigger than 3″ (7 cm) high.

What does it all mean? It means that only you control the size of your portrait (assuming the sitter agrees). It means that you can do an entire family group on a canvas 12″ x 14″ (30 x 36 cm) if you desire. It means that a 10″-high (25 cm) portrait can be fully as meaningful as one 90″ high (228 cm), assuming the quality of the work is equal.

Of the six artists featured in this book, Draper and Kinstler sometimes paint men's heads a bit larger than lifesize; Pfahl and Smith paint them somewhat under lifesize; and Seyffert and Sanden paint them lifesize. The usual argument of those who advocate painting a man's head over lifesize is that this lends the subject a measure of rugged, commanding presence. Those who paint the man's head a touch *under* lifesize argue that this fosters the illusion of reality, since people normally see each other at some distance and, therefore, a bit under lifesize. Those who paint men's heads at precisely lifesize argue that this is most natural and realistic. But the main reason the various artists employ a different approach to this problem is that each employs the size that's most suitable for *him*.

Which is the correct method? Apparently all three are acceptable, since there is nothing wrong about *any* approach to painting. What you should do is try painting the head in all three sizes and see which seems most natural and comfortable. I do strongly recommend that you vary both the size you paint the sitter and the size and shape of the portrait itself. This will help keep you alert, interested, and intrigued by the challenge of each new portrait experience.

SETTING THE MOOD

A factor you must establish early is the attitude or mood the portrait is going to present. Will it be happy, somber, brooding, lighthearted, assertive, sensitive, pensive? The kind of portrait you're going to paint, personal or institutional; the subject himself; the place where it will hang; the costume and background—all these factors help determine a mood. Color, key, value tonality, design, pose, and lighting are the tools used to achieve the mood once you have decided upon it.

Men's portraits are *usually* painted in a more solemn mood than women's. The color is usually stronger, the tonal range greater, the key lower, the lighting more dramatic, the shadows deeper, and the costume darker. Backgrounds also tend to be darker, more neutral, and less colorful. All this is probably based on stereotypical reasoning, but the fact remains that artists hesitate (especially in commissioned work) to paint a woman in the same somber, shadowy mood they might employ without hesitation for a male subject.

The reason behind this approach is that it's generally presumed that men envision themselves as rugged, commanding, dynamic individuals. This assertive image is even more avidly sought in the institutional portrait, which usually represents a mark of recognition bestowed upon a person of demonstrated leadership qualities. After all, few companies, schools, government bureaus, or other institutions would commission a portrait of a third-assistant clerk. Add to this the influence that books, movies, commercials, and other media have imposed upon our culture, and we come up with an image of masculinity that pays obeisance to strength and aggressiveness. Whether this is good or bad is outside our concern—the fact remains that the image is there.

Artists also respond to these stimuli, and thus male subjects tend to be painted in stronger color, deeper shadow, more dramatic lighting, lower key — all factors contributing to a forceful, super-vigorous mood in the portrait. That many men are anything but powerful, dynamic creatures is all too apparent. And here is where fidelity must cross swords with the stereotype, and the artist must decide whether to adapt the subject to the mood or the mood to the subject. I strongly opt for the latter. If a man is a gentle soul who prefers flowers, ballet, and

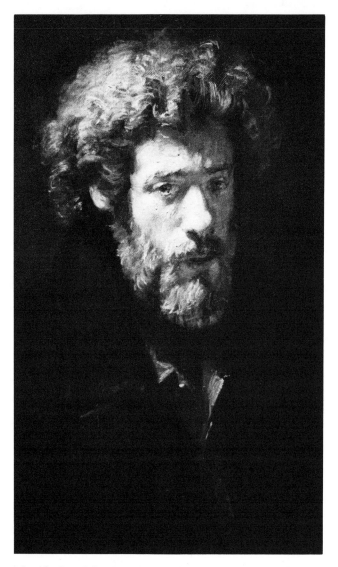

Lionel (detail) by David A. Leffel, oil on canvas, 24″ x 20″ (61 x 51 cm). Although Leffel has painted his subject lifesize or nearly so here, he usually goes below lifesize— often two to three inches less than the actual size of the subject. This is an instinctive approach fueled by the artist's personal feelings about size. Leffel finds the head painted larger than life gross and offensive. To him the ultimate accomplishment is to paint a subject small and still evoke the illusion of reality. The question of the size of the subject varies from painter to painter, but most artists paint a man a bit larger than a woman to project a sense of "masculinity."

Ethan Stroud (opposite page) by Marilyn Conover, oil on canvas, 20″ x 24″ (51 x 61 cm), collection Mrs. Kathleen Stroud. Informality is the approach in this light, airy study of an attractive young man. The windblown hair, the unbuttoned collar, the sunlit background all contribute to this effect. Artists commissioned to paint boardroom portraits envy the latitude given informal portraits such as this and strive to be as free within their restricted milieu.

poetry to football, he deserves to be painted honestly in a mood that's suited to his personality. The only question is whether he sees himself as he really is or—a victim of the media assault—pictures himself a modern-day Caligula.

This is a sticky problem only the artist can resolve. Should you elect to attain a softer mood, go higher in key, brighter (but not darker) in color, flatter in lighting, less assertive in pose? You might show your subject leaning back, rather than forward, and looking off to the side, rather than fixing the viewer with a gimlet eye. Whatever mood you finally decide to lend your portrait, do remember that it must have a specific mood or attitude. A portrait lacking this attribute tends to emerge flat, vapid, and ambiguous. It fails to make the statement every great work of art proclaims.

FORMAL OR INFORMAL APPROACH

Part of a portrait's ethos is its degree of *formality* or *informality*. Factors affecting this spirit are costume, pose, design, lighting, and background. Formality can be interpreted as tradition, sedateness, convention, and conservatism. *Informality* can be seen as casualness, frivolity, and experimentation.

Since painting men so often involves the institutional portrait, there is less room for the artist to introduce informality than there might be in the more personal and intimate woman's portrait. For this reason some artists deliberately avoid painting men, opting for the fun and the lack of pressure that prevail when doing women's and children's portraits.

The middle-aged man dressed in the dark blue suit, white shirt, and red tie, and sitting primly at his desk is the bane of many a portraitist's life. The painter strains to do something to break out of the rut, but often he cannot, since boards of directors are not too keen on portraits of their chairmen wearing jeans and perched on their desks holding guitars.

What sometimes happens is that the artist begins to play little tricks—to insert items or gestures into the portrait as a kind of inside joke—at times even in collusion with the sitter. Besides the incident with the hypodermic needle described in his interview in Chapter 10 of this book, Ray Kinstler once allowed his subject to brush in a few lines in his own tie. The man later boasted that he had "helped paint" his own portrait. I mention these little peccadillos merely to point out the deep urge that drives busy portrait painters to somehow depart from the customary formal portrait.

At this stage, you may be looking forward to the day when you're in the position to be asked to do one boardroom portrait after another; but when that time comes, you too may well long for the luxury of painting a highly unconventional, innovative,

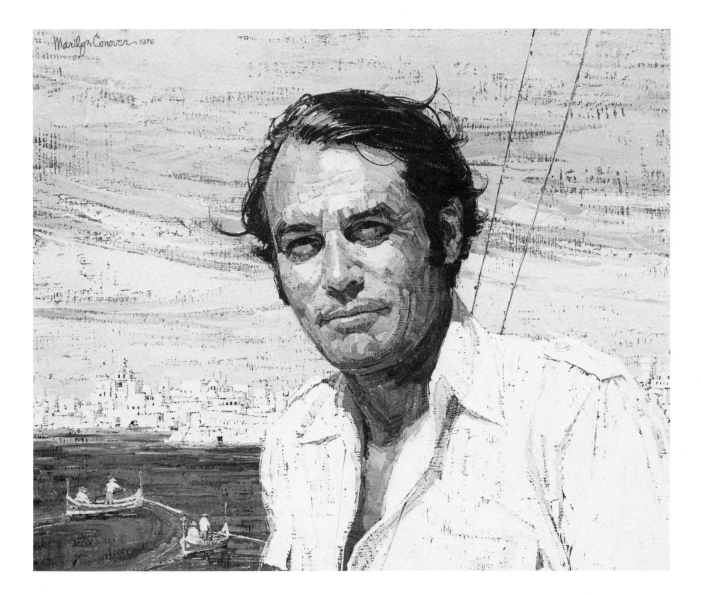

experimental portrait in which your subject is stripped to the waist or executing a yoga position. Painting a formal portrait may be great fun — but not if it isn't interspersed with other, more diverse assignments.

BACKGROUND

A background is a vital component of the total painting. It mustn't be treated perfunctorily or as an afterthought but rather, should be carefully and intelligently thought out. You might compare a portrait to a theatrical production — the subject is the actor and the background is the scenery against which the actor performs. There are experimental plays which do away with scenery altogether, but audiences generally prefer a rich and varied setting for the play. It intensifies the mood of the drama and heightens the enjoyment of the performance. It's the same with the portrait. A drab, unimaginative background takes some of the impact away from the sitter. A striking background, on the other hand, enhances it. A background can be:

Light in tone
Dark in tone
Solid or broken in tone
Composed of the full gamut of tone
Harmonious in tone with the subject
Bright or neutral in color
Harmonious in color hue with the subject
Solid or broken in color
Composed of the full range of color
Mass only
Delineated with objects
Part of a landscape
Part of an interior
Abstract in line, tone, and color
Combinations of the above

Backgrounds can be either arranged or invented. To *arrange* a background means first to set up the elements to fit one's conception or visualization of the portrait and then to paint what you see. To *invent* a background means to include those colors, shapes, tones, and lines you desire without actually having

Robert Henri by George Wesley Bellows, oil on canvas, collection the National Academy of Design. This is a splendid study of one American master by another. Robert Henri, who inspired a whole school of painting, is probably one of the five most important figures in American art. His book The Art Spirit is found in most artists' libraries and is widely read and consulted to this day. In this striking portrait of Henri, Bellows employed the old-master device of an all-dark background; the head seems to emerge from it, while the clothing blends into it. It's a lighting arrangement that's still used successfully by portrait artists even though modern critics tend to deride it as old-fashioned.

those elements present. A third option is to omit the background altogether and paint the head and/or figure as a vignette.

To arrange a background, you move the sitter about until he is posing against the wall, fireplace, garden, window, or whatever you wish to include in the finished portrait. Or you can employ folding screens with cloths and draperies and set them up behind him. To invent a background requires only a vivid imagination. However you opt to handle your background, don't leave it to chance. Plan it, visualize it, and compose it with some definite ideas in mind so that sometime during the evolution of the portrait it doesn't suddenly pop up as a perplexing, mind-boggling problem.

SELECTING THE BACKGROUND

Having determined not to leave the matter of background to chance, you are faced with the problem of selecting the proper background for each portrait. There are several ways to accomplish this:

Contrast of Tone. One way is to vary the tonal contrast of the background against that of the subject. If the subject presents an overall dark tonality, you make the background all light. For an overall light subject, you provide an overall dark background. A variation of this is to break up the tones of the background and use contrasts in selected areas. Thus you would throw a dark background against a light area in the subject and vice versa.

Contrast of Hue. This means using various hues contrasting with those within the subject. For instance, for a pale blond man in a tan suit you'd paint a green background. For a red-haired, florid type in a reddish shirt, you'd use a gray background. Or, you'd break up the hues so that a green area might be used against a yellow area in the subject or a yellow would be used against a green in the subject.

Contrast of Color Temperature. This is the use of a cool color against a warm color (or vice versa) throughout the painting or cool areas against warm areas (or vice versa) in selected places.

Harmony of Tone. To harmonize tones, use a tone in the background that's similar or close to the tone of the subject, whether throughout the painting or in selected areas.

Harmony of Color Hue. This could be the use of red in the background of a painting with a predominantly red subject, or the use of a red accent next to a red shirt and a green accent next to green slacks.

Harmony of Color Temperature. To harmonize temperature you can use an overall cool background behind an overall cool subject (or vice versa), or a cool accent next to a cool area in the subject and a warm accent next to a warm area.

WHICH BACKGROUND IS APPROPRIATE?

The next question might very well be, "When do I use which background?" I can offer several suggestions.

Light-toned background is appropriate for:

An informal background
An upbeat portrait
A background with lots of color
An impressionistic style
The personal portrait
The modern portrait
The outdoor portrait
The younger man
The backlit portrait

Dark-toned background can be used:

For the somber portrait
With overhead or dramatic lighting
When focusing interest on the head and hands
To drift the figure into the background
For the traditional or formal portrait
With the glazing, underpainting technique
To gain an old-master effect

Harmoniously toned background is ideal for:

The tranquil portrait
The elderly sitter
A high-key painting

Bright-colored background works well with:

The upbeat portrait
The personal portrait

Cool Background can:

Set off a warm subject
Promote the illusion of receding space

Warm background can be used to:

Set off a cool subject
Promote the illusion of advancing space

Harmoniously colored background is used:

To achieve color unity
When employing an overall color scheme

Background with objects delineated can:

Place the subject within a definite locale
Associate the subject with a specific profession, hobby, etc.
Establish a subject's height or girth in scale with objects of known dimensions

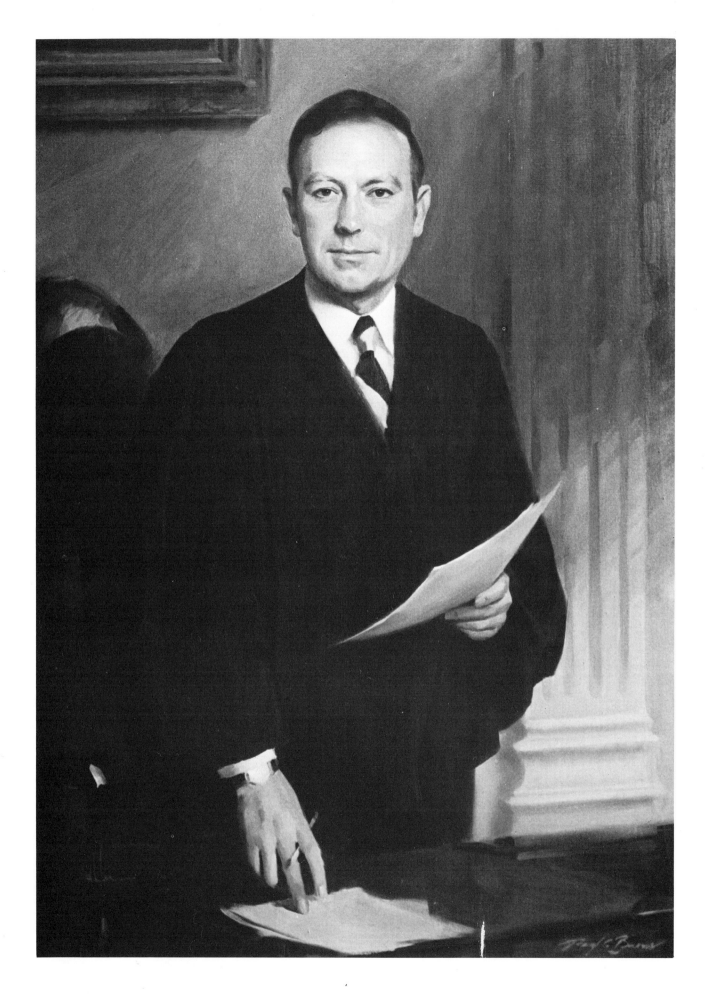

CHAPTER THREE
Posing and Composing

The next stage in planning your portrait is deciding how to pose your sitter and how to compose the overall design of the painting. Some artists reverse this order and first compose and *then* pose. Regardless of the order you choose, each subject should be posed according to the following factors, which were discussed in the previous chapters. These are: the size and shape of the painting; the subject's physical and emotional makeup; the kind of portrait it is to be—personal, institutional, etc.; the purpose of the portrait, which includes its projected mood, degree of formality, etc.; the place where it will hang; and the costume to be worn by the subject.

There are four essential ways the portrait subject may be posed: standing, sitting, in action, and lying or in repose.

Additionally, there are three ways of viewing a subject's head: full-face, three-quarter face, and profile.

Also, there are three more ways for the artist to be positioned while looking at the subject: at eye level, from above, and from below.

This gives us a total of ten poses and viewing angles. But when combinations of these ten possibilities are calculated and measured against the six factors dictating the pose, they present us with a staggering number of ways of posing and viewing the portrait subject. To avoid confusion, let's clear

the air a bit by laying down some general ground rules. There are four types of poses.

THE STANDING POSE

This might serve best for:

A long, narrow canvas
A tall man
A lean man
A youth or young man
A commanding personality
A spiritual, government, or military leader
A man of action
An athletic personality
A formal portrait
A solemn portrait
A canvas seen from afar
A man wearing a uniform
A man wearing distinct clerical, medical, or
 academic robes

THE SITTING POSE

The sitting pose might best be used for:

A three-quarter-size or head-and-shoulder study
A square or round canvas
A stout, short figure
A stooped or asymmetrical figure
An elderly sitter
A more pensive, less assertive type
A man of intellect rather than one of obvious
 physical character
The more intimate, personal portrait
The standard boardroom portrait

THE ACTION POSE

This type of pose provides instant recognition of a subject's hobby, sideline, or profession. He might be posed with a favorite pet or an object such as a sports car, a flower garden, a boat, a trophy, or the tools and accoutrements pertaining to his specific area of interest. Basically, the subject is shown *doing something*, such as:

Chief Justice Pierre Garven, *by Paul C. Burns, oil on canvas, 46" x 34" (117 x 86 cm), collection the Supreme Court of New Jersey. Burns posed his subject standing in his judicial robes to get the maximum effect possible for a man of his position. Although a judge normally executes the duties of his office while seated, the standing pose allowed Burns to give the subject a degree of importance that might have been less apparent in the sitting position. Thus Burns avoided the obvious and let his intelligence and perception dictate the pose. As I will repeat again and again, planning the portrait deserves at least as much time and effort as executing it.*

Hunting
Operating on a patient
Performing some athletic feat
Fighting a battle
Overseeing a construction job
Addressing an audience
Acting or dancing on stage
Painting or sculpting
Writing
Composing a symphony
Playing a musical instrument
Gardening

THE RECLINING OR LYING POSE

Men are seldom painted in indolent, reclining poses, but there is no good reason this can't be attempted in selected instances, such as in a radically horizontal canvas or with the subject in the following poses:

In a relaxed atmosphere such as picnicking
Playing with an infant or young child
Frolicking with a pet
Sprawling casually in a hammock or beach chair
Daydreaming in a field
Fishing while propped against a tree.
Reading in bed
Relaxing in a family group
Squatting on the floor
Lying in front of a fireplace

Because this is rarely done is no reason you shouldn't do it. It may make for a strikingly different and most attractive male portrait. Now, let's consider the angle at which you'll view the sitter and the most appropriate use of each variation: full-face, three-quarter-face, and profile.

THE FULL-FACE VIEW

This is an angle some artists avoid, since it tends to flatten the form somewhat and doesn't offer the contrast of value and the effect of roundness provided by the three-quarter view. Also, some artists feel it promotes a sense of monotony in that the two sides of the face are seen showing similar components rather than hiding some, as do the other views. Still, many men's portraits are painted full face, and there are some occasions when this might be feasible. For instance:

1. To depict an aggressive or outgoing personality.

2. To lend impact and immediacy to the portrait.

3. To purposely attain a two-dimensional, mural-like effect in the genre of the Japanese print or Egyptian frieze.

4. To expand and soften a particularly narrow, hatchet, or angularly featured face.

5. To counteract the curvature of a humped or sloping nose.

6. To lend some firmness and strength to a receding chin.

7. To mitigate the forward thrust of a lantern jaw.

8. To enhance eyes that are attractively set and shaped.

9. To emphasize a square chin.

10. To set off dimples.

11. To show the sweep of a handsome mustache or the shape of an unusual beard or side whiskers.

12. To avoid the effect of distortion which strong eyeglass lenses might impose upon the contour of a cheekbone if seen from the side.

13. To stress a characteristically piercing gaze.

14. To depict unusually thick or curiously angled eyebrows.

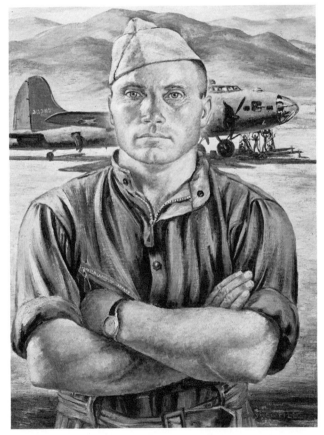

Master Sergeant Richard Olsen *by Charles Baskerville, oil on canvas, collection United States Air Force. In this painting, one of a series Baskerville did for the military authorities during World War II, the burly crew chief of a bomber in the 19th Heavy Bomb Group looks us squarely in the eye with a direct, unflinching gaze. This full frontal view is avoided by many artists, since it brings down the range of values in the face and reduces the darks. Yet note how skillfully Baskerville manages to turn the planes of the face so that they go back and lend roundness to the face. There is no reason not to paint the face in full frontal view because of the alleged problems this angle presents. Confront these challenges and find creative solutions to them.*

15. To emphasize a broad, high, or lofty forehead.

16. To point up the insignia or importance of military, academic, or professional headgear, such as a surgeon's head mirror.

17. To emphasize a broad smile or evenly set teeth.

THE THREE-QUARTER VIEW

This is the angle at which most men's portraits are painted. Its popularity is due to a number of factors:

1. It provides the fullest range of tonality in the face.

2. It's best for rounding the form.

3. It creates interestingly cast shadows.

4. It best brings out the character of the features.

5. With the eyes facing away from the viewer, this is a good way to depict a pensive, introspective personality.

6. It's particularly effective for painting boys and teenagers because it lends more form and depth to features that tend to be still soft and unformed.

7. It can negate the disadvantage of eyes too closely or too widely set.

8. It can be used to seemingly trim a face that's too broad or fat.

9. It can conceal a gaze that's slightly crossed, wall-eyed, or otherwise out of balance.

10. It can minimize the effect of protruding ears.

11. It can neutralize the effects of a face that is too wide on top or too pear-shaped.

12. It can be used to enhance the characteristic of high or protruding cheekbones.

13. The eyes may be shown facing up, down, or sideways—a factor that's rather limited in the full-frontal view. The direction of the gaze is an important means of revealing the emotional traits of a subject: looking straight at the viewer connotes directness and strength; looking up suggests piety or spirituality; looking down conveys modesty, humility, or timidity; and looking off to the side suggests pensiveness or introspection.

THE PROFILE VIEW

Many of the artists I've spoken with have expressed the desire to paint profile portraits, yet few do so, particularly in commissioned work. One of the reasons for this is that it is the most difficult type of portrait to bring off. Also, few sitters would consent to be shown in "half-view," as one might describe this. And finally, few subjects, male or female, have profiles handsome enough to warrant such an endeavor. So when is it desirable to paint a profile portrait?

1. When the sitter's features approach those of a Greek god—or at least of a John Barrymore.

2. When one is sufficiently fired up to overcome a particularly difficult challenge, which usually occurs when ability, confidence, and bravado merge in one propitious moment.

3. As a startling antidote to a steady diet of similar and somewhat monotonous poses.

4. To give a regal, Caesar-like aura to an appropriate subject — perhaps a high-ranking general or political leader. I can see the late George Patton or Dwight Eisenhower, with their magnificent bald domes, or a George Washington, with his jutting chin, painted in this fashion. Think of a coin or medallion in this regard.

5. To depict an intensely romantic, sensitive quality

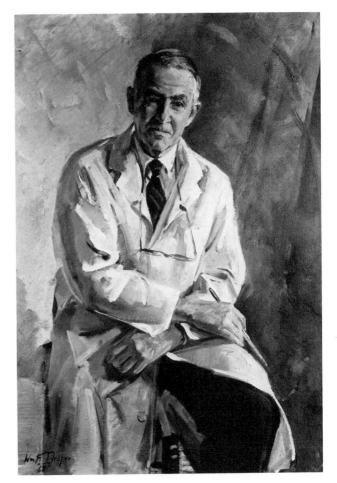

John Bordley, M.D. by William F. Draper, oil on canvas, 45" x 30" (114 x 76 cm), collection Johns Hopkins Hospital. Draper perched his subject on a high stool and painted him from a somewhat below eye-level view. In a sense, we are left "looking up" at the subject in both the figurative and literal sense. Here, this view works effectively, particularly in allowing an extended view of the medical coat. However, the pose is casual, and there is no sense of the aloofness such an angle might otherwise connote. Instead, we see a smiling, pleasant individual with a compassionate, interested gaze.

—perhaps a Lord Byron type brooding against the stormy sky over the cliffs of Dover.

6. To lend impact, spice, and variety to a small canvas showing the head and neck only.

7. When executing a quick vignette study—the profile view works particularly well against a lack of background.

8. To show the fine, delicate contour of a boy's or youth's face.

9. In a situation where the illumination is extremely flat and even and there is little or no shadow. A profile can be successfully painted with a minimum of tonal contrast, since it is essentially flat and contains little depth of form.

10. In a group portrait with one subject in profile facing another in full face. This can lead to psychological interpretation and, incidentally, makes for a particularly striking design.

11. By posing the subject facing himself in a three-way mirror so that he is simultaneously shown in double profile, full-face, rear view, or in any number of interesting combinations. By the way, this also works very well in self-portraits.

In addition to deciding the subject's pose and the angle of the subject's head, the artist must decide from which angle of view he will paint the subject. You can paint him at your eye level, looking up at him, or looking down at him.

EYE-LEVEL VIEW OF SUBJECT

This is the angle most often chosen by portrait painters. The reasons are simple. It provides a view that's most natural and therefore the easiest to paint. The reason it's the most natural is that people instinctively seek to place themselves at eye level with their fellow men. Most of us will sit if our companions sit and stand if they stand. This makes it easier to converse and saves wear and tear on neck muscles by avoiding stretching our heads to see and hear what the other fellow is trying to communicate. Thus we become accustomed (within limits of stature) to seeing our business associates, friends, and relatives at eye level, and the wise artist exploits this factor to provide us with a view of a person with which we are most familiar.

Another reason for this angle's popularity is that in this age of familiarity and equality, it usually doesn't feel appropriate to elevate the subject to some lofty position from which he looks down on us. It seems aloof and undemocratic. Also, this angle allows the subject to look us straight in the eye, which, in our culture, is an alleged indication of honesty, integrity, and artlessness.

An eye-level view also offers minimum distortion and makes it easier for the painter to attain a likeness. In order to paint the model eye to eye, most artists employ a model stand which permits this view when the subject sits and the artist stands. However, despite all its advantages, there will be occasions when you will want to get away from this perspective.

LOOKING UP AT THE SUBJECT

When might you want to paint your subject from below?

1. If he is short, you can make him appear taller.

2. When his head appears to sit right on his shoulders, looking up at him will seem to lengthen the neck and minimize the effect of squatness.

3. You can make a stout subject appear leaner. However, there is a very strong exception: make sure his chin and neck aren't so fleshy that the upward view serves only to emphasize this condition!

4. If his head is too large for his body, looking up at him will help equalize this disparity.

5. If his nose is too long, the upward angle tends to correct this fault.

6. To conceal a lack of hair, the upward angle might minimize some of the expanse of bare skin on top.

7. You can consciously invest the sitter with a lordly, commanding air. The aristocrats of earlier centuries wouldn't pose except with their nostrils fluttering high up in the air.

8. You can depict the effect of physical strength. Think of the canvases of the 1930s' school of social protest and the murals of Rivera and the other revolutionary Mexicans in which we gaze up at magnificently muscled workers and peasants hailing the New Order.

9. You can lend a holy or divine quality to the subject. This is evident in religious paintings of saints, martyrs, and angels.

LOOKING DOWN AT THE SUBJECT

This is a perspective rarely chosen for portraits, since it presents a number of difficulties. It makes the subject appear to have no neck; it psychologically diminishes his importance; it causes a distortion that makes likeness difficult to attain; it's potentially uncomfortable for both sitter and artist. Still, we mustn't dismiss it arbitrarily. When does it work?

1. For a super-casual portrait showing the subject in a state of total relaxation.

2. For a boy or teenager who feels natural kneeling or sprawled on the floor.

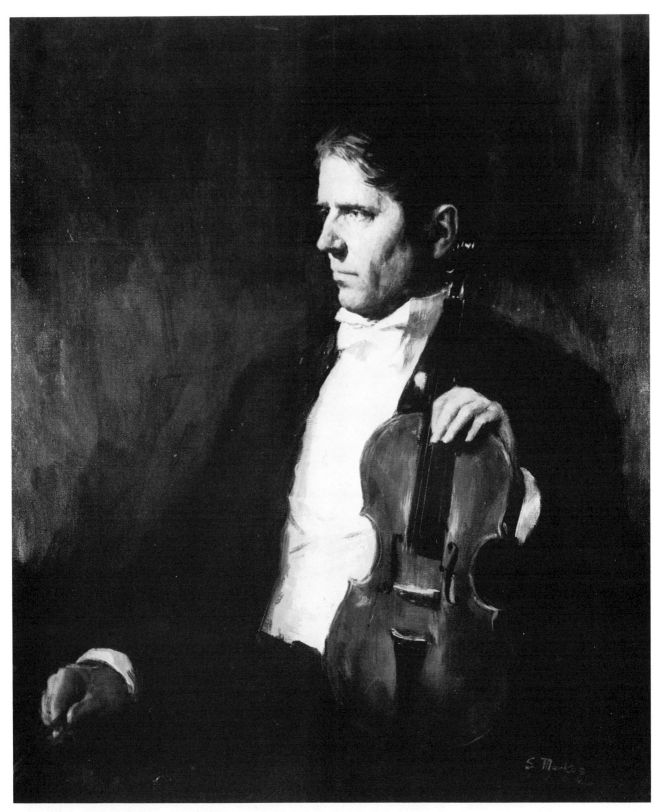

Meditation by Lajos Markos, acryllic on canvas 20″ x 24″ (51 x 61 cm). The
question of how much air to allow in the portrait continues to intrigue artists.
Some prefer to leave little space and to clutter the canvas; others include as
much air as possible. Considering the limitations imposed by the space allotted
them, portrait painters deal with the matter either by painting their subjects
below lifesize or extending the canvas size despite restrictions of fee or hanging
space. Here the artist has left considerable air around of the head to heighten the
effect of the musician's intensity of gaze.

3. In a family portrait with one or several members shown below eye level to achieve a good overall composition.

4. In some action pose that requires the subject to lie, kneel, or squat.

5. In an outdoor portrait in which a great expanse of sky is desirable.

6. In an unconventional, Degas-like composition which consciously seeks a startling viewpoint.

7. To point up some emotional turmoil which compels the subject to hang his head.

8. To depict the peak of intellectual concentration — a surgeon in the act of operating, a scientist or inventor considering a vital discovery, an author absorbed in his writing, or a scholar lost in a book.

9. A devout individual in the act of prayer, confession or penance.

10. A loving father cradling his infant child in his arms.

11. A boy lolling on the grass and gazing up at the sky.

12. A workman taking a break.

HOW MUCH AIR?

"Air" is the artist's term for the amount of space surrounding the head and figure within the expanse of the canvas. Some painters like to leave a lot of air in the portrait, others tend to grow more cramped. The question of how much air to leave around the head is predicated on several considerations:

1. The size of the canvas.
2. The shape of the canvas.
3. The size of the head and figure.
4. The pose taken by the subject.
5. The subject's costume.
6. The type of background depicted.

I'll discuss each of these in turn.

Size of the Canvas. Obviously the bigger the canvas, the more air you can include within its confines. The problem of air only grows pressing when necessity compels the canvas to be small with lots of information included. The decision regarding how much air to include dictates how many inches down from the top of the canvas you will place the top of your subject's head. This practice varies among portrait painters.

Shape of the Canvas. Obviously a long, vertical canvas will have air apportioned differently than a wide, horizontal canvas, a round canvas, or a square canvas. The shape of the canvas has much to do with where you will want to leave open space.

Size of the Head and Figure. If you paint over lifesize, you have one of several choices regarding air — either increase the size of the canvas to include more air, settle for less air, or show less of the subject to gain more air within the allotted space. If you paint under lifesize, you automatically have more air. If you want to reduce it, either cut down on your canvas or show more of the subject.

The Subject's Pose. A standing pose generally provides more air on the sides, but less on top, while a sitting pose does just the opposite. A lying pose leaves potentially lots of air above or below, and a pose that includes hands, particularly if they are somehow dispersed or active, tends to cut down on air. An action pose tends to reduce air.

The Subject's Costume. Academic, medical, or clerical robes usually cut down the amount of air. Any hat, cap, or other head covering reduces the amount of air on top. A theatrical costume is often elaborate and serves to reduce air, as do capes, cloaks, robes, and ethnic costumes. Uniforms tend to be close-fitting, allowing more air, as does the modern business suit. Sport costumes tend to be somewhat bulky, except for tennis or swimwear, and working clothes vary with the profession or trade.

Type of Background Depicted. The kind of background you select for your portrait plays a big role in the amount of air you show. A pure-tone background allows more air than one depicting actual objects. Props such as canes, umbrellas, musical instruments, tools, weapons, sporting equipment, scientific instruments, etc., all help reduce the amount of air in a portrait. Dogs, horses, bicycles, boats — anything solid, substantial, or concrete, from a desk to an aircraft carrier — in the background serve to clutter the portrait and rob it of air. The ultimate question is: is lots of air good or bad in the portrait? The answer depends upon the goals ascertained for that particular painting.

PUTTING IN MORE AIR

When do you want *more* air in the portrait? There are certain times when this is appropriate. Some of these are:

1. When you're consciously seeking an open, spacious, uncluttered look to stress these qualities in the subject.

2. To portray the effects of loneliness, alienation, the impact of a human being's essential isolation in a complex world.

3. To present a mystical or surrealistic atmosphere — perhaps that of a sailor, flier, or astronaut about to confront the challenge of open sea, sky, or space.

4. When seeking lots of contrast in color hue or temperature between subject and background — for

instance, a stark red figure against large areas of gray.

5. To emphasize the diminutive size of a boy about to embark into manhood.

6. To present an actor on stage with all the lights and eyes focused on him, the central figure in a drama.

7. To show a powerful speaker, or a religious or political leader whose presence at the rostrum commands the interest and inspiration of thousands.

8. To impart an air of affluence to the subject.

9. To promote the illusion of depth—the feeling that the figure sits somewhere behind the plane of the canvas.

COMPOSING WITH LESS AIR

Just as there are portrait situations most appropriate to a lot of air, others are most effective with less air. Some of these are:

1. To show a busy, dynamic, high-powered individual whose life is full of responsibilities. It's best to have him dominate the canvas with little room for blank, unfilled areas.

2. To show a frank, direct, gregarious personality who loves people and wants them around him at all times.

3. When the subject requires definite identification or classification by calling, profession, hobby, or other affiliation. Props, animals, clothing, or specific actions then dominate the canvas and leave the eye less room for roaming about.

4. If you seek to focus on some unusual feature such as the subject's eyes, hair, or mouth, it's best not to leave too much empty space, which will only subvert or diminish your intentions.

5. When you want to make a very slight person appear more substantial, it's best not to leave too much air around him.

6. To lend a kind of instant immediacy or impact to a portrait, bring the subject right up to the picture plane and reduce the amount of air all around him.

7. To present a personality who's bigger-than-life, fill the canvas with him and have him appear as if he were climbing right out of the picture.

8. For the informal, personal, intimate portrait for the home, less rather than more air is indicated.

MEETING THE PORTRAIT'S DEMANDS

I have listed dozens of possible guidelines for you to consider in posing your subject and composing the portrait. All that remains is for you to gather all the data pertaining to the subject's physical and emotional traits and costume; the kind of portrait intended; its projected mood, size, and shape; and the place where it will be displayed. Armed with this information, you can then refer back to these various guidelines and determine which will best fulfill the portrait's requirements.

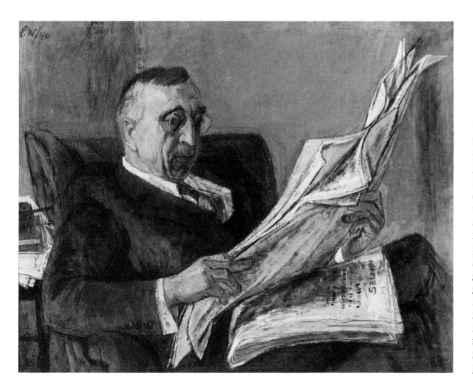

Thomas R. White by Franklin C. Watkins, oil on canvas, courtesy the Philadelphia Museum of Art. Let's examine how the artist suited the pose and composition of this portrait to its purpose. Obviously he had good reason to show the subject engrossed in a newspaper. Was he perhaps a publisher? An editor? Without knowing anything of his background, this would be a good guess. Or perhaps he was a figure in the news or one who had made news. Whatever the case, the pose most likely wasn't selected arbitrarily but had some important relevance to the figure being painted.

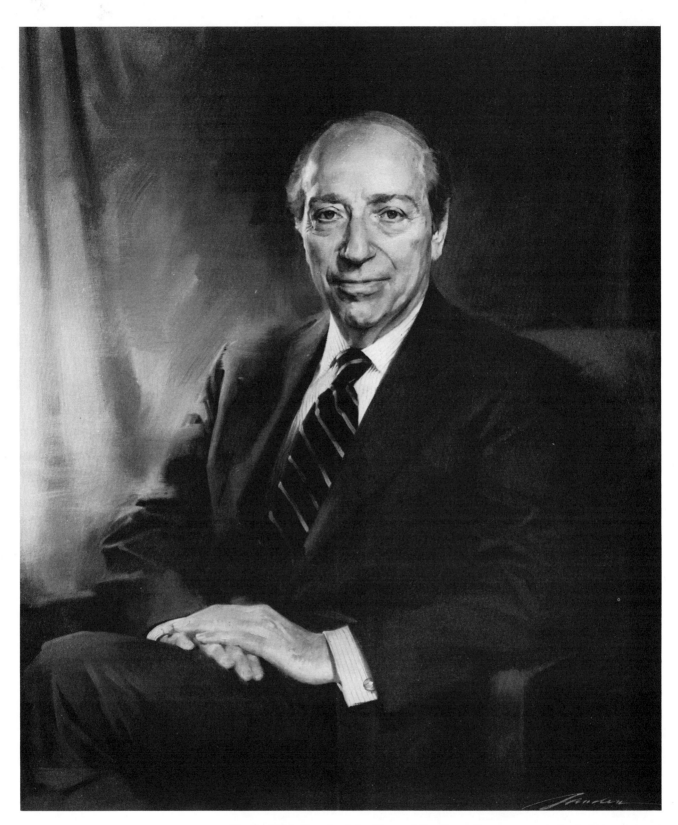

Dr. Rudolph Baer *by John Howard Sanden, oil on canvas, 36" x 30" (91 x 76 cm), collection New York University. The strong reflected light on the right side of the subject's face was used by Sanden to lend roundness to the form of the head. This is a device that must be exercised with care, since, in the hands of a less-than-consummate artist, it can wreak havoc with the value relationships of the painting. That it works well here is proof of Sanden's ability to control his values. The beginner is advised to learn to paint a head so that it appears to be turning without using reflected lights; he can then add them if he wishes, once he has mastered the initial skill.*

CHAPTER FOUR
Value and Light

Light is the factor that brings form into view. The intensity, proximity, and direction with which light bathes a form — in the case of a portrait, the head and figure—serves to break up the illuminated form into degrees of tone or value. Where the light strikes the head at the most direct angle, the brightest value appears. The area closest to the light also produces the brightest value. As the head turns away from the light, it progressively darkens in value until, at that point where no light strikes it at all, it becomes completely shadow.

Painting realistically is the effort to reproduce this effect of light on form in degrees of tone and color calculated to simulate the real thing. For purposes of practicality the artist reduces the large gradation of values that he actually sees to a more manageable number that he can effectively mix and put down on canvas.

NINE DEGREES OF VALUE

Those who came before us determined that the range of values in painting can be most practically and effectively reduced to nine. There is no reason to dispute this contention.

This reduction imposes upon the realistic painter a retraining of his eye so that when confronting his subject, he can automatically relegate each area into one of nine values. To facilitate this approach it pays the beginning painter to make up a value chart that he can use until his eye is sufficiently educated to take over.

You can make up such a chart by dividing a board or strip of canvas into nine squares lying side by side. Number the top one #1 and paint it pure white. Then add a touch of black for #2 and continue going progressively darker with each square until you reach #9, which is pure black.

Now you can begin training your eye to see in nine degrees of tone only. Carry this chart with you wherever you go and hold it up against various things — buildings, sky, grass, people — and see what value number they match most closely. This requires a bit of visual juggling since nature is not obligated to adhere to this format. But by slightly lowering or raising the values of the objects you see, you'll soon manage to make them conform to your standard. After a while you'll lay this chart aside permanently, but until experience takes over, let it serve as your guide.

If you can, lay your hands on a *transparent* value chart printed on plastic or celluloid and sold in photography supply stores. These are even more valuable in that you can look *right through them* at the object, then spin or move the chart until it matches the value of the area you wish to classify.

SIX TYPES OF VALUES

Another way artists identify values is to break them up into six basic types.

1. Light
2. Halftone
3. Shadow
4. Highlight
5. Reflected light
6. Cast shadow

Actually, only the first three matter, and the latter three are less essential. Let's discuss each one in turn.

Light. This represents the area or areas lying closest to the illumination and in a most direct angle to it. Here is where you see most of the color of the subject. It's the area where the color is the lightest in tone, the brightest, and the warmest (tending toward the red and yellow side of the spectrum).

Halftone. This is the area where the form begins to turn somewhat away from the most direct illumination and begins to darken. It's the area lying between light and shadow. It possesses less color than the light area and is somewhat cooler (tending toward the blue and green side of the spectrum).

Shadow. This is the area lying farthest away from the illumination and at the most indirect angle to it. It's therefore the darkest in value, the dullest, and

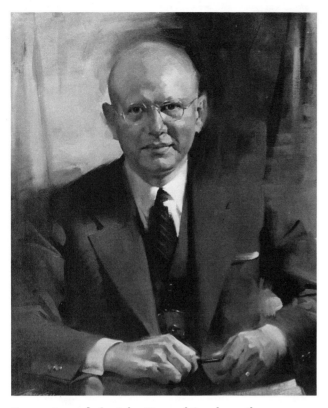

George Lamade by John Howard Sanden, oil on canvas, 30" x 25" (76 x 64 cm), collection Grit Publishing Co. Sanden shows how the adroit use of the highlight over the sitter's left eye promotes the illusion of a rounded skull. Although the rest of the head is painted in comparatively few tonal gradations, it's the addition of this significant highlight accent that makes the vital difference. Cover the highlight with your finger and see how the head tends to flatten. The highlight is like a spice in food. It should be used sparingly but in the most appropriate place for maximum effect.

usually the coolest in color. While it's possible to divide the subject into these three basic categories and paint him accordingly, most artists prefer to further subdivide and include the following three types of value.

Highlight. A highlight is two things in essence. It is the highest value within the light area of the painting. It is also a small area of light lying within an area of darker value. Thus, a highlight can be a pinpoint of light laying in halftone or shadow, and it can actually be *darker in value* than some of the tones lying within the lighter areas of the painting. This must be clearly understood since it's a very common misconception that a highlight is automatically the lightest area in a painting.

Reflected Light. A reflected light can also be one of two things: It can be an area of color that's reflected from some shiny surface back into the form. Or it can be a light that issues from some secondary light source and disturbs the natural light — halftone — shadow pattern created by a single source of illumination. Thus a shiny blue shirt can throw a reflected blue light onto a subject's chin and jawline. Or an electric bulb hanging off to one side can cast its light (not by reflection) somewhere onto the subject's head or figure.

Reflected lights find extensive use in portrait photography, particularly among unimaginative craftsmen with less than impeccable taste. They're to be avoided or severely curtailed in painting since they tend to weaken the roundness of the form and are a gaudy attention-getting device except in certain outdoor situations where they exist naturally.

Cast Shadow. This is merely the shadow that's cast by some projecting form, such as a nose, and causes a dark to fall within the basic light or halftone areas. The only difference between a regular shadow and a cast shadow is that the former is separated from the light areas by areas of gradually darkening halftone, while the latter creates a more abrupt separation between dark and light. Otherwise both shadows possess the same characteristics and are handled alike.

COORDINATING VALUES

By now we've determined that for artistic purposes all subjects are broken up into nine degrees of value and into six types of value. The trick is to incorporate the degree into the type. This means that you'll paint the head in three essential divisions of value — light, halftone, and shadow, and that within these categories you'll fit the nine degrees of tonal gradation — ranging from white to black. This doesn't mean that you have to use all nine degrees in every painting or that the 9th or *lowest* degree must necessarily be pure black. The whole thing is

dependent upon the factor of key, which is our next topic of discussion.

HIGH, MEDIUM, OR LOW KEY

Though the *relationship* of degree #1 to degree #9 remains the same, the overall range rises or falls depending upon whether one uses high, medium or low key. High key means that the overall tonality is lighter than medium, while low key means that the overall tonality is darker than medium. Thus a #9, or the darkest degree in a high-key painting, might be only as dark as a #6 degree in a low-key painting. Once this principle is understood, an artist can lower or raise the key of his painting to suit any particular situation so long as he remembers to maintain the proper relationship among his nine values.

When to Use High Key. High-key painting generally works best in the following situations:

To show lots of color in the shadows
For a light, bright background
In outdoor portraiture
To attain a happy, upbeat mood
To bring out the color of a light costume
For warm, bright color
To attain a decidedly modern, up-to-date look
With an impressionistic or expressionistic technique
In a personal, informal portrait for the home

When to Use Low Key. Low Key may be employed most advantageously in the following situations:

In chiaroscuro painting
Under overhead lighting
To attain an old-master effect
With dark costume
With dark background
To depict a brooding, somber mood
With much or most of the portrait lost in shadow
For a solemn, religious portrait
With an underpainting, glazing technique

When to Use Medium Key. Obviously painting in medium key offers the largest range of expression in that it allows one to go to either extreme, all within the confines of a single painting. Most experienced artists, therefore, choose this key and tend to stick with it throughout their careers. However, the danger exists that never varying one's key may lead to routine, formula portraits.

QUALITY AND TYPES OF LIGHT

As already stated, light gives visual substance to form. The type, intensity, temperature, clarity, and direction of light are all factors that determine the kind of painting that will emerge. There are basically two types of light — natural and artificial. Within the first category are two more possible di-

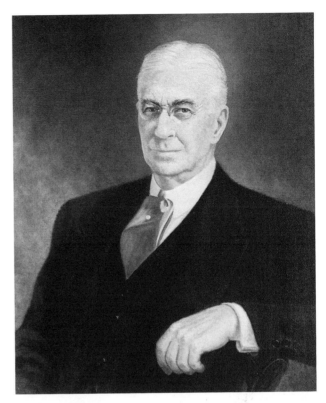

Bernard Baruch by Charles Baskerville, oil on canvas, collection Belle Baruch. A fine example of a high-key painting which coincides with Baskerville's upbeat, joyful approach to portraiture. Because of its high key and the almost full frontal direction of light, there is a minimum of deep shadow in the face. This might disconcert certain painters, but in the hands of an experienced artist it obviously presents no problems. Key is largely a matter of personality and temperament, but one should adjust the key to the singular conditions and characteristics presented by each sitter.

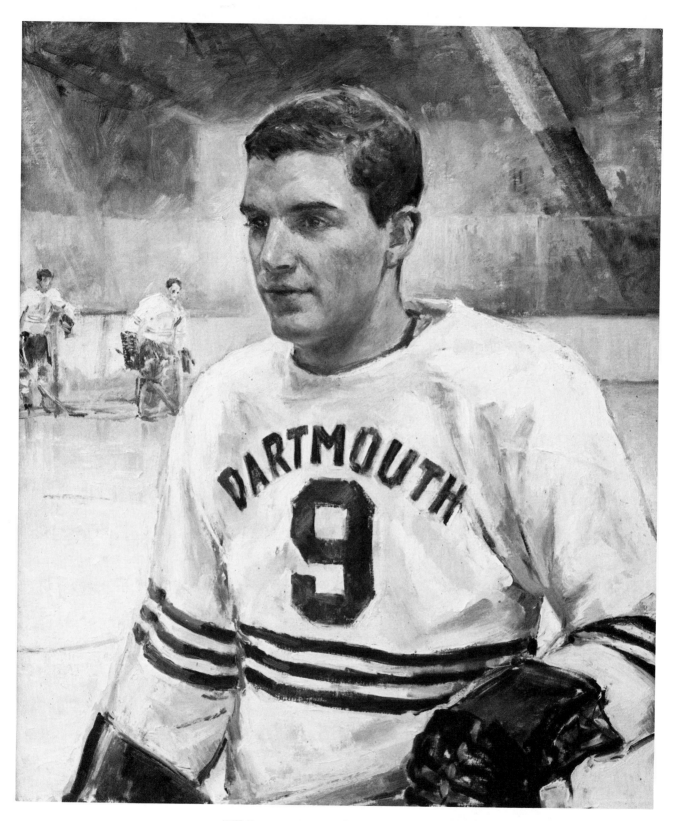

Bill Smoyer, Dartmouth '67 by Peter Cook, oil on canvas, 36" x 30" (91 x 76 cm), collection the Bill Smoyer Room, Dartmouth University Hockey Rink. This obviously represents an artificially lit situation—the brightly illuminated sports arena with strong overhead lighting which is reflected by the ice. Such tricky illumination causes lights and shadows to be dispersed discordantly and raises havoc with color. Although the portrait was probably painted in the studio—a hockey rink would hardly be a suitable place to set up an easel—all the elements seem correct and fitting.

visions—indoor and outdoor natural light. Finally, there are possible combinations of various types of light in one situation.

Indoor Natural Light. This is the kind of light under which 90% of portraits are painted. Most professional portrait painters occupy studios with windows and skylights positioned to capture the maximum amount of light during daylight hours. Usually this is a north light, which is the least changeable of all natural lights and has served as the traditional source of illumination for painters through the ages. Only one of the artists I have interviewed over the years, John Sanden, paints the majority of his portraits under artificial light out of choice. Sanden is a rare exception — many artists will refuse to pick up a brush unless daylight is present, and some will work under artificial light only under extreme duress.

Outdoor Natural Light. While many artists profess an urge to paint portraits outdoors, few actually do so. The reasons are obvious. Outdoor light is tricky, changeable, and inconstant, and sunlight creates additional problems. Shadows on skin tend to go much higher outdoors, and there is a great deal of reflected light. Subjects squint when posing in sunlight, and there is glare on the canvas. A canvas painted in sunlight can look ghastly when viewed inside, unless one has learned to compensate for the disparities of light and color seen indoors and out. Wind, clouds, and haze also add their influence. This is the reason why so many "outdoor" portraits are really painted inside where the artist can more easily manipulate the conditions, and the outdoor elements are simulated.

Artificial Light. There are two kinds of artificial light: *incandescent* and *fluorescent*. *Incandescent* is the usual warm, yellowish nightlight to which we are accustomed. *Fluorescent* is a colder, bluer type of illumination that sometimes is used to simulate daylight. Of the two, the incandescent is probably the more *natural*, since it doesn't mimic anything but is natural to its environment.

The chief disadvantage of artificial light in painting is that it affects the colors of the skin so that some of the subtler tones and shades are altered or lost altogether. Its main advantage is that it can be manipulated and controlled more easily than daylight.

Combinations of Light. Occasionally artists will combine two types of light in a portrait. They'll pose the subject in daylight and use artificial lights to fill in and enhance the main source of illumination. This can lead to serious trouble, since the two types of light may prove incompatible. A cool natural light mixed with a warm artificial light (or vice versa) requires a master hand to control.

INTENSITY OF LIGHT

The intensity of natural light varies from continent to continent, from region to region, between times of day, and with season and weather conditions. Light is strongest in a warm climate, in summer, on a cloudless day, at noon, and in the desert. These are the optimum conditions. Each change in these circumstances would diminish the intensity of the light. Since these are factors we can't control, short of moving to the proper location and awaiting the propitious moment, we must learn to do with what we have.

TEMPERATURE OF LIGHT

Natural light can be warm or cool depending upon the season, time of day, weather, geographical location, and direction. Winter light is generally cooler than summer light and light is coolest at dawn, in late afternoon, right after sunset, and on a rainy, foggy, or overcast day. Light is also cooler in the northern regions of the world than in the southern, and north light is cooler than that of other exposures. Light is generally cooler in the mountains rather than the plain, and by the seashore rather than inland. The desert usually produces the warmest light.

The factor of light being warm or cool in essence is something you must consider in portrait painting. If it's decidedly weighted to one extreme or the other, and if it interferes with your goals for the portrait, take conscious steps to counteract it. For instance, if you are stuck with a southern exposure which you know to be warm and you're aiming for an essentially cool portrait, cut down on your yellows and reds and lean toward the bluish, greenish mixtures. It's your absolute duty as an artist to control your painting rather than submit to conditions imposed upon you. You must exercise the creative guidance over your painting, since, in essence, it's your hand that gives it life and breath.

CLARITY OF LIGHT

Light, besides being natural or artificial and warm or cool, can also be *direct* or *diffused*. *Direct* light is that which passes from the source directly to the subject without intervening matter. *Diffused* light is that which is filtered through screens, shades, dirty glass, plastic, or other artificial objects put up by the artist specifically with this goal in mind.

Obviously there's nothing we can do about the mass of pollutants that already linger in the atmosphere between the sun and ourselves. These serve as natural diffusers along with fog, mist, smoke, smog, and clouds; but such light must still be considered direct, since it's not been diffused by man's hand.

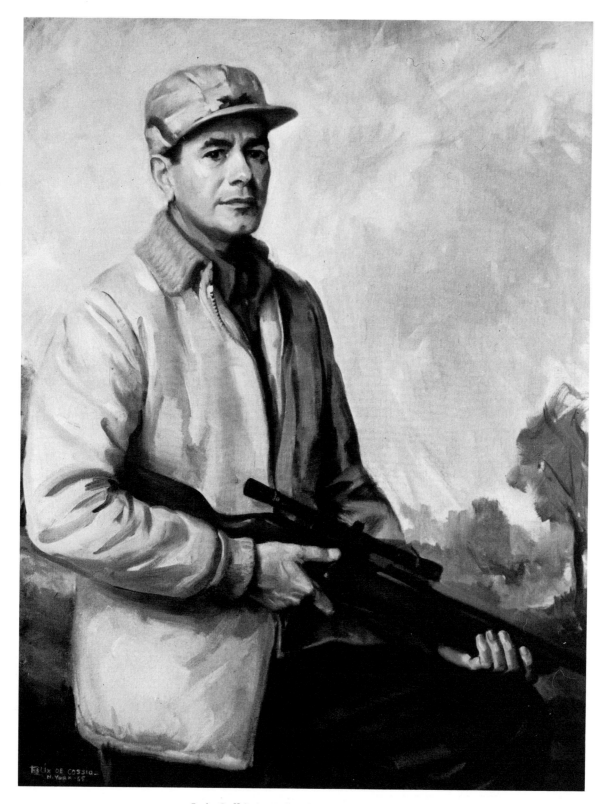

Luis Galbis by Felix de Cossio, oil on canvas, 40″ x 30″ (102 x 76 cm). The challenge of painting a portrait outdoors is one most artists seize upon eagerly. Natural light that's not blocked or diffused by any intervening objects provides an illumination that can't be matched inside any studio. It's difficult to say whether this picture was actually painted outdoors, but it appears as if it had been, which is what's really important. A skillful painter can paint such a portrait inside and add the proper elements to make it seem like a location portrait. Incidentally, compare this painting of a hunter with that by Eugene Speicher on page 15.

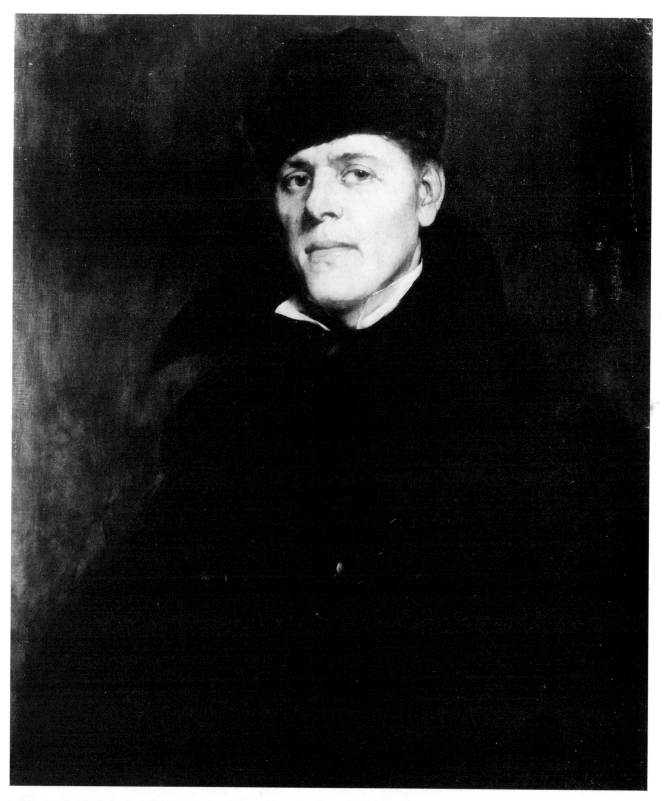

Major D. H. Clark *by Frank Duveneck, oil on canvas, 30" x 25" (76 x 64 cm), collection the Corcoran Gallery. Here the artist manipulated the light to gain the desired effect. He brought up the values in the face and collar so that they pop out of the picture; he brought down the values in the coat, hat, and background to provide a dramatic contrast to the face. Actually, such illumination couldn't co-exist—either the coat would be lighter, or the face darker. But nowhere is it written that the artist is bound to fidelity. His only responsibility is to produce a handsome work of art through any means he can command.*

ANGLE AND DIRECTION OF LIGHT

The final aspect of light is its direction—the angle at which it strikes the subject. This is a most important consideration, since it affects or actually determines the mood, coloration, tonal quality, composition, and general appearance of the portrait. Choosing the angle of the light is every bit as important as selecting the pose, palette, key, and overall design for the painting.

Let's consider the various options of light direction:

Overhead Lighting. This is the so-called Rembrandt lighting, made famous by the great man and imitated by his disciples, mimics, and successors. It owes its origin to the fact that artists' studios of that time were fitted out with skylights which served as the sole source of illumination. Thus circumstances dictated the light, not the other way around, as some historians would like us to believe.

The overhead light worked very well in its time. Today it strikes many observers as dated and mannered. The artist who paints a portrait under such illumination is often labeled a bogus Rembrandt. The overhead light throws much of the face into deep shadow. The eyesockets, forehead, and much of the lower part of the face is dark. Light is concentrated on the top of the head, on the nose (especially at the tip), on the tip of the cheekbone, and possibly the chin. The shoulders and hands may also catch some of the light, but the rest of the costume and the background are in deep shade.

Side Lighting. Side lighting is the most common illumination in modern portraiture. The only variation lies in the height from which it originates. Many artists' studios today are furnished with tall windows stretching from waist-height to the top of the ceiling, which may run 18 or 20 feet. Most are also fitted with shades that *roll up from the bottom.* It's a common practice to control the direction of the light by manipulating these shades. By raising or lowering them, one can obtain anything from same-level illumination to very high sidelighting which almost approaches the effects produced by a skylight.

High Side Lighting. High side lighting lends a full range of tonality and roundness to the head. The shadows are deep and rich, the halftones are clearly delineated, the lights are bright, and the cast shadows are distinct. On face value this appears to provide all the color fidelity, tonal contrast, and roundness of form the portrait painter would desire; in fact, it's the type of illumination most artists select.

Same-Level Side Lighting. This is the kind of light we live by indoors (unless you live in a barn). Although it provides *less* contrast of value, *less* color variation and *less* roundness of form than does high side lighting, some painters choose it for the very reason that it's the light that's most familiar to us and, therefore, most natural for the portrait.

Light from Below. If you have ever stuck a flashlight under your chin as a child and observed the eerie effects in a mirror, you know what happens when light strikes the face from below. There aren't too many occasions when this would work in a portrait, but there are exceptions.

Backlighting. Backlighting causes the head to fall into shadow for a kind of silhouette effect. It's tricky and most difficult to carry off such a tour de force; however, successful portraits have been painted this way. It's more feasible in an outdoor situation, where an excess of reflected light would tend to nullify the great variation of light between the bright light issuing around the contours of the head and the deep darks within it. The reflected light would also throw more light onto the features, rendering the attainment of likeness that much easier.

Outdoor Lighting. Light outdoors throws us into a whole new ballgame altogether. Barring such intervening factors as trees, foliage, and umbrellas, outdoor light is a combination of overhead, high side, level, back, and possibly even below-level illumination. These factors lend outdoor lighting its fascination and, simultaneously, its extreme complexity. Few genuine outdoor portraits (those actually painted outdoors) have succeeded. Only the Impressionists managed time and again to capture the spirit of outdoor light in the portrait. Perhaps the reason *they* succeeded lies in the very essence of outdoor light, which complemented their techniques. Outdoor light offers a greater variety of colors than does indoor light. Its quality is gemlike—broken up into tiny mosaics and patterns of hue and tone. This is precisely the way the Impressionists handled color, and it explains their affinity for the outdoor portrait.

Another factor of outdoor light is its inconstancy. Sunlight changes to shade and back again, clouds pass over the sun, haze forms and vanishes, the sun (actually the earth) moves from east to west, shadows form and disappear—the whole effect is a kaleidoscope of rapidly shifting color such as children rotate before their eyes in a tube.

The factor of reflected light is also very much in evidence outdoors. Water, grass, foliage, rocks, sand, snow — all tend to reflect lots of color back into the subject. This causes shadows to weaken and become suffused with color. The presence of glare is another factor to contend with. Blinding sunlight tends to rob color of its intensity and to

William G. Lyles, Sr. *by Everett Raymond Kinstler, oil on canvas, 35" x 35"*
(89 x 89 cm), collection L.C.B. & W. Corporation. The picture was painted under
rather unusual circumstances. The subject, who is an architect, took Kinstler
into the top story of a building that was under construction; as the artist studied
the sitter as they conversed, the pose suddenly evolved for him. You'll note that
the light in this striking portrait is at both sides of the subject's head. The chal-
lenge of the rather tricky lighting was such that Kinstler sacrificed the distinct
character of the subject's eyes, which are partly lost in shadow, to capture a pose
that seemed natural to the sitter and pictorially attractive. For Kinstler, it was a
pleasure to get out of the studio and paint a portrait on location.

Self-portrait *by David A. Leffel, oil on canvas, 14" x 12" (36 x 30 cm), collection Mr. and Mrs. Max Selzer. Here the light issues from high above, almost directly overhead. This results in an old-master effect in which the eyes, mouth, and chin are thrown into deep shadow. Such illumination might prove difficult to carry off in a commissioned portrait as most subjects don't want to be concealed from view. It takes a bold artist to pose his subject in such light—Rembrandt's portrait career floundered after just such an experience when he painted his famous* Night Watch *with half the subjects barely recognizable.*

render it whiter. Sunlight also causes subjects to squint, sweat, or burn. A glare forms on the palette and canvas. Leaves cause a dappled effect. All these problems must be confronted and compensatory measures must be taken when painting outdoors.

LEARNING TO USE LIGHT

In this chapter, we have discussed light as it affects the male portrait. Now, we'll consider how to use the different types and aspects of light to best advantage.

Type of Light. By any measure, natural light is superior to artificial light. However, if it proves necessary to paint by artificial light, which is better — incandescent or fluorescent? In my estimation, fluorescent light — particularly the type labeled as "daylight," is infinitely more satisfying. It most closely approximates the cool temperature of daylight and is a credible substitute for the real thing. I do, however, urge you to paint edges more softly and shadows less darkly than you actually see them when working under artificial light, since fluorescent light tends to show edges as too crisp and to darken and dull shadows excessively. Also it might be a good idea to go a bit brighter in color, particularly in the shadows and halftones, since artificial light tends to kill the subtle color tones, especially in the darker skin areas.

Intensity of Light. Strong light is good, but a light that's *too* strong is not desirable. If the light where you live is so powerful as to be a disturbing factor, cut down its intensity with shades, rollers, blinds, or other filtering agents. Or move back deeper into the studio where the light is dimmer and less glaring.

Temperature of Light. The rule of thumb is: cool light for cool subjects, warm light for warm subjects. Thus you wouldn't intentionally paint a florid-faced man in a Santa Claus suit in the cold, gray light of dawn, or a gray-skinned, gray-haired man in a blue suit in the hot noon light of the desert. Although this is a factor you can seldom control, try whenever possible to match the temperature of your light to that of your subject.

Clarity of Light. Direct light produces darker shadows, stronger colors, brighter highlights and, sharper edges. Diffused light works the very opposite effects. When to use each?

Use direct light when seeking:
Deep contrasts of tone
A dramatic, chiaroscuro effect
Bright, intense color
Crisp, tight edges and outlines
Strong highlights and accents
More roundness of form

Use diffused light when seeking:
Softer edges
Lighter shadows
Paler color
Less contrast of tones
Broken outlines and contours
More flatness of form

Angle and Direction of Light.
Use overhead lighting for:
Deep, rich shadows
Dark backgrounds
Melting the figure into the background and focusing attention on the head and hands
A brooding, somber mood
An old-master effect
Emphasis on tone rather than color
Cool color
Limited color
A religious portrait
An elderly subject (it hides the ravages of age)
A thick, pastose, knife-painting technique
Low key

Use high side lighting for:
A complete range of values
Roundness of form
Distinct halftones
Good color in lights, halftones, and shadows
A dispersement of shadow and light that is not extreme
Natural and crisp cast shadows
Color in the costume
Medium key

Use same-level side lighting for:
A natural, familiar effect
More flatness of form
Lighter shadow
Less total shadow
No cast shadows
A youthful subject

A bright, upbeat mood
An open, uncomplicated subject
More total light
An intimate, undramatic mood
Warm color
High key

Use light from below for:
An on-stage footlight effect
An ominous, omnipotent mood
A subject seated by a fire outdoors
A subject seated before a fireplace indoors
A steelworker before a hearth
An occult portrait to stress the subject's supernatural powers
Light reflected up from water or grass outdoors
A scholar reading by a small desk lamp
A person at prayer or making a benediction over candles
A jeweler examining precious gems

Use backlighting for:
An outdoor portrait different from the ordinary
A man seated between two windows
Accentuating the depth and roundness of the head
Lots of sky in the background
A distinct silhouette, like a strong profile
To hide a subject's objectionable features

THE GREAT OUTDOORS

And finally—paint a portrait outdoors for the sheer fun and challenge of it. You'll see skin colors as you've never seen them before. You'll use mixtures you wouldn't have dared consider inside. The experience will serve to shake you up and divest you of those tricks, habits, and mannerisms to which you've become slave, not master. Going outdoors will turn you away from the isolation and introspection to which all artists fall prey. Your portraits will lose that dusty, fusty, studio look and will become suffused with sun, wind, air, and—above all—life.

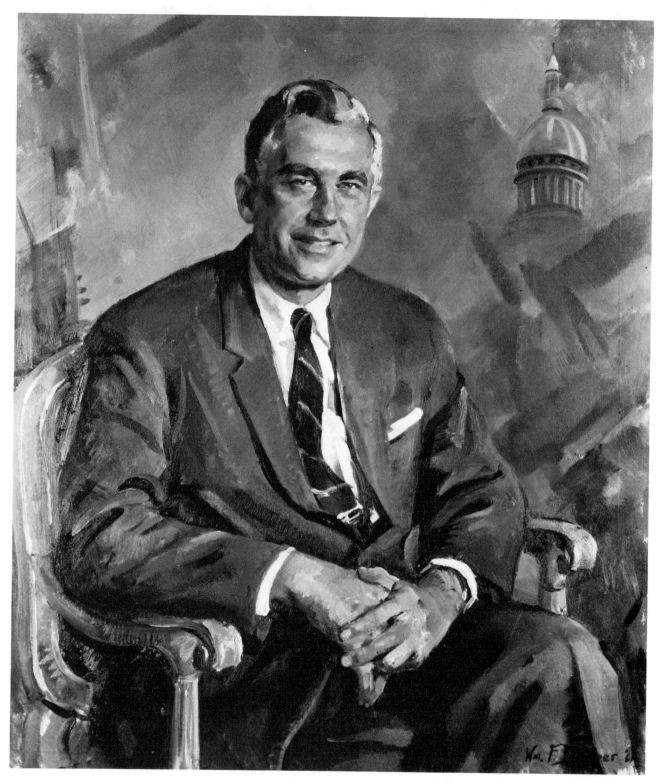

Governor Robert Meyner by William F. Draper, oil on canvas, 40″ x 32″ (102 x 81 cm), collection New Jersey State House. Here the mood is happy, animated, and positive. Note the loose brushwork in the background where Draper merely included a cupola to suggest the governor's position. Had he painted in the entire building, it would have made one wonder just where Mr. Meyner was sitting. As it is, we are satisfied to accept the symbol without worrying too much about the actual location of the elements. The use of such symbolism is a shortcut artists use to make a statement. It's akin to poetry, where a word or two can suggest many levels of meaning.

CHAPTER FIVE
Color

Color, its use and perception are such subjective factors that the conscientious instructor must avoid absolute opinions that brook no rebuttal. All that a teacher or author can do is offer certain basic principles which the student or reader can absorb to enhance his own knowledge of color and then exploit these facts and guidelines in practical application.

INTENSITY OF COLOR

Some inner sense, which probably issues from instinct, environmental influences, and personality, dictates whether an artist paints in subdued or intense color. Naturally, a single painting can contain both dull and vivid color, but artists generally lean toward one or the other. Often, the same drive that pushes a painter toward one or another technique also controls his tendency toward subdued or intense color. Those who work in a low key and a somber mood are also likely to hold down the intensity of their color. Dark tonality seems to go hand-in-hand with duller color. An Impressionistic or Expressionistic technique usually evokes vivid color.

The first thing you, as a prospective painter of portraits, must determine is *where* your personal leanings regarding color seem to point. If you're naturally inclined toward bright, snappy color, it would be infinitely more productive to declare yourself early and build your career around your color proclivities rather than *waste years of futile effort trying to curb or alter what you sense and feel.*

In portrait terms, it works out this way:

If you're a naturally bright-color person, don't vigorously pursue the boardroom portrait; rather, aim your guns at the personal, informal portrait for the home, where your inclinations will stand you in better stead. Concentrate on commissions of women and young people. Unless things change radically in the next few decades (which they may), the boardroom, institutional portrait will elude you for the main part.

My advice, based on *what is* rather than on *what should be*, is to sensibly adapt your color perception to your career goals. This doesn't mean that one cannot transcend prejudices and convention and succeed brilliantly in all fields of portraiture despite one's color inclinations. I merely suggest that it's wiser to recognize and acknowledge one's tendencies and exploit them to their fullest advantage rather than spend years in needless frustration.

TEMPERATURE OF COLOR

Color is divided by artists into warm and cool. Within these categories there are general divisions and subtle subdivisions. The *general* category of warm color includes red, pink, yellow, orange, and brown. The *general* cool color category includes blue, green, violet, purple, and gray. Within each color— whether warm or cool— there are further, more subtle temperature variations. Thus, there are warmer and cooler reds, warmer and cooler blues, warmer and cooler grays, etc.

The separation of warm and cool colors is usually based on whether the color leans toward the yellow or blue side of the spectrum, regardless of its basic hue. Thus, a red with bluish undertones, such as alizarin crimson, would be a *cooler* warm color; and a red with yellow undertones, such as cadmium red pale, would be considered a *warmer* warm color.

All this can become very tedious and involved if you let it. I advise that you don't become overly concerned with labels and that you trust your eye to differentiate between cool and warm colors. By sticking firmly to the blue-yellow system of classification, you'll soon learn to read and classify the temperature of each color in your subject and on your palette.

Once you have learned to make distinctions between warm and cool color, you'll be able to exploit this factor to enliven your portrait. A contrast of cool and warm color is usually visually exciting. By playing one against the other, you'll achieve sparkle and interest in the painting. Or you may

intentionally paint an all-warm or all-cool portrait. Now that you're aware of the factor of warm and cool color, you can control it in your painting, rather than ignore it or treat it in a haphazard fashion.

USE OF COLOR TEMPERATURE

Cool and warm colors have some very general applications in portraiture.

Use generally cooler colors or mixtures for:
Halftones
Shadows
Receding planes
Highlights on black skin
Oriental skintones
Veins in hands
Teeth
Whites of eyes
Solemn moods
Older subjects
Pale skin

Use generally warmer colors or mixtures for:
Lights
Highlights (except on black skin)
Lips
Earlobes
Knuckles
Cheeks
Advancing planes
An upbeat mood
Younger subjects
Ruddy or tanned skin

SELECTING A PALETTE

The process of selecting a palette may be compared to the selection of a mate. Some persons are constantly changing, adopting, and rejecting colors in their palette, while others pick a palette and stay with it for life.

There are close to 500 different oil colors available to the assiduous seeker of variety. True, many of these are closely related or slight variations on a shade; still, such an assortment can be devastating to one who is somewhat unsure of himself and overwhelmed by this plethora of paint.

I propose a fairly simple solution, one based on the principle that the human eye sees only the colors reflected by the prism. These colors are:

Red
Orange
Yellow
Green
Blue
Violet

Some break up green into yellow-green and blue-green to construct a more complete spectrum.

We now end up with seven colors which — *ostensibly*—should provide us all the color mixtures existing in nature. Matching these colors with approximate artist's paints, we end up with the following palette:

Cadmium red light
Cadmium orange
Cadmium yellow pale or light
Thalo green or chromium oxide green
Cerulean blue
Ultramarine blue
Cobalt violet or alizarin crimson

This appears technically correct, but it seldom affects an artist's choice of palettes. The reasons are many. For one, painters don't choose palettes for scientific, but rather for esthetic and practical reasons. Besides, a prime consideration to painters is whether a color is transparent or opaque. A second is its drying time. A third is its strength or covering power. A fourth is its texture.

The spectrum *can* be used as a starting point from which to launch one's search for the perfect palette. You may elect to pick a red, yellow, orange, blue, green, and violet for your palette, or you may decide to pick only a red, yellow, and blue, and mix your own orange, green, and violet. Or you may decide to pick a warm and a cool of each of the seven colors. Or, you may elect to choose ready-mixed browns, such as umber, instead of mixing them yourself. You may include or exclude black. Again, how does one go about selecting a palette? There are several guidelines.

1. Decide if you're an essentially bright or dull-color painter.

2. Decide if you're an essentially warm or cool color painter.

3. Decide if you prefer transparent to opaque color.

Having ascertained these facts, match them against the factor of the seven colors of the spectrum and see where you are. Let's begin with yellow. Cadmium yellow pale is an intense, fairly warm, semi-opaque yellow. Yellow ochre is a dull, cool, opaque yellow. Hansa yellow light is intense, cool, and transparent. Naples yellow is dull, opaque, and either warm or cool, depending on the brand. Do you get the idea? Acquire color charts put out by the various manufacturers and go down the list of yellows, listing the properties and characteristics of each; then select the one or two that most closely match your requirements as to intensity, temperature, and opacity. Follow the same procedure with the other hues.

This is about as good a way as any to assemble a starting palette. Eventually, you'll test and try all the other colors until you've arrived at a palette

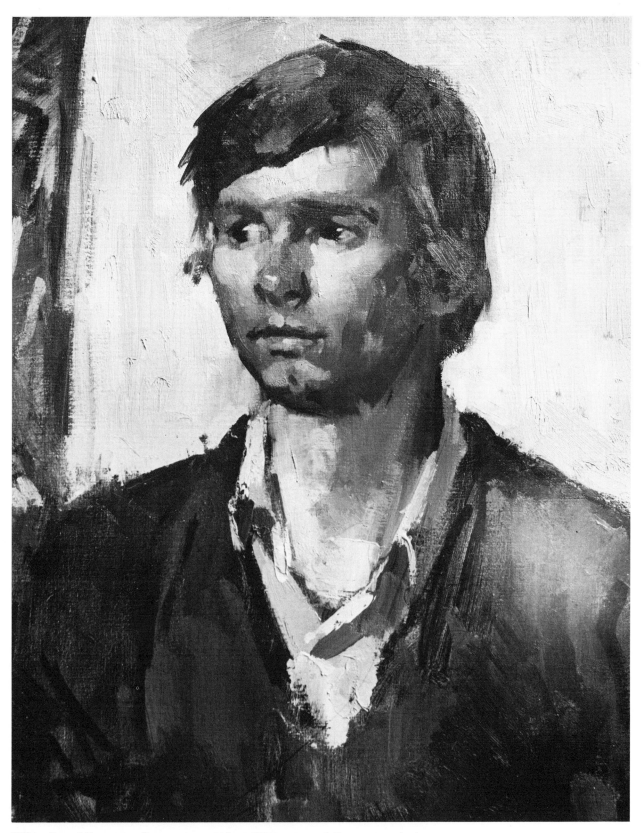

Bill by Sergei Bongart, oil on canvas, 26″ x 24″ (66 x 61 cm). Bongart works in a decisive, broad technique that marks off the form into definite, strong planes. You can see the variety of strokes, which lie where they are placed, with little attempt at blending or fusing. Compare this to some of the glossier techniques employed by other painters in the book. Which of these styles suits your personality best? Technique is almost invariably the result of individual character. Often, the extrovert will lay his paint heavily and broadly, while the more introspective type is less free and sweeping in his movements.

Chevy Chase by Clifford Jackson, oil on canvas, 48" x 38" (122 x 97 cm). There is something reminiscent of El Greco in this elongated posture of the young man casually perched on the edge of the stool and gazing contemplatively ahead. The expression suggests a trace of cynicism, as if the subject were somewhat disappointed in the world around him. Jackson occasionally paints his subjects from a slightly below-eye-level angle which, he contends, lends them a touch of regality. Note the rough brushwork in the sweater, which strongly suggests the knobby texture of wool. Jackson is very much a painter of textures.

you can live with. It may not be the one you end up with, but you have to make a start somewhere.

As to the ultimate extent of your palette, only time will establish that. I paint with seven colors where I once used fourteen. You'll find your own number with experience.

OVERALL COLOR SCHEMES

A unique way to achieve color harmony is to pre-arrange an overall color scheme for a painting. This means painting a picture that's essentially blue, orange, yellow, red, green, or what-have-you, à la Picasso's blue period or rose period.

There are several ways of doing this. One is to mix some of the predominant color into every color on the palette prior to painting. Another is to tone the canvas with the predominant color, wait for it to dry, then paint lightly over it so that the underlying color shows through. A third is to tone the canvas *thickly* with the predominant color and then paint into the tone *while it's still wet*, so that the overlying layers pick up some of the color of the tone.

While an overall color scheme creates color harmony, it also diminshes color contrast. Still, it's an interesting device which will help expand your knowledge of color—something you can never get enough of.

EXAGGERATING, SUBDUING, INVENTING

In realistic painting, there are two basic schools of thought regarding color. One believes in putting down the colors seen in the subject with absolute accuracy. The second jazzes up, plays down, or invents color to suit the painter's creative requirements.

I'm afraid I have to lean toward the latter view, since it's my belief that the artist should not try to mimic nature, but rather to provide an impression of nature. And this may entail fiddling with existing elements. It took me time to come to this conclusion, since for years I was an exponent of rendering subjects exactly as seen. Age and wisdom have brought me around to revise this view.

If a painter spends years learning to copy slavishly what his eyes see, he has wasted his artistic life, in my opinion. The whole purpose of art is to make a personal statement. Otherwise, what need would there be for so many artists? I strongly urge you to invent, subdue, exaggerate, and control color rather than attempt to transform yourself into a human Xerox machine.

SUGGESTIONS FOR PAINTING SKIN TONES

Although I've just finished telling you to be liberal with color, remember that we're still dealing with realistic painting in which the colors must at least approximate those seen in the subject. I'll ignore

the colors of the costumes, props, and background, where your latitude is somewhat broader, and concentrate on skin color; in the portrait this must emerge with a good degree of fidelity, regardless of which approach you take.

Toward this end, I'll suggest some general skin tone mixtures for the various racial types, with the understanding that I'm offering *possible* combinations of skin tone colors, each of which would be modified by the intensity, angle, temperature, and clarity of light with which the subject was illuminated.

Combinations for Caucasian Skin in Warm Light
Cadmium red light, white
Yellow ochre, cadmium red light, white
Raw sienna, cadmium red light, white
Yellow ochre, Venetian red, white
Yellow ochre, burnt sienna, white
Burnt sienna, white
Venetian red, white
Alizarin crimson, white
Cadmium orange, yellow ochre, white
Cadmium orange, raw sienna, white
Cadmium yellow light, cadmium red light, white

Combinations for Caucasian Skin in Cool Light
Yellow ochre, white
Raw sienna, white
Yellow ochre, cerulean blue, white
Yellow ochre, ultramarine, white
Yellow ochre, chromium oxide green, white

Combinations for Caucasian Skin in Halftone
Cadmium red light, chromium oxide green, white
Cadmium red light, raw umber, white
Raw umber, chromium oxide green, white
Raw umber, cerulean blue, white
Raw umber, yellow ochre
Raw umber, yellow ochre, cerulean blue
Raw umber, yellow ochre, chromium oxide green
Cerulean blue, yellow ochre, white

Combinations for Caucasian Skin in Shadow
Raw umber, cerulean blue
Raw umber, ultramarine blue
Raw umber, chromium oxide green
Burnt umber, ultramarine blue
Cerulean blue, burnt umber
Cerulean blue, raw umber
Cadmium red light, chromium oxide green
Cadmium red light, yellow ochre, black
Black, yellow ochre

Combinations for Oriental Skin in Light
Yellow ochre, white
Raw sienna, white
Yellow ochre, cerulean blue, white
Raw umber, white
Raw umber, cerulean blue, white

Combinations for Oriental Skin in Halftone
Raw umber, cerulean blue
Raw umber, chromium oxide green, white
Raw umber, ultramarine blue, white
Raw umber, raw sienna, white

Combinations for Oriental Skin in Shadow
Burnt umber, chromium oxide green
Burnt umber, ultramarine blue
Black, raw umber
Chromium oxide green, raw umber, black
Cerulean blue, burnt umber

Combinations for Black Skin in Warm Light
Raw umber, cadmium red light
Raw umber, Venetian red
Raw umber, burnt sienna
Raw umber, cadmium orange
Burnt umber, yellow ochre
You can add white or cadmium yellow light to all these, depending on the darkness of the skin.

Combinations for Black Skin in Cool Light Areas
Raw umber, cerulean blue
Raw umber, chromium oxide green
Raw umber, Naples yellow
Raw umber, ultramarine blue
You can add white or yellow ochre to all these depending on the darkness of the skin.

Combinations for Black Skin in Shadow
Burnt umber, ultramarine blue
Burnt umber, chromium oxide green
Black, cadmium red light
Burnt sienna, ultramarine blue
Burnt sienna, chromium oxide green
Black, burnt umber, yellow ochre.
Chromium oxide green, burnt umber, cerulean blue
Burnt umber, alizarin crimson
Burnt sienna, ultramarine blue
Burnt sienna, chromium oxide green
Black, burnt umber, yellow ochre
Chromium oxide green, burnt umber, cerulean blue
Burnt umber, alizarin crimson
Burnt umber, burnt sienna
Black, alizarin crimson

It's wise to remember that black skin in particular presents definite warm or cool characteristics. For warm black skin, go to the browns, reds, and yellows. For cool black skin, go to the blues, greens, blacks, and grays.

FINAL NOTES ABOUT COLOR

Here are some useful "rules" or principles regarding color.

1. Use colors that are absolutely permanent only.

2. You don't need more than two versions of any one hue on your palette—two blues, two reds, etc.

3. Adding white to any color or color combination lowers its brilliance.

4. Seek to reduce rather than expand your palette. The simpler the palette, the cleaner and more beautiful your color will emerge. Rembrandt painted with only six colors.

5. Use lots of grays and other muted tones to enhance selected areas of bright color. A painting in which many brilliant colors vie for attention will turn stomachs.

6. Test various brands of colors and then select your palette from one brand. Paints of one family tend to be more compatible as to drying time, texture, density, etc.

7. Decide to mix your colors *either* on the palette *or* on the canvas, never on both. One of these two methods will serve you better, but you should be consistent. This avoids fumbling, indecision, and frustration.

8. Read up on and learn all you can about the properties of every color. Do you know, for instance, the difference between ivory black and mars black? Or between lead white, zinc white, and titanium white?

9. The only way to learn about color is from studying the works of the masters. No book or books can teach you as much about color as ten intense minutes in front of a Hals, a Rembrandt, or a Vermeer.

10. Color is not only hue, intensity, and temperature, it's also *value!* You can't separate them.

11. The color of shadow on skin is never quite as dark as you may think. Take a second and third look before you put down the value of a skin shadow.

12. The so-called "flesh" colors put out by manufacturers are an affront to the eye. Whose idea of flesh is it? Certainly not nature's.

Portrait of Jack Levine *by Moses Soyer, oil on canvas, courtesy ACA Galleries. In the words of the artist, "I worked on this portrait a long time, but tried to keep the appearance of a large sketch—except for the head. The paint is thinly washed on in most parts, and the head is thickly painted with palette knife and brush." Jack Levine is himself a well-known American artist. Although I've never met him, I feel that I know much about him from this powerful, incisive study. This is the mark of the successful portrait—the extent of insight it provides into the subject's character.*

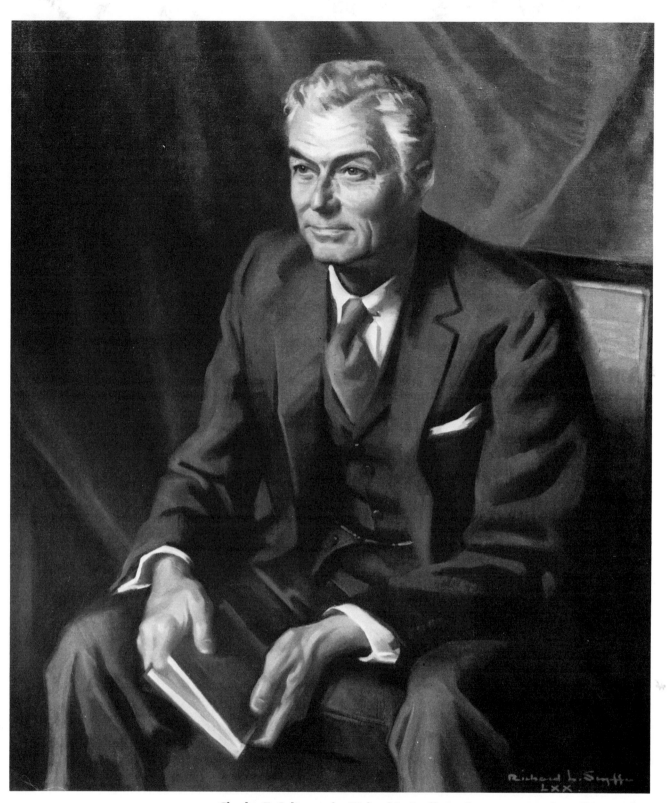

Charles E. Saltzman *by Richard L. Seyffert, oil on canvas, 40″ x 34″ (102 x 86 cm), collection University Club, New York City. Seyffert placed the book in the subject's hands to lend some visual interest to the lower part of the painting. He exploited the musculature, veininess, and boniness of the male hands to create a striking, arresting design. The light shirt cuff is a good touch—it helps break up the monotony of values and draws the viewer's eye to the area. This is one of the instances when the subject was painted with the painter looking down at him. Although this is a viewing angle infrequently employed, it works fine here.*

CHAPTER SIX
Clothing, Hair, and Hands

The problem of clothing in a man's portrait is more acute than in a woman's due to the relative drabness and uniformity of male attire.

THE BOARDROOM PORTRAIT

In the boardroom or institutional portrait, the subject's clothes usually consist of a dark brown, blue, gray, or black business suit, a white shirt, and a sober tie. The most inventive artist is hard put to make something exciting out of this combination. However, some painters do make the effort. They may urge the sitter to wear a lighter suit or a sport jacket of some interesting color, texture, or pattern. Or they may suggest a blue or green shirt or one that's striped, checked or dotted, or push for a striking, colorful tie.

In many cases, however, the sitter or the organization that has commissioned the portrait is so ultraconservative that any deviation from the "norm" would be frowned upon. Then again, many a sitter is having the portrait painted *explicitly* to convey his image as a solid, substantial citizen. Such an individual would hardly care to be portrayed as a devil-may-care swinger. All this militates against the artist whose overriding goal is to produce a viable portrait.

Compelled to live with the boardroom "uniform," the artist has several choices:

1. Ignore its existence, cast it into the background, and place all the emphasis on the head and hands.

2. Light it in such dramatic fashion that it becomes intriguing despite itself.

3. Spice up or lighten the background to such a degree that the dark suit becomes an integral and nonexpendable tonal or compositional element.

4. Arrange a pose so unusual and striking that the drab suit emerges overshadowed and comparatively unimportant.

5. Surreptitiously sneak some color and texture into a suit that basically possesses neither.

Some artists who face the prospect of one boardroom portrait after another use one, or a combination, of these devices. Other artists merely give up and simply paint boring, repetitious, formula portraits in which you could substitute one head for another with no appreciable difference.

THE PERSONAL PORTRAIT

Here is where some latitude exists as to variety of costume. Personal portraits—especially these days —are painted in all kinds of dress, ranging from a T-shirt to a ski parka. With male clothing generally growing more diversified in fit, color, and style, the artist can now indulge some of his more innovative urges and really let himself go in the male portrait slated for the home. It's up to the painter to guide the subject in his choice of clothing and convince him that a sweatshirt or jeans may produce a livelier, more provocative portrait than the old three-button worsted.

SPECIALIZED COSTUMES

Most artists eagerly welcome the chance to paint a subject in a military uniform, clerical or academic robes, ethnic dress, a medical smock, a riding or sailing outfit, a sports outfit, or any specialized costume representing a hobby, trade, or profession. Here is a chance to paint some unusual shapes, colors, patterns, and accoutrements. Military caps, ribbons, sashes, belts, brass buttons, swagger sticks, birettas, crosses, miters, stethoscopes, head mirrors, guns, boots, crops, hockey sticks, and helmets—all these are grist for the artist's urge to introduce something different and unusual into the portrait.

Specialized costumes can also affect the size, shape, and pose you might select for the portrait. A flowing robe almost demands a standing pose, as does a form-fitting uniform—the first to fully portray its sweep and scope, the second to set off a fine, erect figure. The danger lies in becoming so involved in the intricacies of costume as to forget the reason for the portrait. Epaulets and medals are fun to paint, but it's still the man inside that counts.

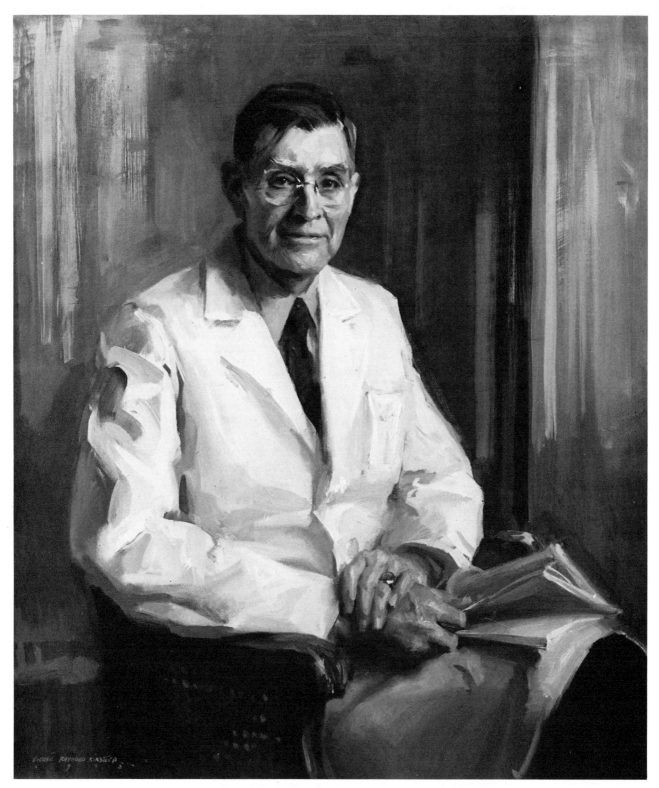

Dr. Wiley Forbus by *Everett Raymond Kinstler, oil on canvas, 40″ x 34″ (102 x 86 cm), collection Duke University. Painting eyeglasses on a head can be a most exacting task unless one understands the principles underlying this problem. If every line, shadow, and glint is included, too much of the glasses emerges at the expense of the features underneath. Then again, if the glasses are added indiscriminately, as a kind of casual afterthought, they may appear unreal and unnatural. To strike a happy balance, the painter must choose a few important accents which will suggest the presence of glasses perched on top of the features underneath. Kinstler poses his subjects with their glasses on throughout the portrait in order to get the shape and shadows right.*

EYEGLASSES

If the subject habitually wears glasses, it's best to paint him with them on, since the glasses are an integral part of his image to those who know him. There are two ways of painting eyeglasses. The first is to have the subject remove the glasses until the underlying areas are realized and then have him replace the glasses at the end. The second is to keep the glasses on throughout.

Proponents of the first method feel that the eyes and surrounding forms cannot be correctly articulated if they are painted while hidden behind lenses and frames. Those who propose the second method claim that having the subject wear the glasses throughout provides the natural shadows and angles that are formed as a result.

Most artists, regardless of which of these methods they employ, will agree that the proper way to paint glasses is to *suggest* their presence rather than to reproduce them in detail. Accents, reflections, highlights, and spots of tone, line, and color can provide *the effect* of glasses without such precision as would draw too much attention to them.

To paint eyeglasses in proper perspective, squint until you can see just the few selected lines, tones, and colors that shape and define them; then put in *these accents only and nothing more!* When the portrait is seen in its entirety, the glasses will then appear natural and correct. However, if you assiduously include every line, dot, and speck, you'll end up with a *portrait of eyeglasses*, rather than of a person who happens to wear them.

HAIR

Like clothing, men's hair tends to be duller than women's. Men are less likely to dye, tease, spray, curl, tip, blow, or set their hair in elaborate coiffures.

Hair—whether human male or female, or animal, and despite its location either on the top or the bottom of the face — should be painted as the *essentially* soft, pliant substance it is. Although some hair is wiry and looks as rigid as plastic or wood, it really isn't. Or at least it shouldn't appear so in the portrait. The most important thing is to hold down the color of hair—no matter how vivid it may appear—and to paint its outer and inner edges so softly that they appear to flow into the skin or into the background. Never, never paint hair as anything but a *mass*. There's nothing uglier and more distracting than painting individual strands, curls, or waves that seem an entity in themselves and unconnected to the rest of the hair. Even the tightest technique must avoid such a repulsive mannerism.

In this age of beards, mustaches, muttonchops, sideburns, and flowing manes, the danger of hair

Kirk by Clifford Jackson, oil on canvas, 20" x 16" (51 x 41 cm). Jackson conveys accurately the texture of the subject's hair. Its frizzy quality is captured through the clever brushwork—particularly in the left-hand area–of the contours of the head. A few light accents in front accentuate the tight curls. Note too how darkly Jackson painted the "whites" of the eyes—they are equal in value to the halftones in the face. Rendering these areas and such elements as teeth too white makes for a lurid, vulgar painting that jars the overall relationship of values in the dark-skinned subject.

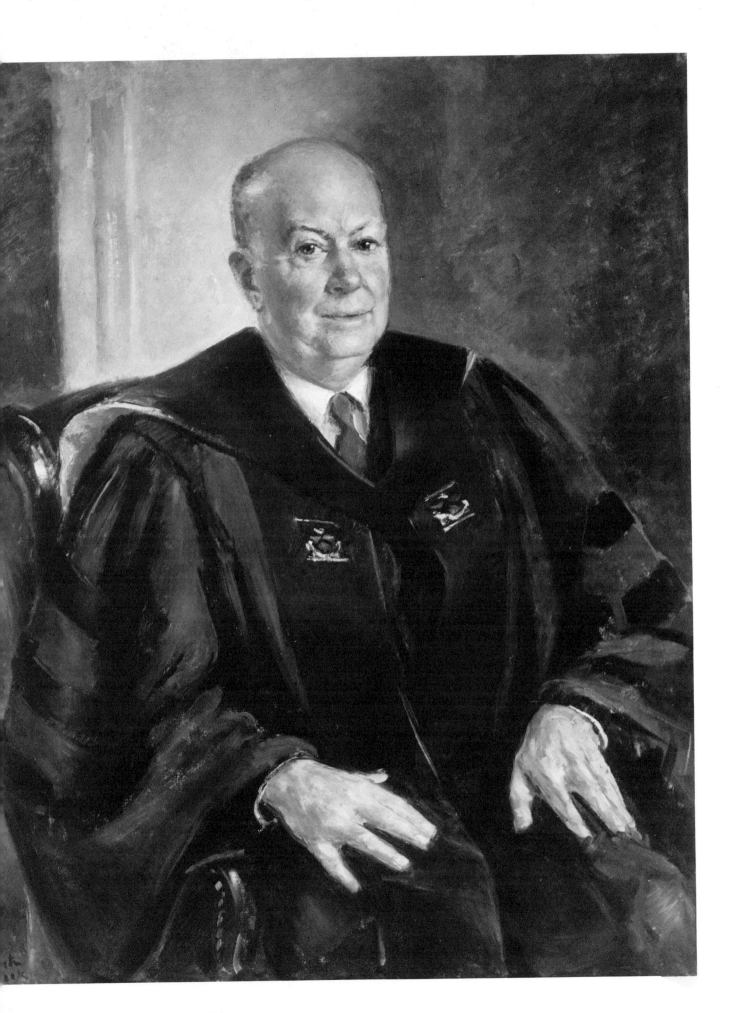

becoming too assertive in the portrait is particularly pressing. If you should run into a subject wearing a toupee—be kind. Those who wear hairpieces don't (or won't) face the fact that the best of such subterfuges are apparent at fifteen yards to almost anyone. Treat the wig as if it were natural hair and lose the edges accordingly.

Finally, don't become so involved in a tricky beard or mustache that it ends up dominating the portrait. It's merely an appendage, and it must be relegated to its proper order of importance in the overall scheme of things. Always think of hair as a part of the background, not as the main attraction.

HANDS

Hands can be an integral part of a portrait, next in importance to the head itself. Male hands offer the artist an intriguing challenge, particularly if they are large, powerful, or thickly veined. Whereas the beauty of women's hands lies in their slimness, grace, fingernail shape, and delicacy of color, men's hands stand out for their size, ruggedness, musculature, and diversity of color. Many artists exaggerate these traits to promote the appearance of masculinity. (See the demonstration portrait by Richard Seyffert.) They'll accentuate the greenness of veins, the redness of knuckles, the boniness of wrists, and the bluntness of fingers.

Hands and arms can be used to good purpose to enhance the design of a painting. They can be posed at any number of angles to extend or constrict the composition. They can also be used to enhance a light effect, as by losing the figure in shadow and focusing light on the face and hands. They can enhance recognition as well—a surgeon's hands holding a scalpel, a scientist's fingering a microscope, a writer's gripping a pen, etc. Unfortunately hands can also encourage a painter's mannerism. Some lazy artists will paint the same hands in portrait after portrait after portrait.

Hands are most difficult to paint until one thoroughly learns their anatomy and configuration. I strongly advise that you study all you can about hands. There is an excellent book on drawing hands by the late, great anatomy teacher, George Bridgman. I have listed this in the bibliography at the end of this book along with a couple of others on drawing hands. I recommend that you look at them.

Hands can be a most valuable addition to the portrait. However, like all the other elements in the painting, they must be carefully posed, lit, composed, and honestly and skillfully executed.

Joseph Elgin by Peter Cook, oil on canvas, collection School of Engineering, Princeton University. The academic robe worn by Dean Elgin is an integral part of the painting, yet Cook has made sure that it doesn't take attention away from the face. The magnificent color and sweep of such costumes are potential stumbling blocks for painters who lack Cook's experience. The tendency to paint in every fold and wrinkle and to stress the robe's sometimes exotic color must be firmly controlled, or what emerges may be a portrait of a robe, not of the person inside it.

Melvin Solomon by Ray Goodbred, oil on canvas, 36″ x 30″ (91 x 76 cm), collection Sam Solomon Stores. Doesn't the subject convey the very essence of the successful executive? The straight-ahead look, the assured smile, the stylish clothing, the accoutrements in the background, all contribute to this impression. The artist was apparently struck by the positive image projected by the sitter and went on to capture it on canvas. Getting to know a subject's emotional traits is a vital aspect of portraiture. It's not enough to render a physical replica of the person—one must peer inside the man and present these data through the pose, lighting, and design best suited to his individual character.

CHAPTER SEVEN
Materials

As any responsible artisan will tell you, the tools of a trade are second in importance only to a knowledge and skill of the craft. Using inferior, inadequate tools is like trying to thread a needle while wearing gloves. Few artists today bother to learn the intricacies and potentials of their materials. I've been stunned to discover how many leading painters display complete ignorance of something as basic as color nomenclature. I strongly feel that anyone working in a specialized medium such as portrait painting owes it to himself to learn all he can about his craft. Enough good material exists that one can learn the basics and then pursue one's own follow-up research.

COLORS

Oil paints today are manufactured with sufficient care that most are perfectly acceptable for permanent results. Some big manufacturers make a higher-priced and a lower-priced grade, but even cheaper grades almost always adhere to the requirements established by the U.S. Commerce Department's National Bureau of Standards. Those that don't carry the Bureau's CS 98-62 designation are to be avoided, especially for commissioned portraiture where the client has every right to expect the portrait to endure beyond his and his children's lifetimes.

The main difference between the various brands and grades of colors is the ratio of pigment to vehicle. All oil paints are a blend of raw pigment (color) and some vehicle, such as linseed or other oil, in which pigment is ground to render it semiliquid. You'll find that some brands or grades of color are denser and some looser than others, depending upon their pigment-vehicle balance. Also, most manufacturers issue color charts and booklets which list the permanence of the colors in their line. Again, these are something you should acquire to help guide you in your color selection, since there's no reason on earth to use any but absolutely permanent colors.

American-made colors are every bit as good as foreign, and often better. Don't make your purchases on the basis of some misconception that European supplies are superior. Also, check the vehicle in which the colors were ground. The tried and tested vehicle is linseed oil. Be suspicious of colors ground in other oils. Permanent Pigments, Weber, Grumbacher, Shiva, and Bocour are the better-known American-made oils. Utrecht and Fidelis are two of the lesser-known brands. Among the foreign brands, Winsor & Newton, Rembrandt, and Blockx all make excellent colors. Beware of cheap so-called "house brands" which list no ingredients. In the long run they'll prove a costly investment.

CANVAS

The traditional surface for oil portraits is canvas. The best kind of canvas — and the only type you should use for permanent work — is linen. Cottons and other canvases are good only for practice, experimentation, and preliminary sketches.

Properly prepared canvas is first sized with animal glue and then given one or two coats of priming. The only kind of priming acceptable for oil painting is lead white. Insist on linen canvas that's sized with rabbitskin glue and primed with lead white for all your important work. If you prefer a smoother surface, pick the double-primed canvas. A single-primed canvas offers a bit rougher tooth. Fredrix, Grumbacher, Weber, U.S. Art Canvas, and Winsor & Newton are some of the better-known canvas manufacturers.

Stretchers for canvas are available almost everywhere in various lengths and in narrow and wide widths. For larger canvases crossbars are available to strengthen the stretcher frame and to help keep the canvas taut. Stretchers can also be ordered in custom sizes and shapes from the bigger art suppliers.

Finally, for those seeking a saving, it's possible to buy raw linen canvas in rolls and size and prime it yourself. Lead white priming and glue for sizing are sold in quart and gallon sizes.

William H. Butler by Peter Cook, oil on canvas, 24″ x 20″ (61 x 51 cm). This was a posthumous portrait of the former recorder of the United States Supreme Court. Nowhere is there any indication that the portrait wasn't painted from life. The kindly expression in the eyes and mouth seems recorded from the person himself. Painting from photographs can be a deadly trap if improperly approached. The best way is to treat the photo as if it were the living model and gaze at it from some distance away so that the edges grow somewhat blurred and the contours fuse with areas surrounding them. I particularly like Cook's crisp brushwork in the hair; it captures its stiff, bushy texture.

BOARDS

The second type of surface used for oil painting is the rigid type that I'll lump under the category of boards. For permanent painting the best board is one made of compressed wood particles and sold in sheet form in lumber yards. Standard Presdwood made by Masonite fulfills all the requirements for an oil painting surface.

Wallboard, cardboard, and metal have all been used for oil painting but are not generally recommended. The common so-called canvasboard, universally sold in art materials stores, is good for feeding the fireplace, not for serious oil painting.

Plywood would be adequate except for its tendency to warp badly. *All* boards beyond 16″ x 20″ (41 x 51 cm) must be cradled (backed by a wooden frame), if they are to be kept from warping or buckling.

The best priming for boards in oil painting is still lead white. Boards can be sized prior to priming, but this is not as vital as with canvas, which tends to rot unless it's sealed by glue to isolate the oil in the priming.

BRUSHES

There are two basic kinds of brushes for oil paintings — *bristles* and *sables*. The bristles are stiffer and are used for the bulk of the painting, while the sables are softer and reserved for very fine detail or for very smooth effects. Both bristle and sable brushes come in various widths, from very narrow to very broad, and in various shapes:

1. *Rounds*—round brushes ending in a point.

2. *Flats*—flat brushes with longer bristles.

3. *Brights*—flat brushes with shorter bristles.

4. *Filberts*—flat brushes with longer bristles and an oval shape.

5. *Blenders*—fan-shaped brushes for blending and fusing.

Economy is achieved by purchasing the very best brushes available. A poor brush falls apart almost immediately, and it pays to buy the top of the line. Delta, Robert Simmons, Winsor & Newton, Grumbacher, Rowney, and Langnickel are some of the better-known brush manufacturers.

KNIVES

A painting knife permits a technique not available with a brush. A knife blade can provide thick, smooth impastos, and many artists are very partial to this tool. The stiffer palette knives are used to prime canvas and to mix colors on the palette. Art supply stores carry knives in various shapes, lengths, and widths.

THE PALETTE

The palette is the area where the colors are laid out and mixed. Palettes for oils come in wood, glass, plastic, and paper. Some artists like a white palette, and some prefer a palette of some neutral shade. Some artists like a hand-held palette, while others opt for a fixed palette set into a stand with or without casters or wheels.

The glass palette is easier to scrape clean of dried paint than the wooden, and milk glass, which is opaque, is often used. Paper palettes are sheets of waxy paper, bound in pads, and are disposable.

Actually, any rigid surface that won't absorb paint is serviceable. It's merely a matter of personal preference.

MEDIUMS, VARNISHES, AND SOLVENTS

A painting medium is used to make oil paint more liquid and more malleable. Some artists prefer their paints stiff and avoid mediums altogether. Mediums vary in effectiveness, and it comes down to which expert you choose to believe. Much research has been conducted into the techniques of early painters, and different claims have been proposed attesting to the authenticity of this or that concoction as the medium of the masters.

Here are a few painting mediums that have been used extensively over the years and have enlisted a measure of support.

Pure Linseed Oil. The argument against this medium is that it introduces excessive linseed oil into the painting (in addition to the oil already used as the vehicle in colors) and is therefore conducive to yellowing.

Stand Oil. This is linseed oil that has been heated to a thick consistency and is said to reduce yellowing.

Sun-thickened Oil. This is linseed oil exposed to sunlight. It hastens the drying time of colors.

Turpentine. This acts to thin oil color and to render it more washlike in character. However, too much turpentine is said to weaken the structure of the painting. Turpentine is also used to remove oil color from brushes and hands.

Copal Medium. This is claimed by some to be the true medium of the masters. Copal is a hard resin, and its opponents question its permanence for oil painting.

Maroger Medium. This is another so-called old-master medium. It is prepared by cooking linseed oil and mastic varnish to a jelly-like consistency. There are strong pro- and anti-Maroger medium factions, but the controversy remains open and unresolved. Maroger medium is said to allow manipula-

Donald C. Smith by Clyde Smith, oil on canvas, 42" x 30" (107 x 76 cm), collection Mrs. Donald C. Smith. The subject here sits in a rather conventional pose in which he appears serene and at peace with his surroundings. Clyde Smith, who leans toward the unusual pose and composition, varied his metier by painting a straightforward portrait and getting the most out of it. The lighting is frontal so that a minimum of shadow appears in the head. The fingers are very roughly drawn in, and the lightest lights are reserved for the shirt, pocket handkerchief, and cuffs. The charm of this painting lies in its simplicity and lack of affectation.

tions unobtainable with any other medium. Its detractors say it's impermanent and damaging to the paint layer. The medium isn't commercially available. You must make your own.

Gel Mediums. These are commercially produced mediums that simulate some of the characteristics of Maroger medium. Perma-Gel, Win-gel, and Gel are some of the trade names for this product.

Oil-Varnish-Turpentine. This traditional painting medium is a mixture of one-third linseed oil, one-third turpentine, and one-third damar varnish, something you can easily concoct yourself.

Retouch Varnish. This is not a painting medium, but blown or sprayed, this thin solution of damar resin brings up the color of areas gone dead between painting sessions. It's also used as a *temporary* final varnish to protect the painting until a permanent final varnish can be applied six months to a year after the portrait has been completed. The final varnish can be of either damar, mastic, or copal.

There are also various driers, solvents, and oils used in different combinations, but this isn't the place for such discussion. Books listed in the bibliography cover these subjects in great detail.

EASELS

A good, solid easel is a must for the studio. It should be sturdy enough to firmly hold a large canvas, should be set on casters, and should be able to tilt forward and backward and roll up and down. An additional portable easel should be obtained for painting on location. The so-called French easel is just fine for this purpose.

MIRROR

A large mirror set on casters is a valuable aid in the studio. You can arrange it so that the subject sees himself being painted. This helps entertain him and keep him from getting bored. Also, by studying the portrait in the mirror, you can quickly spot flaws that might not be apparent otherwise. A mirror can be useful for self-portraits and for observing poses from different angles.

MODEL STAND

The model stand elevates the sitter to eye level. It should be sturdy, set on wheels for mobility, and big enough to accommodate a large piece of furniture. It's helpful if it has steps leading up to it for easy mounting and a carpeted floor to avoid slippage.

Some artists construct their model stands to fold so that they can be taken along on location. As far as I know, model stands aren't commercially manufactured. When not occupied by a sitter, the model stand makes a good work table.

FURNITURE

A collection of chairs, stools, settees, and couches is desirable to accommodate the various poses you might conceive and to introduce variety into your portraits. Look for unusual and striking pieces in antique and junk stores or at garage sales and auctions. Also, you might obtain some old tables and cabinets in which to store your equipment.

SCREENS

A hinged, three-sectioned folding screen at least seven feet high and set on wheels or casters will prove handy to arrange backgrounds, block lights, etc. With it, you'll want a collection of variously colored and textured cloths and draperies. Also accumulate some reflecting material, such as silver paper or tin sheets, which you can drape or pin to the screen to throw additional lights into shadows that are too dark.

ADDITIONAL EQUIPMENT

Here are some other items you might need:

Brushwasher—whether homemade or manufactured, to clean your brushes.

Mahlstick—to steady your hand.

Staple gun or a hammer and tacks—to stretch your canvas.

Masking tape—to mark the location of your easel and the model's chair between sessions.

Razor blades—to scrape your palette.

Reducing glass—enables you to see the painting in miniature while standing close to it.

Blue-glass—reduces all color to monochrome so that you can see things in tone only.

Atomizers—to blow retouch varnish.

Cups—to hold various mediums and solvents.

Also, you can accumulate rags, paper napkins, keys to tighten the canvas, housebrushes for priming or varnishing, drawing equipment such as charcoal or pastels, charcoal fixative, sketchpads, thumb tacks, pliers to loosen tight paint tube caps, calipers to measure the subject's features—the list can go on forever. Obviously experience will teach you what you'll need and what you can do without.

Portrait of a Young Man, *by Albert Handell, oil on canvas, private collection. Here is a powerful study of tonal contrasts known as chiaroscuro. This dramatic type of illumination works well pictorially but often throws individual features into dark shadow, so that, while the form is clearly defined, such aspects as color of eyes and shape of mouth are sacrificed to the overall concept. In commissioned portraiture this approach might create difficulties, since, to the layman's eyes, it is individual features, not forms and masses, which present the greatest visual appeal. It's up to the artist to guide the subject along so that he learns to appreciate and accept broader approaches to art.*

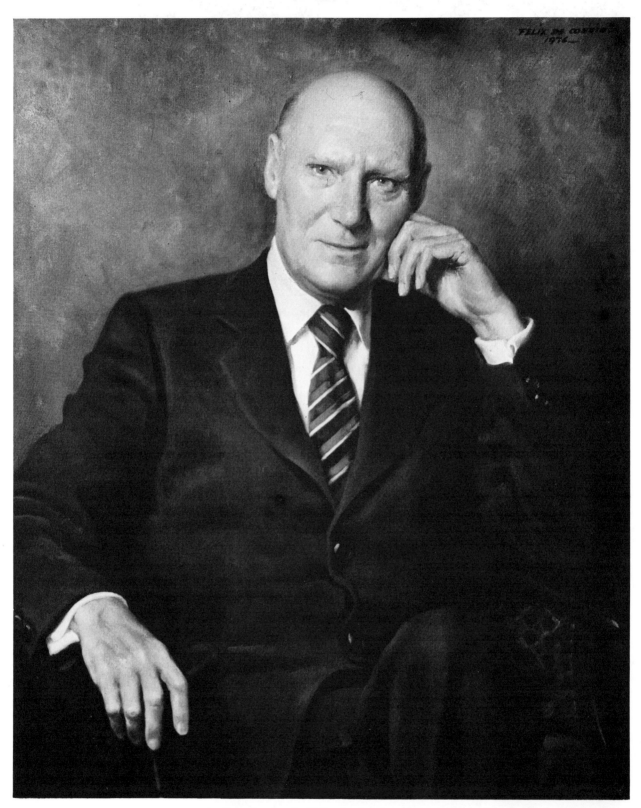

Dr. Ernst Weber *by Felix de Cossio, oil on canvas, 33″ x 27″ (84 x 69 cm), collection Brooklyn Polytechnic Institute. This and the portraits on pages 75 and 76 should be studied together, since they represent essentially the same pose as seen and painted by three painters divergent in style and approach. Of the three, De Cossio is the tightest in method. His edges are sharper, his outlines more closely defined, and his treatment of detail most exact. Compare, for instance, the handling of the tie in the three portraits and the rendition of the hands. It's vital that early in your career you decide how loosely or tightly you wish to paint. One help in deciding this is to determine the technique that appeals most to you in other artists and then adapt it to your own.*

CHAPTER EIGHT
Methods and Procedures

Having discussed various aspects of planning and conceiving a man's portrait, it's time to get into some specific do's and don't s concerning actual painting procedures and related matters.

WHERE TO PLACE THE EASEL?

Having resolved how to pose, light, and view your sitter, you must now get into actual position to paint him.

The first problem is how far away to station yourself from the subject. Assuming your sight is normal and that your studio has sufficient room, this can mean standing as far as twelve or as near as three feet away. I see well, but I like to be as close as possible to my model. Therefore I set up my easel almost flush with the model stand. Other painters I know stand farther back. And still others begin at some distance away and then move in closer as the portrait progresses.

The argument against painting too close to the model is that this leads to a portrait that's too tight and too detailed. I strongly reject this allegation. The distance from artist to model has nothing to do with the quality of the painting; only the technique does. To avoid painting tight edges, painters don't need to move back until these edges begin to blur.

My way is to plant the easel smack up against the model stand—as close as I can get without frightening the sitter. Then, before placing a single stroke, I move backward as far as I can go, take a good hard look, walk forward with my gaze still fixed, and then mix and place the appropriate brushstroke!

This system works like a zoom lens on the camera. I first see the overall view, then slowly focus closer and closer until I concentrate my gaze on the area I wish to reproduce and put it down the way I want it to appear.

I urge you to give this method a try. It took me some thirty years to work it out and I've found it the best way to paint a portrait. I concede that it's probably somewhat unorthodox, but I can assure you that it works. If nothing else, all the exercise you get will keep you in good physical shape.

Incidentally, unless there's some physical reason for it, I strongly advise against painting a portrait while seated. It cuts down on the artist's mobility.

LAYING OUT THE PALETTE

Having set up and marked the easel's location with masking tape, you'll need to set your palette down somewhere, unless you choose a hand-held one. I like my palette lying quietly. Being right-handed, I keep my palette on a waist-high drawing table (set on wheels) on the right side of the easel and flush up against it. A left-handed person would probably put it to his left.

My palette is quite large, at least 30″ x 24″ (76 x 61 cm), and the colors are squeezed out onto it in big enough quantities so that I don't have to replenish them during the two or three hours the average portrait session lasts. I've found that one of the peculiarities of art students is that they always squeeze out tiny little pips of color. This reflects a kind of fear and uncertainty and also tends to make the person paint in a picky, hesitant manner.

Always put out more color than you'll need. Some of it may be wasted, but the practice will encourage you to paint in a bolder, more vigorous fashion.

HOW MANY BRUSHES?

Some instructors advocate having dozens of brushes handy so that they're always assured of a spotlessly clean mixture. Again, I take exception. Their argument reminds me of those esthetes who insist on having all their food served in separate plates. Doesn't it all mix a few seconds later in the stomach (or on the canvas) anyway? If you use four, or at most five, brushes and a rag—and clean your brushes when you switch colors—you can get by very nicely. Fooling around with dozens of brushes is confusing, awkward, and time consuming.

TONING THE CANVAS

Before you begin painting, you must decide whether to work on a white, pristine canvas or

whether you'd prefer it toned some particular value or color. Let's consider some reasons for toning. Toning works best for:

1. The underpainting, overpainting, glazing technique.

2. Scumbling (painting in lighter tones over a darker underlayer.)

3. Adopting a pre-arranged color scheme.

4. Obtaining readymade lights. A light toned canvas needs only halftones and shadows added.

5. Obtaining readymade halftones. The toned canvas can serve as the medium value, and only lights and darks need be added.

6. Obtaining readymade shadows. A dark tone needs only lights and halftones added.

7. Obtaining a readymade background.

8. Advancing the speed of the portrait. By toning, you can cover the interstices — those little goose bumps of canvas — and save time and paint by merely adding a top layer.

9. Mixed techniques. Some artists make a combination tone *and* drawing in tempera and then overpaint it all in oil. Acrylics are *not* considered as permanent in combination with oil.

10. Affecting the final colors. A red tone will warm all the colors painted over it; blue tone will cool all overlying colors.

PREPARING FOR THE SESSION

Here are some things to remember in getting ready for the session.

Get rid of all clocks. Nothing makes a sitter squirm more than watching the minutes tick by.

Eliminate all noise. This means telephones, dogs barking, children squabbling, dishes clanging, conversation from other rooms, sounds of traffic, etc. Painting a portrait is an intimate, personal relationship and should be conducted without external intrusion. Concentration is vital. The only exception might be music, if it disturbs neither you nor your subject.

Discourage visitors. Although some artists claim that they don't mind visitors during a portrait session, I'm against it. Gainsborough painted with dozens of fops and ladies in attendance. He could afford to. Can you?

Keep your conversation down. You're there to paint, not to display your wit or erudition. Avoid controversial subjects and encourage your sitter to do most of the talking. It'll keep him awake and stimulated.

Dispose of extraneous elements. This means ridding your studio or hiding such certain attention-grabbers as paintings, statues, mirrors, aquariums, elaborate knick-knacks, African fertility figurines, Mexican artifacts, and the like. The reason is simple. Even though you've traveled the world and touched many bases, all this paraphernalia will only serve to disconcert the sitter. If he sees other portraits, he may wonder why you're not painting *him* holding an elephant gun as you did the famous Lord what's-his-name.

Why look for trouble? Keep the studio filled only with those objects essential to the portrait, and with your own magnetic presence. Portrait sitters are like small children. They're easily distracted, have short attention spans, and are tempted by whatever they see.

THE PRELIMINARY STUDY

Some artists, prior to commencing the actual portrait, prepare a series of line, tone, or color studies in which they work out problems of design, likeness, value relationships, and color harmonies.

These studies are independent of the portrait itself in that they constitute experimental, preliminary steps — educational aids much like a writer's research notes that he prepares before he writes a single line.

Other artists—those of a more impulsive nature—omit this step altogether and pitch right in. If you're able to curtail your impatience, make preliminary studies.

THE DRAWING

Whether or not you've toned the canvas, you'll need some sort of sketch or outline of the subject. This can be in charcoal, pencil, pastel, or oil, and it can be as simple or as elaborate as you elect.

Some artists prepare a most meticulous drawing either on the canvas itself or on paper, which they transfer to the canvas either by the use of transfer paper or by projecting the drawing with an opaque projector and tracing the outlines. They then proceed to stick fairly accurately to this drawing. In essence, they fill in its outlines with appropriate brushstrokes of oil color. This tends to produce a rather tight painting which, however, is very accurate as to precise proportions and dimensions.

This method permits the artist to resolve all the problems of line at the very start, and concentrate only on the aspects of value and color.

Other artists—and they are in the majority today —map out a rough outline on the canvas with the brush and go on from there. They consider the act of painting a function that combines line, tone and color, and they proceed accordingly.

Such a rough outline can consist of a series of

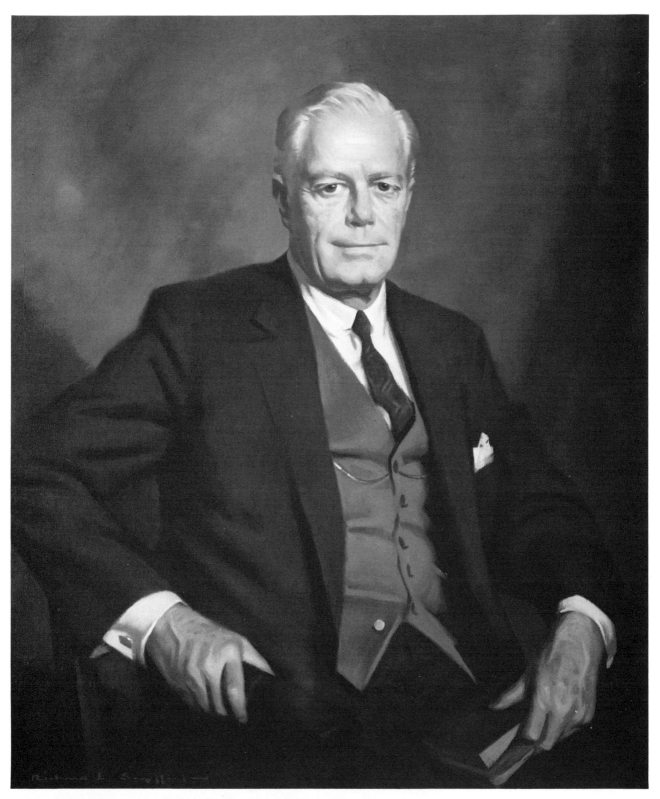

Walter R. Beardsley *by Richard L. Seyffert, oil on canvas, 40″ x 34″ (102 x 86 cm), collection Miles Laboratories, Inc. This is a perfect example of a fine boardroom portrait. The pose is conventional and the mood is properly formal, but Seyffert took care to arrange the subject's hands interestingly and to light the head so we are attracted to it. It takes an inventive spirit to do something striking and unusual within the limited confines of the boardroom painting. The tendency to slip into habits and mannerisms must be strongly resisted, and the artist must forever be alert to little touches that will lend individuality to the painting.*

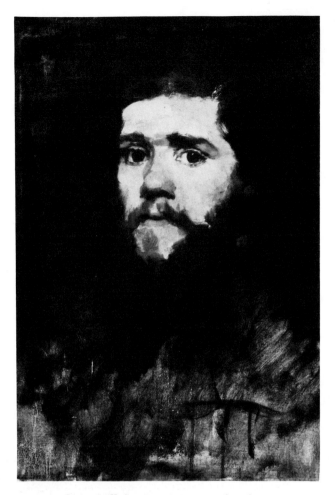

Portrait of Mr. Mills by Frank Duveneck, oil on canvas, 19" x 15" (48 x 38 cm), collection the Cincinnati Art Museum. Here is a perfect example of the alla prima technique by an American master. In this technique, an attempt is made to paint the entire picture in one sitting, or at least as swiftly as possible, No underpainting or glazing is employed, and the paint is laid on thickly and broadly; the artist aims for the correct color and value with every stroke. Theoretically, such a portrait can be executed in one sitting, but this takes an unerring eye, a sure hand, and a perfect command of one's tools and materials. The masters were all expert at this. Some of the world's greatest portraits were finished in a matter of hours.

Gordon Butler (opposite page) by Paul C. Burns, oil on canvas, 36" x 30" (91 x 76 cm). Burns is looser than De Cossio but not as loose as Watkins, on page 76. Note especially how smoothly the material of the suit is painted here. The paint quality is more liquid and flowing, the edges are softer, and there is less attention to detail than in the portrait on page 70. Burns might be classified as falling somewhere between a loose and a tight technique. This middle-of-the-road approach allows for freedom but is sufficiently disciplined to be acceptable to most portrait clients.

lines indicating the various contours outside the head and figure, and angles within the head and figure.

Or it can consist of dots or short strokes marking important points in the head or figure—the top of the head, the eyes, the nostrils, mouth, etc.

Or it can be a series of curves or ovals indicating the direction and sweep of the various forms.

Or it can be a kind of tonal pattern, indicating where all the darks of the subject are present.

Or it can be a combination of all these approaches.

Some artists also employ a system of negative shapes. These are the empty areas within the canvas which form *around* and *within* the positive forms of the subject, such as the space formed by the hollow of an arm bent at the elbow and resting on the hip, the area beneath the chin and down the neck, etc. By getting the *negative* shapes in correctly, the *positive* shapes are sure to emerge proper and right.

Still another system is to employ the principle of plumb lines—lines that run in a horizontal, vertical, or oblique direction. By running such a line from one point to another within the subject, one can ascertain the correct location of elements lying in relation to other elements in the head and figure.

All these tricks and devices are useful in establishing accurate placement, proportions, dimensions, and relationships of the subject's outer contours and inner features.

PAINTING *ALLA PRIMA*

Painting *alla prima* means working direct, seeking to place the correct tone and color from the very first stroke. It's basically a wet-into-wet method in which the artist tries to retain a single cohesive layer of paint rather than painting in stages, which means waiting for one coat to dry and isolating it before moving on to the next.

UNDERPAINTING AND OVERPAINTING

The opposite of *alla prima* is the underpainting, overpainting, glazing technique. In this method, the picture is built up in successive stages or layers and these paint layers are deliberately isolated from one another.

A painting executed in this technique may proceed through the following stages:

1. *Toned Ground.* A color is laid over the white primed surface to provide a middletone. (A toned ground may also be used in *alla prima* painting.)

2. *Grisaille.* The head and/or figure is rendered in monotone only, usually gray. No color as such is employed.

3. *Overpainting and Glazing.* Once the forms are established in monotone, the painter can proceed to

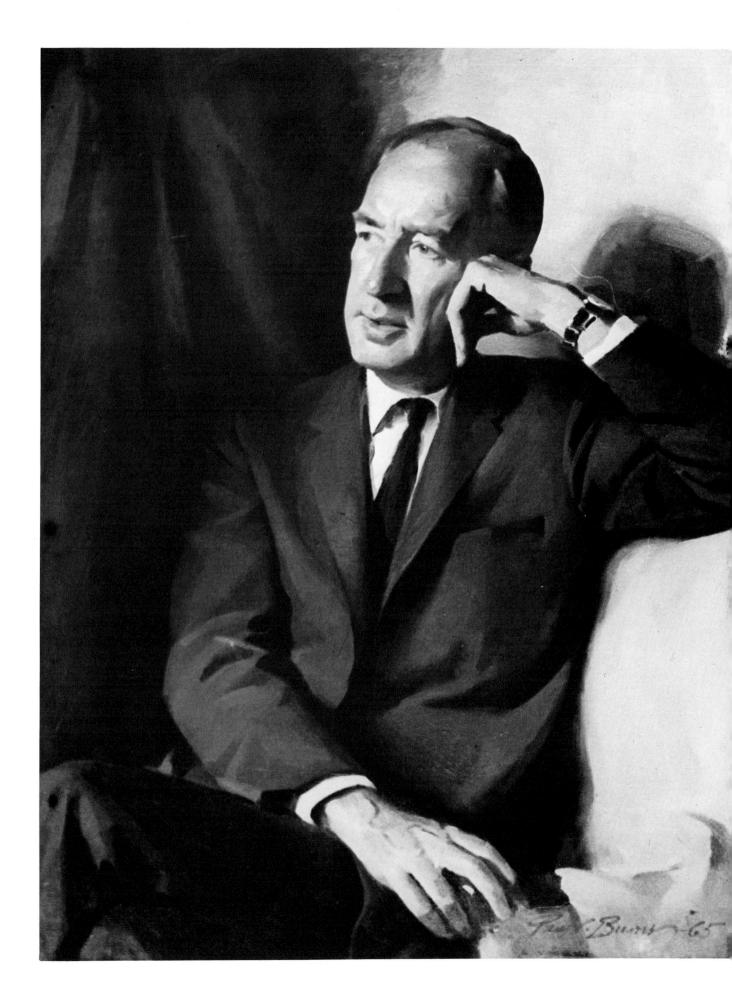

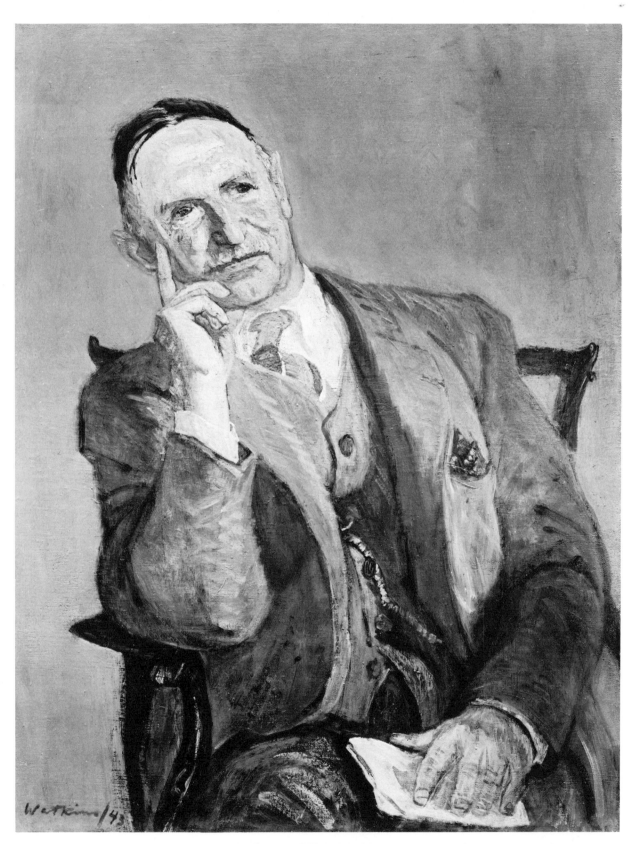

Portrait of J. Stogdell Stokes by Franklin C. Watkins, oil on canvas. This is the other extreme—a completely loose and broad technique, with the paint applied dryly, roughly, and scratchily. Note the drawing of the subject's left hand compared to those in the other two portraits. There's a mere indication of fingers hastily sketched in with no concern for detail; only the general shape of the hand is indicated. The three paintings looked at together reveal how much room there is in art for individuality. Always follow your own inclinations—but first determine what they are.

lay in the colors. This can be done in two ways —painting in opaque color, and/or glazing. The former is self-explanatory. The latter means placing one or more *transparent* layers, or glazes of color, so that the underlying color or colors are allowed to show through. This is done by diluting a color with medium or varnish to a thin, watery consistency and brushing it over the area in question.

PHOTOGRAPHY IN THE PORTRAIT

The use of photographic reference material in portraiture is a most common phenomenon today. There should be no stigma attached to it; it's been said that if the masters had access to the camera, they would have used it extensively.

The only restriction regarding photographs is that they should be exploited properly. This means that a photo should be used constructively, not merely something to *copy*.

Unless the subject is dead or unavailable for posing, the photograph may be used to remind the artist of details in the costume, props, or pose. But even if he's forced to work entirely from the photograph, the artist mustn't become so literal as to faithfully reproduce every speck, dot, and crease he sees there. He should retain his concept of edges, of masses, of large form instead of detail, and be eternally vigilant against the distortion the camera produces.

Above all, don't ever rely on the color in photographs, since it's invariably false as to hue and temperature. If you must refer to photographs for color, do it merely as a rough, general guideline. A portrait slavishly copied from a photograph invariably looks stiff, rigid, and unreal, and immediately recognizable for the phony it is.

KNOWING WHAT TO LEAVE OUT

Always paint in big forms with least concern for worthless detail. In the portrait, include only those things necessary to "tell the story." If it's an important general with tons of medals, by all means include them, since they probably mean so much to him. But don't paint in each one in glorious red, white, and blue. Instead, simplify, blur, suggest.

Compose the portrait in such a way that the viewer's eye is immediately directed to areas most important for expressing likeness, character, and expression. Leave the other aspects more-or-less vague and unobtrusive. If everything is granted equal importance, it can be compared to a town meeting at which every person is talking at once.

Ask yourself what few aspects of the portrait deserve prime importance, then stress those aspects to the exclusion of the others. But make sure you don't have *too* many of them. Just as in every human situation, you can't have all chiefs and no Indians; some person must invariably dominate.

PAINTING GUIDELINES

Getting down to the actual painting, we enter an area where each artist must follow his own urges and compulsions. No one can say that it's proper to start at the top, the bottom, the middle, the foreground, or the background, since each person does it differently — for which, heaven be blessed. Otherwise, we would all paint alike and the result would be mechanical renditions indistinguishable from all other such renditions.

Let's indicate some positive guidelines however:

1. Most artists find it helpful to begin by placing the darks first, halftones second, and the lights last.

2. Most artists find it easier to work all over the canvas simultaneously, rather than finishing a section thoroughly before moving on. Thus, you'd begin by blocking in the rough masses all over, then commencing to refine all over, etc.

3. Most artists lay in the initial forms in some neutral shade and then go progressively brighter in color as the portrait approaches conclusion.

4. There are two essential ways of painting: *one* is to mix a brushstroke, place it on the canvas, and let it stay there; the *second* is to mix a brushstroke, place it on the canvas, and then slosh or move it around. Which is better? Neither. It's a strictly personal decision. See which method works better for you.

5. Some artists pick up and deposit lots of paint on the canvas at one time, while others put down small, economical brushstrokes. Again, this is a matter of personal choice.

6. Some artists like their paint fat and juicy. They get this by mixing it with lots of medium. Others opt for the dry, scratchy effect by getting their paint as dry as possible. You can remove much of a paint's vehicle (oil) by letting it stand on a newspaper, blotter, or tissue just after it's been squeezed from the tube.

7. Another method is to put down a brushstroke and then scratch it away with a knife so that only a little of it remains on the canvas. By constantly repeating this procedure, you obtain a rather rough, but interesting, texture.

8. The more blending or fusing you do, the smoother your paint surface will emerge. Some artists deliberately go for the glossy-smooth surface, while others strive to show bumps and ridges. It all depends on how you build up your paint layers.

9. Lights are usually painted thickly and opaquely, and shadows are painted thinly and transparently. Thus, the densest stroke would be reserved for the highest highlight. This is in line with the tradi-

tional method of oil painting in which shadows were placed exclusively with thin glazes.

10. If you use retouch varnish during the intermediary stages of the portrait, be very sparing. An excess of retouch varnish tends to make the paint surface so slippery that new paint won't adhere to it.

11. I subscribe to the theory of always using the biggest possible brush. When you start using tiny brushes, the tendency to fuss and noodle about becomes heightened. The ideal would be to paint the entire portrait with nothing smaller than a #12 brush. It can be done.

12. There's no such thing as a line in nature. What appears to be a sharp edge is merely a cluster of atoms clinging closely together. Accordingly, there's only one way to paint edges—soft and softer. Look at any of Rembrandt's portraits. There ain't a sharp edge in it. When the Master wanted to indicate such an optical effect, he placed *contrasting* tones or contrasting color hues together, which served to produce the *effect* of a sharp edge. By all means, don't paint an all-soft-edge portrait — vary their consistency without going completely sharp anywhere in the portrait.

13. A word about textures. *They* do exist in nature, and it's a great challenge to reproduce them in the portrait. You can show textures in strictly physical fashion—rough brushwork for rough textures, soft blending for soft textures, etc. By using a knife, finger, piece of fabric, tip of your brush, or whatever, you can obtain a variety of textural effects in oil painting. It was said of Rembrandt's late portraits that they could be "picked up by the nose." The Master was devoted to texture and strove to paint it with fidelity. Look at his armor or jewelry— it fairly vibrates with life and reality.

WHEN TO STOP?

Teach yourself not to overpaint; set a rigid schedule for the portrait and stick to it *no matter what*. By purposely making this schedule tight, you'll force yourself to finish the portrait within an allotted time. This will fulfill four aims:

1. You'll establish good habits of discipline by learning to work under pressure.

2. You'll feel compelled to paint quickly, economically, and purposefully — not wasting a single stroke.

3. You'll learn to shoot for the *essence* of the portrait, not for the nonessentials.

4. You won't leave yourself time to fuss with the portrait to excess.

Every experienced artist knows that it's better to leave a painting slightly undercooked rather than slightly overcooked. Working too long on a painting is the bane of the beginner. Knowing that you have only a predetermined number of hours to finish the portrait will force you to abandon it long before it begins to spoil from too much attention. In time, you'll need no artificial gimmicks to tell you when to stop, but for now, an enforced schedule is an invaluable device.

And now, good luck.

COLOR
GALLERY

Bodyguard in Nepal by Charles Baskerville, oil on canvas, 14" x 10" (36 x 25 cm). Painted during one of the artist's frequent trips to exotic locations, this is a gem of a painting which includes a wealth of information in a comparatively small canvas. Baskerville's broad experience as a muralist is evident in his treatment of the background elements, which are given considerable importance but are painted flatly in contrast to the rounded planes of the head. The hues are vivid but never harsh — no area intrudes upon another, and the color relationships are harmonious and complementary. Note how low in value the whites of the subject's eyes are painted. This is true of dark-skinned subjects.

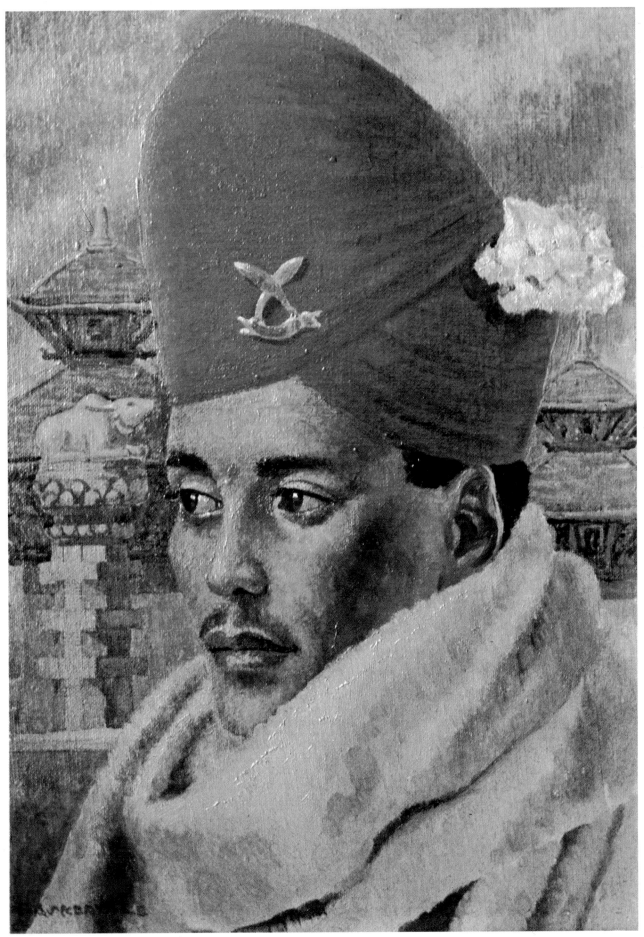

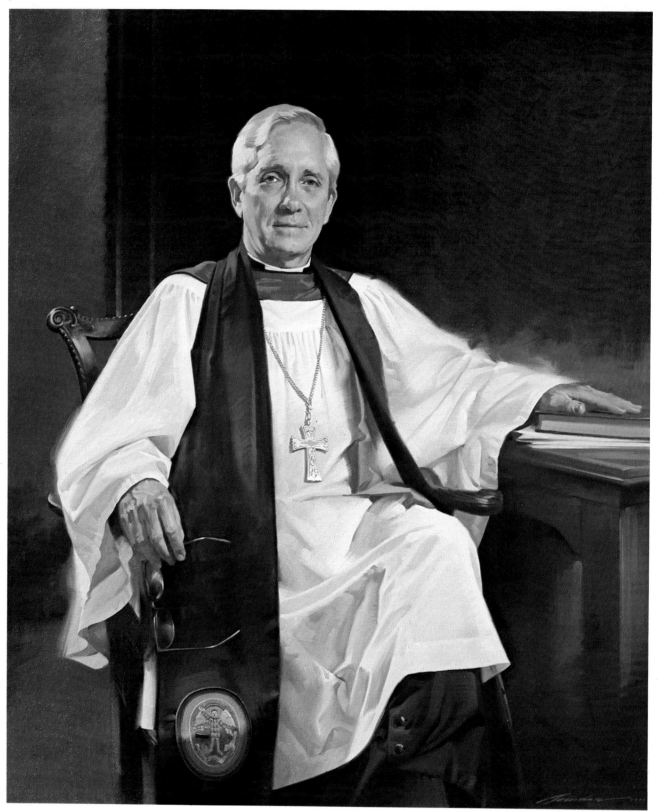

Reverend Dr. Robert Ray Parks *by John Howard Sanden, oil on canvas, 50" x 42" (127 x 107 cm), collection Trinity Church, N.Y.C. Sanden loved the challenge of painting a white-robed subject against a dark red background. This causes all the light areas to nearly pop out of the canvas and must be kept under firm control. Every gesture in a Sanden painting means something—almost nothing is left to chance, since Sanden must visualize the picture totally in his mind before he lays down a single brushstroke. It's this kind of precise planning combined with impeccable craft that makes Sanden one of the most sought-after portrait painters today.*

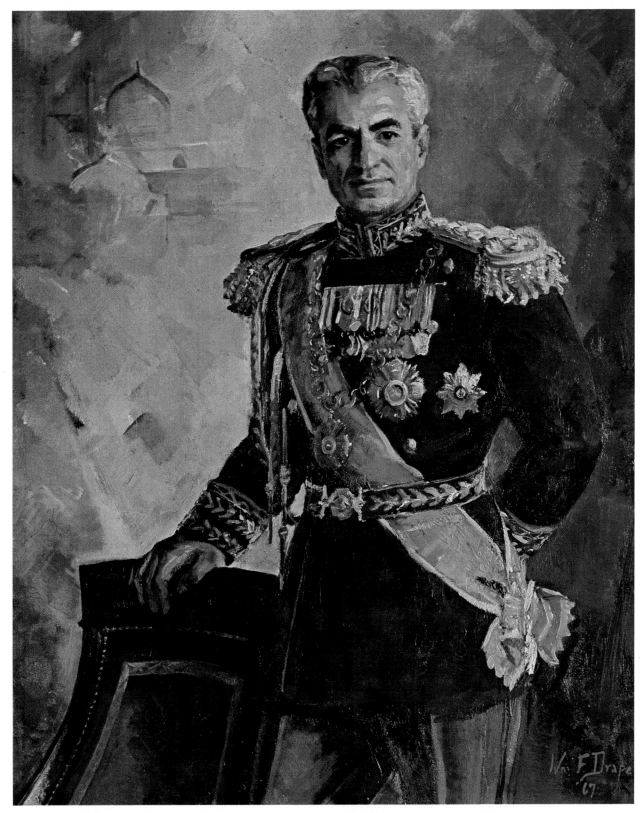

The Shah of Iran by William F. Draper, oil on canvas, 55" x 40" (140 x 102 cm),
collection The Imperial Palace, Teheran. Painting a subject of the stature of the
Shah of Iran, who is undoubtedly one of the world's most powerful men, places
a considerable amount of strain on an artist. Draper was able to meet this chal-
lenge. Despite the abundance of colors emanating from the sash, shoulder
boards, medals, and uniform, Draper was able to focus attention on the Shah's
distinctive and well-known features. By softening edges and holding down
lights, while sacrificing none of the identity of all the trappings, Draper manages
to control the subject rather than allow it to overwhelm him. I consider this a
true tour de force.

Ward Keener (detail) by Charles Pfahl, oil on canvas, 50″ x 40″ (127 x 102 cm), collection B.F. Goodrich Company. Note the contrast of cools and warms in the skin. Unless one studies it carefully, Pfahl's technique can mislead one into thinking that he paints tightly. In fact, most of his edges are soft and subdued, and the illusion of detail emerges from his superb drawing skills and the subtle transition of the planes which so closely mimic the actual texture of skin. Pfahl uses sable brushes to attain his basically smooth paint layers. He avoids the bravura brushwork which results in the splashy impastos that form distinct hills and gullies on the surface.

Head in Profile by Charles Pfahl, oil on board, 12″ x 16″ (30 x 41 cm), courtesy Far Gallery. In this handsome painting Pfahl demonstrates what the accomplished artist can achieve in the profile portrait. The front of the face is suffused with brilliant light that fades only slightly as the planes recede toward the back. Nowhere in the head is there a truly dark shadow, yet the progression of planes is honestly and most convincingly rendered. I particularly like the way Pfahl handled the cheekbone and the subtle indentations of the cheek and temple. Altogether this is a most satisfying and sensitive study of the male head.

Ben Sonz by Richard L. Seyffert, oil on canvas, 40″ x 34″ (102 x 86 cm), collection the Lotus Club, N.Y.C. Seyffert cleverly used the headline to fix the chronology of the painting. It's apparent that our first astronaut has just landed on the moon. Such devices are most appropriate when introduced subtly and unobtrusively. The globe was used to add a touch of importance to the event, and to complement the rounded emblem of the Lotus Club, of which the subject is president. Seyffert was delighted at the opportunity to paint an institutional portrait in which the costume is light and the pose somewhat different from the usual. It's a goal most experienced portrait artists pursue vigorously.

Andrew Price by Everett Raymond Kinstler, oil on canvas, 46" x 34" (117 x 86 cm), collection Mt. Ranier Bank, Seattle. A man of considerable height and of lean physique, the subject seemed uncomfortable in every chair provided him. While resting between posing sessions, he assumed the above pose, and Kinstler immediately seized upon it as best representing the angular, youthful informality Mr. Price presented. Kinstler excels at this type of portrait. The plastic, sculptural treatment of the planes of the head; the solid, three-dimensional feeling he tends to get in male hands; the alert expression; the tastefully rendered garments —all contribute to this example of male portraiture at its best.

Trygve Slettland by Paul C. Burns, oil on canvas, 36" x 30" (91 x 76 cm). Burns balanced the rather hot coloring of the subject's skin with the cools of the suit and background. This serves to focus our attention on the face immediately, since the human eye tends to be drawn to warm colors at first glance. The rather extreme angle of the right arm tells two things: the subject is a man of considerable height, and Burns posed the arm this way to utilize the light accents of the shirt cuff and wristwatch. I particularly like the way Burns painted the head in sculptured, distinct planes that accentuate the sitter's rugged, virile features.

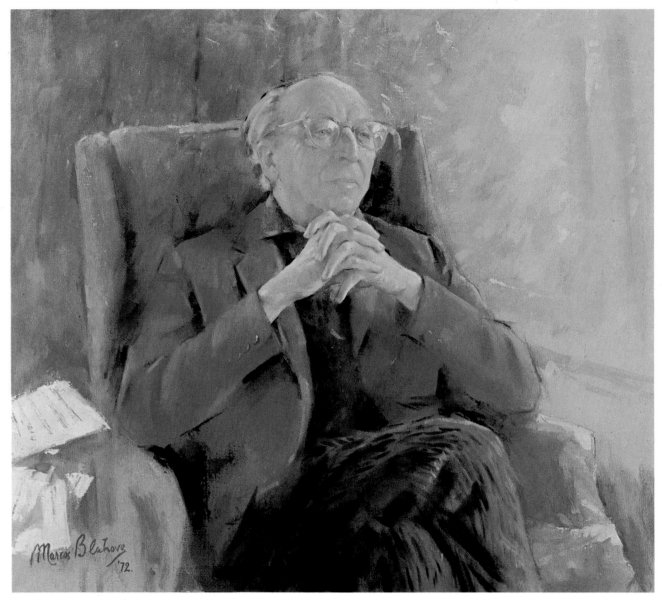

Aaron Copland by Marcos Blahove, oil on canvas, 26″ x 32″ (66 x 81 cm), collection Smithsonian Institution. Blahove is a high-key painter. Note the absence of deep shadow anywhere in the face. Except for a few blue accents in the shirt collar and the table, the entire painting is composed of warm reddish and yellowish tones. The apparent sketchiness with which the figure seems composed shouldn't mislead one into thinking the artist is lax in his drawing. On the contrary, his is a very sophisticated, modern style which reveals all that is important and omits the extraneous or superfluous.

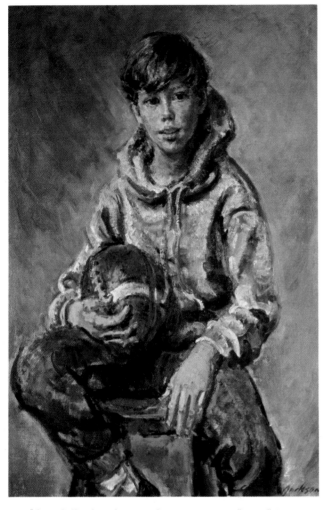

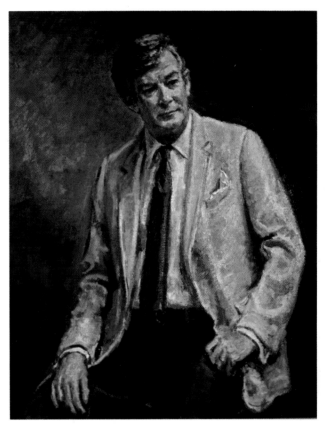

Paul by Clifford Jackson, oil on canvas, 36" x 24" (91 x 61 cm). This young fellow barely squeaks by as a subject for a book about men's portraits, yet I've included him because I enjoy the casual approach the painter employed to show the charm and innocence of youth. Contrast his eager, open-eyed gaze with that of the other portraits. Note too the absence of discernible forms in the background. Many painters feel compelled to show solid objects behind the sitter, but Jackson tends to paint his portrait backgrounds as mass. Neither approach is more desirable—it's merely a matter of personal choice.

Bob Brown by Clifford Jackson, oil on canvas, 40" x 28" (102 x 71 cm). The subject is so alive he seems about to step out of the canvas, yet the technique is hardly the tight, detailed method one might associate with extremely realistic paintings. The answer here lies in Jackson's ability to show life without rendering his forms with absolute fidelity. His is the skill to create the illusion of life through adroit application of color, value, and an inner essence which lends realistic spirit to the subject. I like the way Jackson painted the folds in what appears to be a linen jacket. They have the appropriate drag and bagginess that I associate with cloth worn over a body.

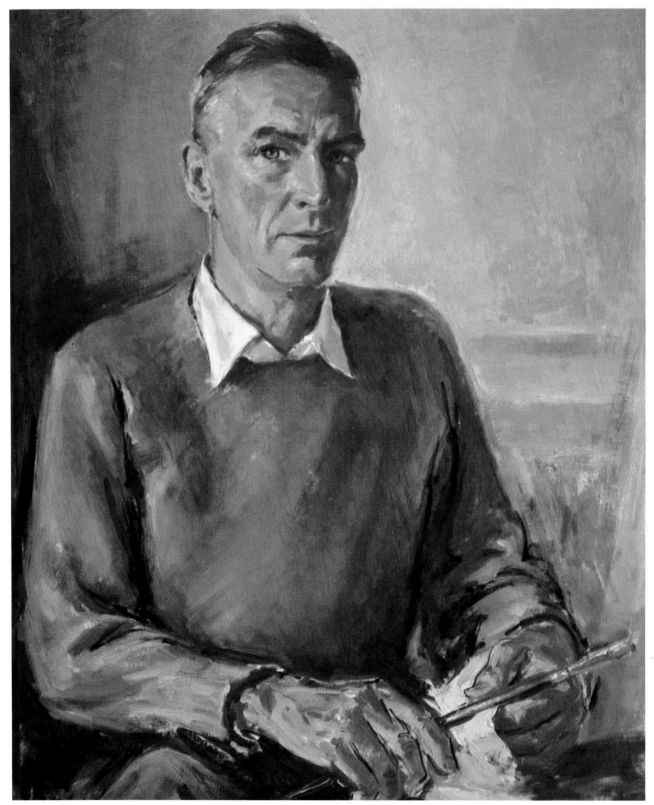

John Folinsbee, N.A. *by Peter Cook, oil on canvas, 30" x 24" (76 x 61 cm). In this affectionate study of his late father-in-law, John Folinsbee, Cook pays personal and professional tribute to a fine American painter who overcame a severe physical handicap to achieve a successful career. Cook wisely placed emphasis on the subject's hands—the strong, capable hands of an artist from whom Cook learned much about art and life. The portrait is basically cool—as is much of Cook's output—with several warm accents in the cheek and forehead. The background is rather vague, lighter next to the dark area of the head and vice versa. The dominant color of the portrait is gray, yet the total effect is not particularly solemn.*

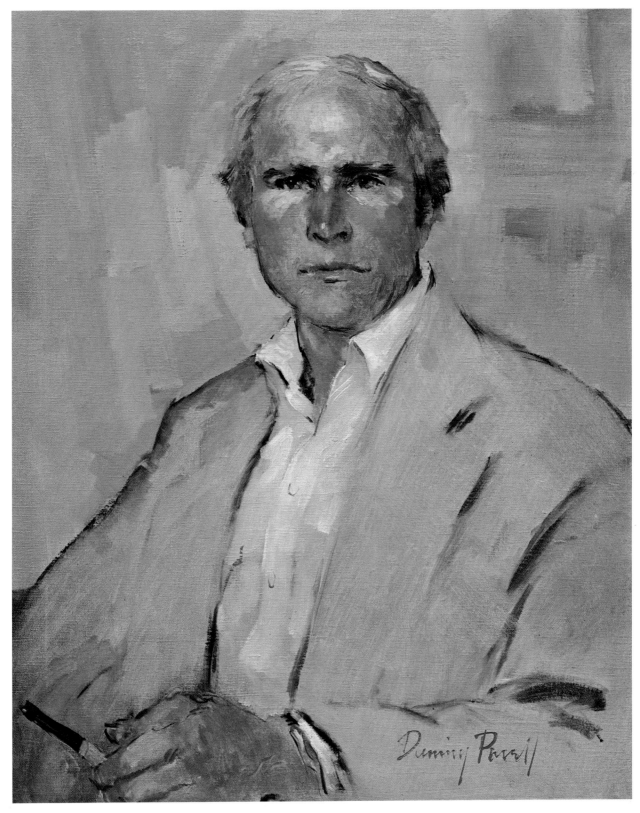

M. Christian Loken *by Dunning Powell, oil on canvas, 30" x 24" (76 x 61 cm), collection the sitter. More and more artists are turning to the modern trend in portraiture as exemplified in this splendid male portrait. The emphasis is on looseness, airiness, and informality. The artist obviously knew what he was doing and didn't feel constrained to noodle over every line and contour. Planes drift together, the background is a mass of broad strokes running in several directions at once, and the clothing was slashed in in a series of swift tones. Commissioned portraits executed in this genre can never feel the threat of photography which almost sounded the death knell of portraiture as it used to be.*

DAVID A. LEFFEL

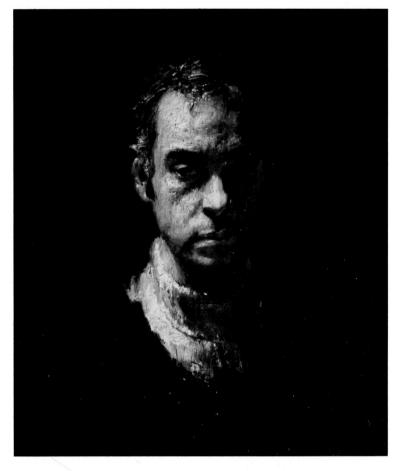

Ludwig Olshansky *by David A. Leffel, oil on canvas, 22" x 18" (56 x 46 cm), collection the sitter. A conscious use of light works here to bring the head startlingly out of its nearly dead-black background. Such a dramatic device is fraught with danger, since by throwing a single value out of balance, the whole thing could easily emerge garish and grotesque. Leffel combines the illumination of the masters with the Maroger medium to provide him the type of effects he requires. This truly is a twentieth-century Rembrandtlike head by a painter who exploits the best elements of both historic and present times.*

Self-portrait *by David A. Leffel, oil on panel, 9½" x 8" (24 x 20 cm). The light in this brooding little study, while high in value, is cool, clear, and subdued. Leffel is more a painter of values than of obvious color. His rough, blocky technique can best be described as penurious, in the positive sense of the word. By concealing so much of the subject, it reveals more in the areas of light than would be the case if it were all apparent to the eye. Leffel manages to invest all his portrait subjects with a deep sense of humanity.*

Self-portrait *(opposite page) by Robert Philipp, oil on canvas, collection Mr. and Mrs. Anthony Mysak. The young painter can learn much from this casual study by a contemporary American master. The technique is rough, dry, and sketchy. Note the lack of a hard edge anywhere in the portrait. See how swiftly and simply the ear is painted. Are the pupils accurately drawn in with a catchlight carefully dropped into each? They aren't, and one is hard put to identify the actual color of the eyes; but in light of the overall view, this hardly matters.*

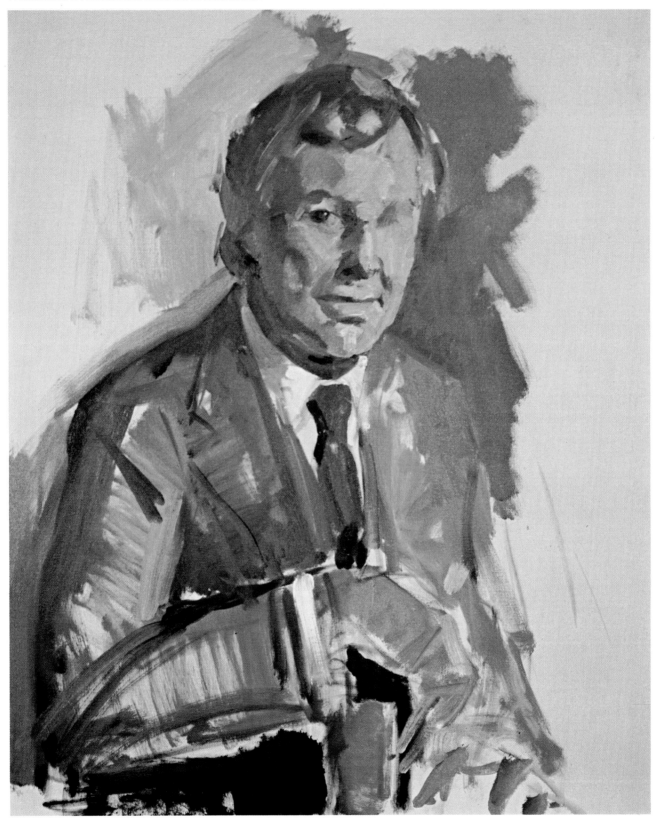

Portrait Mid-stage. *Draper hasn't yet placed all the elements to his satisfaction. The right elbow is still within the frame of the canvas, and nothing yet has been resolved about the left arm. The mouth remains closed, and the left eye is not yet affirmed. Draper works in a rather impulsive fashion and waits for the decisions to suggest themselves to him as the work progresses. He'll change things again and again if a better solution becomes apparent. This results in a living portrait that continues to grow and evolve as it is being developed.*

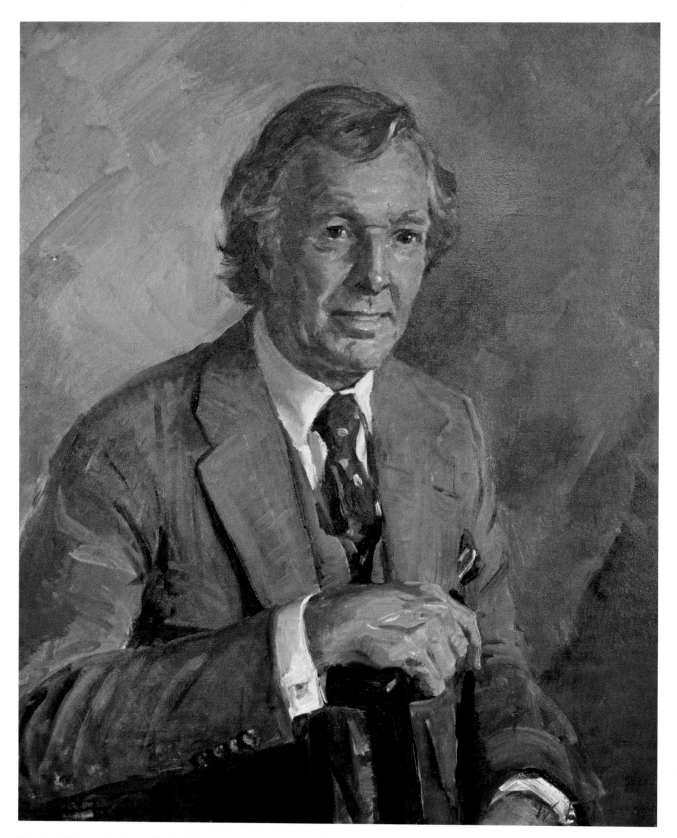

Finished Portrait, Perry T. Rathbone, *oil on canvas, 30″ x 25″ (76 x 64 cm),*
collection the sitter. This shows how Draper thought out many earlier problems
and challenges. Note such small but striking color accents as the cufflink; the
lapel ribbon, and the pocket kerchief. The blue veins of the hand are shown in
bold, cool accents. The light pattern on the tie is suggested in several places—it
isn't necessary to show it all over. Draper likes to show an occasional detail
such as the four buttons on the sleeve, but his overall technique is loose and
almost impressionistic. (To see steps of this demonstration in black and white,
refer to pages 112–115.)

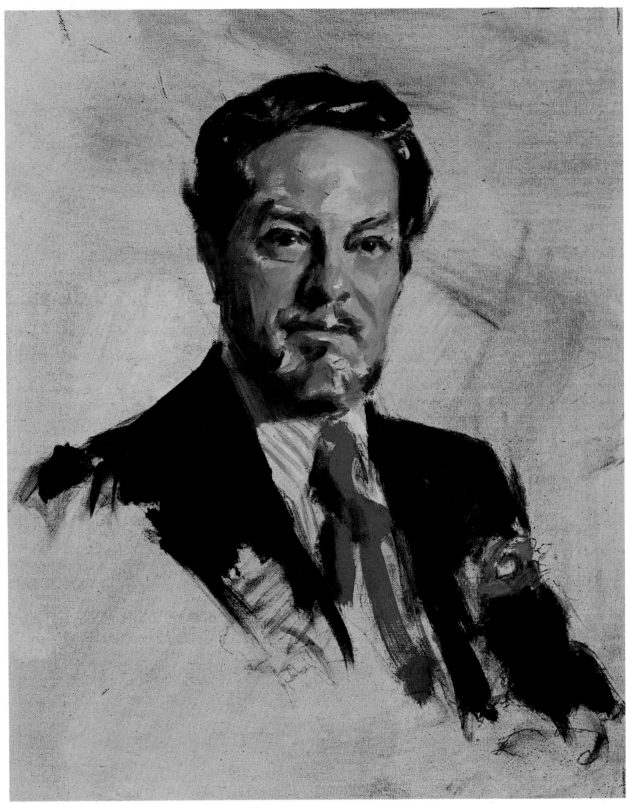

Portrait Mid-stage. *Throughout this portrait Kinstler concentrated on holding the gold-brown tone of the canvas. It's apparent in such areas as the left side of the beard, the spot just above the upper lip, and the area above each eyebrow. The subject's complexion is toward the high, warm side, and the blue shirt serves as a cool accent against it. Note how few tones Kinstler used to round the forehead. The further his career advances, the more simply Kinstler paints. Long practice and experience make good artists learn to do more with less.*

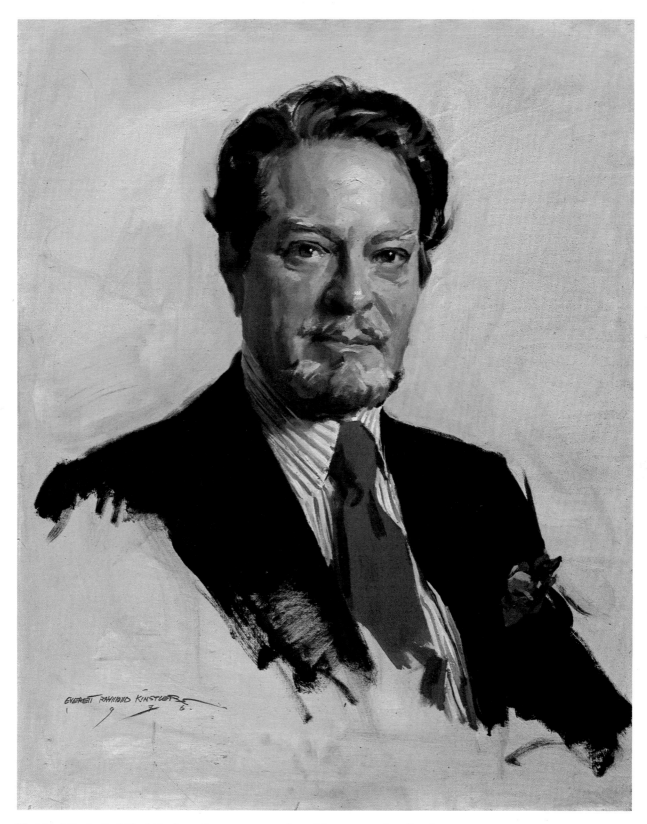

Finished Portrait, Alfred Drake, *oil on canvas, 30" x 25" (76 x 64 cm), collection the sitter. Kinstler employed considerable blues, grays, and greens in the beard. Although the pocket kerchief was really a solid red, Kinstler felt it would help the picture if it were broken up into a pattern, and he added blue to it. Kinstler doesn't feel constrained to paint exactly what's before him, but believes it incumbent upon him to create a painting rather than render it slavishly. The final and a most important touch was the addition of the signature which, in Kinstler's opinion, provided the completed design. (To see steps of this demonstration in black and white, refer to pages 122–125.)*

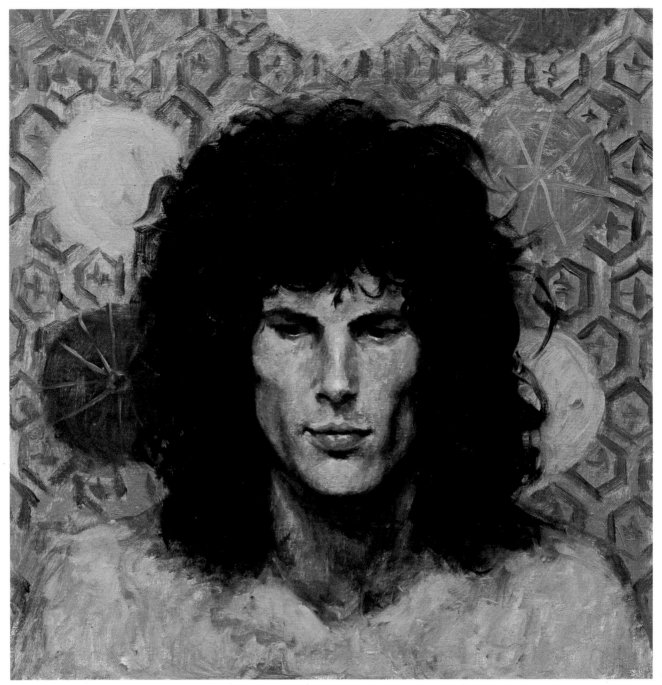

Portrait Mid-stage. *The variety of different colored strokes in the skin shows how Pfahl proceeds toward his final statement. There are purples, greens, yellows, oranges, reds, and browns. By placing stroke after stroke and letting each stay without moving or blending it, Pfahl builds up a layer of mosaiclike paint which subsequently fuses into an overall color tone which resembles the actual subject. This method varies from those in which the paint is laid on in a flowing, rather liquid fashion like watercolor washes.*

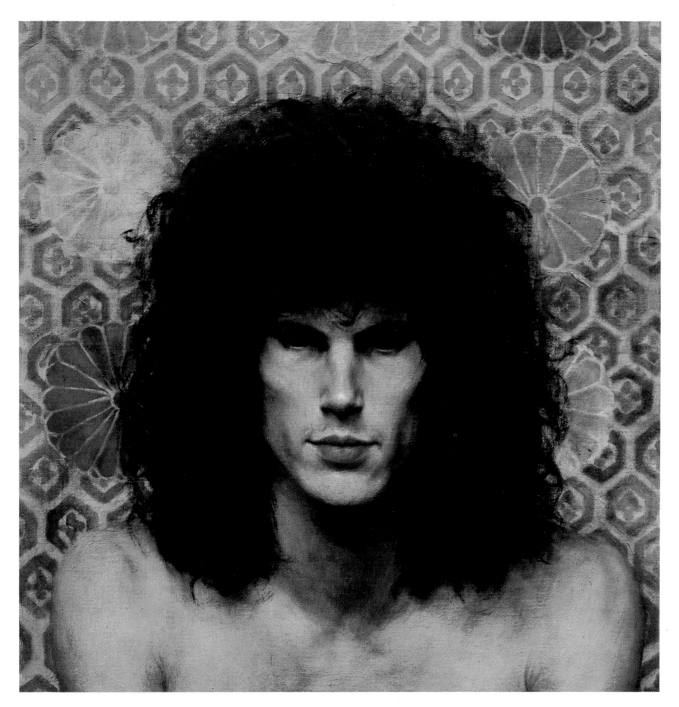

Finished Portrait, Diego, *oil on canvas, 20" x 50" (51 x 127 cm). Although the overall effect is now smooth and cohesive, it's merely the result of many strokes blending visually. In other words, our eyes do the fusing, not Pfahl's brush! A cool touch is provided by the hair growing just beneath the skin in the upper lip areas. The young man's lips are an unusual dark red color, but this is a characteristic observed in many Latin peoples. The hair is painted very loosely to depict its character. Note how soft its edges are along the shoulders. Realistic effects are achieved here with subtly turning planes, not with sharp edges. (To see steps of this demonstration in black and white, refer to pages 130–133.)*

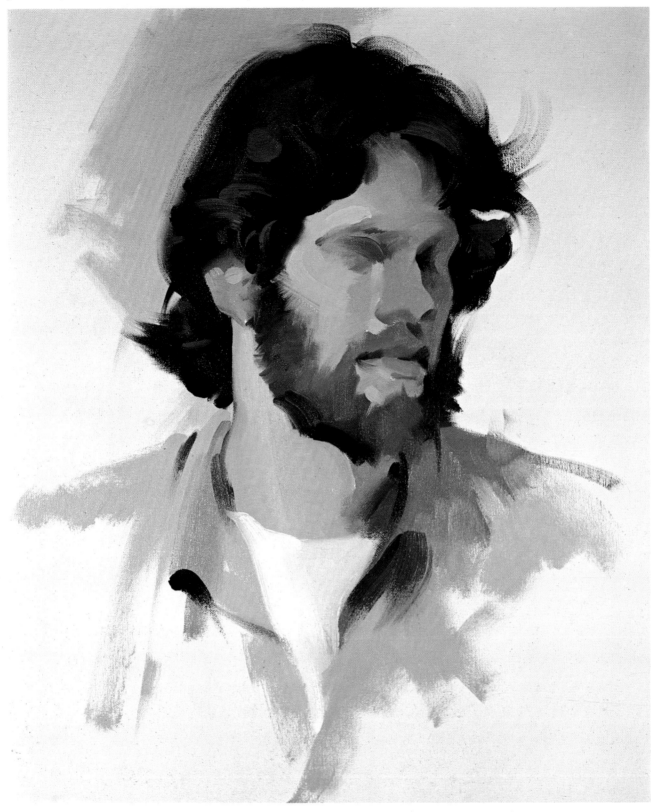

Portrait Mid-stage. *Note the sharp breakup of hues within the head at this stage. The nose and ear are a warm red, the left side of the face is olive, the light areas in the temple are pink, and the halftone in the brow is a cool greenish-gray. Sanden proceeds in a most disciplined, controlled fashion. Relying heavily on his premixed flesh colors, he knows exactly what mixture to place in any prescribed area. His is definitely not a fumbling, indecisive technique.*

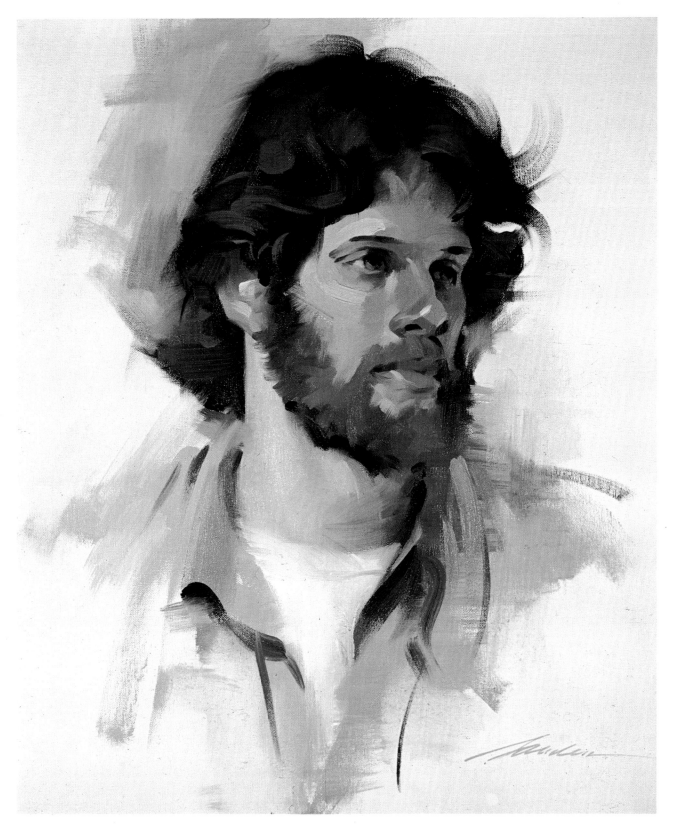

Finished Portrait, Steve, *oil on canvas, 24" x 20" (61 x 51 cm). Here are the mixtures Sanden employed to achieve the final results: for the iris, a cool gray with umber for the darks around the eyes: alizarin crimson and white for the highlight on the lower lip; burnt umber and alizarin crimson for the dark of the nostril. Sanden is first and foremost a colorist, a fact that's quite evident in this powerful, vivid vignette. Note particularly the careful, economical placement of background tones for maximum effect. Sanden contends that using his Pro Mix colors greatly facilitates painting the human head. (To see steps of this demonstration in black and white, refer to pages 140–143.)*

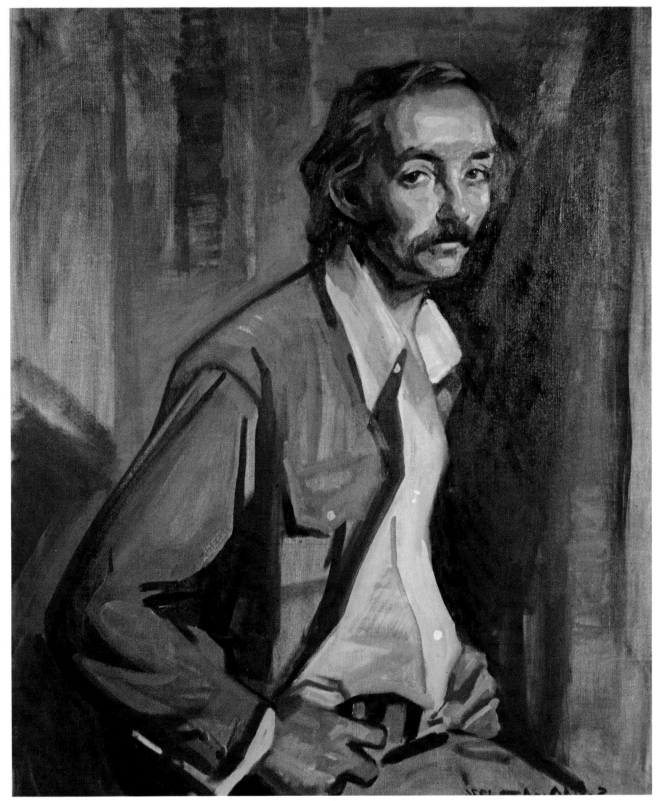

Finished Portrait, Frank Williams, *oil on canvas, 36″ x 30″ (91 x 76 cm). The coloring is subdued throughout, with emphasis on the cool side of the spectrum. Seyffert leans toward the greens, browns, and blues, rather than the vivid reds, yellows, and oranges. The tendency toward warm or cool color is very much tempered by an artist's personal color sense and his personality. Chances are good that, given similar circumstances, another painter may have painted the same subject in hot, bright colors. Each one of us possesses his own built-in color reactor. (To see steps of this finished demonstration in black and white, refer to pages 150–153.)*

Finished Portrait, Francis Hunsicker, *oil on canvas, 27" x 40" (69 x 102 cm).*
There are interesting combinations of warm and cool color within the subject's
head. Smith works in patches of strong color, somewhat in the manner of poin-
tillist painting, which produces more color in the shadows and renders them
lighter. Smith teaches his students not to rely on ready-mixed earths and browns
but to achieve shadows with combinations of brighter colors. This method varies
sharply with that of painters who work essentially in value and consider color of
secondary importance. Each artist must determine which of these two ap-
proaches works better for him. (To see steps of this finished demonstration in
black and white, refer to pages 160–163.)

CLYDE SMITH

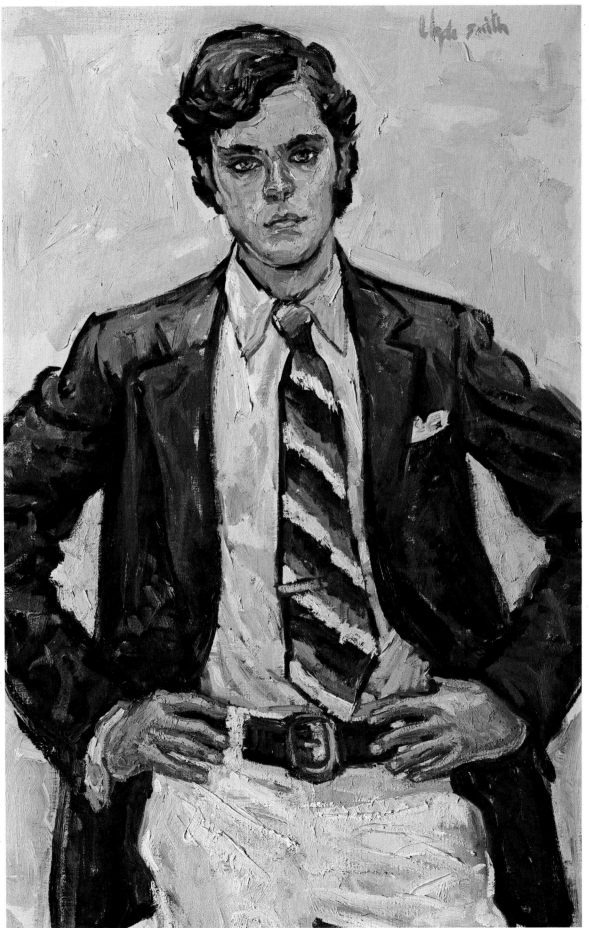

ARTISTS AT WORK

Peter McGee by Clyde Smith, oil on canvas, 40" x 27" (102 x 69 cm), collection Mr. and Mrs. McGee. The long narrow canvas works particularly well for a slim, young man whose slenderness is complemented by the shape of the painting. With a minimum of warm color Smith has managed to convey a strong sense of the subject's personality. The overall coloring is blue, with comparatively few touches of yellow in the tie pin, belt buckle, and flesh accents to break up the cool overall scheme. The straight-on, front-face view lends immediacy and alertness. The eyes look directly at us in a kind of assertiveness which is appealing and attractive in a youthful subject.

CHAPTER NINE
William F. Draper at Work

William Draper was born in Hopedale, Massachusetts and educated at the Pomfret School and Harvard University. He studied at the National Academy of Design and the Art Students League in New York and at the Rhode Island School of Design and Charles Hawthorne's Cape Cod School of Art, which has probably influenced more artists than any institution its size.

Draper was a Navy lieutenant during World War II, and in his official capacity as combat artist executed a number of impressive battle scenes in the Pacific theater of operations. He later was commissioned to do murals for the U.S. Naval Academy. His portraits, landscapes, and flower scenes have been exhibited in prestigious galleries and museums including the National and Corcoran Galleries in Washington, D.C.; the Metropolitan Museum of Art in New York; Boston's Museum of Fine Arts; the Chicago Art Institute, and galleries and museums in London, Paris, and Australia. Draper's portrait commissions have included such well-known personalities as President John F. Kennedy, the Shah of Iran, General Lauris Norstad, Ambassador Walter Annenberg, John Foster Dulles, Terence Cardinal Cooke, and Paul Mellon.

The first thing William Draper establishes with his sitter—whom he frequently doesn't meet until he actually begins the painting—is that the sitter must make himself available for five consecutive days, beginning on a Monday. During this period Draper will paint daily from 10:00 a.m. to noon and from 2:00 to 4:00 p.m. Once this condition is accepted, Draper makes sure to arrive exactly at ten—not one minute before—so that he must take time to squeeze out paint, arrange tools, etc., rather than begin to paint immediately. All this is calculated to give him time to study his subject, to size up the subject's reactions to him, and to plan poses for the portrait. During this first encounter Draper acquires an impression of his subject and often lets it serve as the basis for the portrait. But this impression may also change as he gets further insight into the person.

A happy, outgoing person, Draper uses this initial meeting time to converse with the sitter, play his player piano, and be as entertaining as possible to put the sitter completely at ease. He finds that a completely relaxed subject presents a lively, animated appearance, with a sense of life that Draper finds invaluable in the portrait. In the meantime the sitter—ensconced in his chair on the model stand—will have taken a number of poses which he can follow in the mirror that Draper has placed behind himself just for this purpose. Finally Draper may suggest that together they try to arrange the ultimate pose that will best represent the subject.

Draper finds that this mutual effort helps promote the kind of reciprocal relationship that leads to the successful portrait. In posing the subject he looks for a rhythm and an intriguing composition that will lend vitality and verve to the portrait. He doesn't insist that the subject sit absolutely still, but prefers that he talk and move around a bit—enough to keep himself alert, awake, and interested in the procedure.

Draper paints his sitters just as they are, but emphasizes the finest attributes they present. Consciously trying to flatter a subject might present him difficulties in getting a likeness. Draper posits a most interesting theory regarding the artist's reaction to the age of the sitter. He suggests that a 22-year-old artist sees a 60-year-old sitter as ancient and paints him accordingly. But when the artist turns 60 himself, he will paint the 60-year-old from an entirely different viewpoint. Accordingly, an 80-year-old artist would paint the same 60-year-old subject as a comparative youngster. He says with a smile: "Somehow the wrinkled don't look so wrinkled to me now . . ."

Draper doesn't consciously probe his sitter's emotional traits. He feels that they emerge during the process of the portrait and remain subject to continuous change. He does believe that a subject's emotional traits assert themselves in the pose rather than in the features. An aggressive

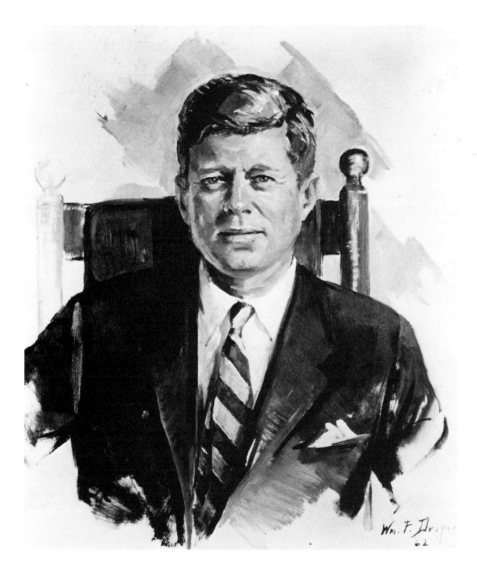

President John F. Kennedy *by William F. Draper, oil on canvas, 30" x 25" (76 x 64 cm), collection Kennedy School of Government, Harvard University. A casual, informal study of the late President, this was painted from life in 1962, a year before his tragic death. Obviously executed rapidly, Draper has managed to capture the charismatic aura of the dynamic young man whose wit, style, and intelligence enchanted the people of the world. Pressed for time, Draper left the background and part of the figure unfinished in order to concentrate on the head. The straight-on, frontal view is characteristic of the late President's direct personality, but in the rigidity of the posture Draper has also managed to catch some of the tension evoked by J.F.K.'s poor health and crushing burden of responsibility.*

man, for instance, might be inclined to lean forward and look the viewer right in the eye.

Draper feels that he paints his commissioned and noncommissioned portraits in essentially the same way. Since his technique is basically loose, there isn't any difference in his approach. Fortunately Draper's clients admire his free technique and often select him because of it.

Draper lists a number of goals he projects for his portraits:

1. To create a good painting in which the color and composition are successfully realized.

2. To present a good likeness of the subject. He finds it great fun as well as a terrific challenge to achieve such a good resemblance that friends of the sitter viewing the finished portrait will exclaim with admiration, "Isn't it marvelous!"

3. To create a portrait which doesn't merely display a face that is consciously posing, but rather one that appears natural, as if "something were happening."

He determines the mood of the portrait by the sitter's personality, the sitter's expectations of the portrait, and the place where the picture is going to be displayed. He cites the case of two Catholic cardinals who although equal in rank, were quite divergent in character. One requested to be painted in the full ceremonial robes of his office, while the other,

who was of a more liberal bent, insisted he be shown in simple clerical
garb. Obviously the two portraits called for dissimilar moods, and the
artist acquiesced to each client's wishes.

When it comes to the question of formality or informality, Draper
again guides himself by the sitter's demands. He agrees that the trend
these days is toward casual and informal attire, especially among men.

Draper works essentially in three sizes, but, given the choice, he
would opt for a 40″ x 32″ (102 x 81 cm) canvas which would allow him
to include the hands and show more than the head and shoulders only.
Draper paints male heads somewhat larger than lifesize, perhaps as large
as 10½″ high. However, he paints his women subjects exactly lifesize.
He does alter this from time to time, however, and did execute a
full-length portrait of a family of five plus three dogs on a 40″ x 50″
(102 x 127 cm) canvas.

Draper's backgrounds tend toward abstract designs of mass and color
rather than specifically delineated objects. He uses elements in the back-
ground to promote compositional balance. Using a cloth or screen he
usually arranges a background of basically warm or cool tones and then
paints it fairly accurately as to color temperature, if not hue. He consid-
ers his backgrounds generally successful and effective.

He prefers to pose his male subjects seated and up on a model stand.
Occasionally he has them perch on a stool that won't show in the por-
trait. At times, as can be seen in the demonstration painting of Perry
Rathbone, if the man's arm is covered by a sleeve, he will run it out of
the canvas and then bring it back again. He doesn't advise this with a
bare arm, however, because it emerges "looking like chunks of sliced
sausage."

Draper feels that he may paint too many male portraits in full-face
views and would like to do more three-quarter views. However, even in
the three-quarter view, Draper thinks the subject's eyes should be look-
ing at the viewer to give the portrait impact and immediacy. Since
Draper paints standing up, he is usually at eye level with his sitters. He
feels that painting the subject while looking down at him would make
the subject look neckless.

Draper customarily positions the subject's head between four and five
inches from the top of the canvas and somewhat off center for more
interesting design. Since he likes a lot of "air" in the portrait, he leaves
extra canvas around the stretchers so that he can later remove and re-
stretch it to gain more space around the head and figure.

Draper welcomes the challenge of interesting clothing and enjoys
painting a tweed or stripes instead of the commonplace dark suit of the
boardroom portrait. However, he doesn't care for shirts or ties that are
too busy. When he wants to show texture or pattern in fabric, he merely
indicates it in a few places and lets the viewer's imagination fill in the
rest.

He thinks eyeglasses and jewelry add interest to the portrait and will
paint them in if they are an integral part of the subject's appearance. He
likes painting hands and will include them whenever possible at "no
extra charge," as he smilingly adds.

To arrange the proper illumination, Draper manipulates the subject
rather than the light. He works best under the cold, natural north light
which issues through his studio windows. Like most windows in New
York City, they are laden with dust and other marks of pollution on the
outside, which soften the light a bit. Occasionally, when the light goes
dim or bleak on wintry days, he will switch on an auxiliary artificial
light which approximates daylight.

Draper tries to avoid painting portraits on location. Although clients
often assure him that the illumination in a particular area is "very

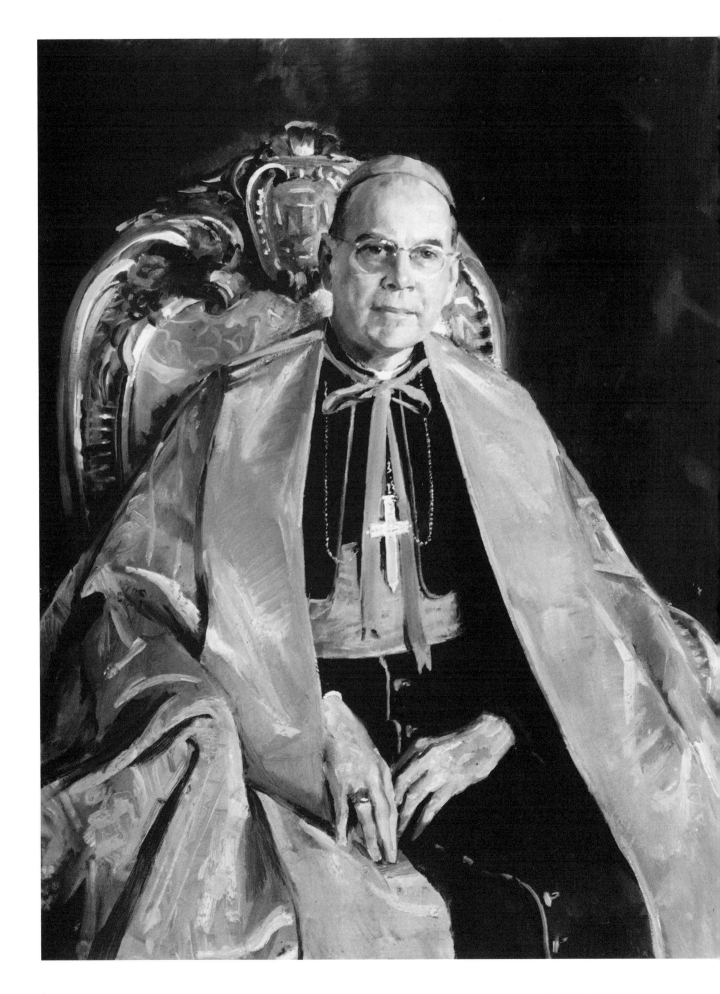

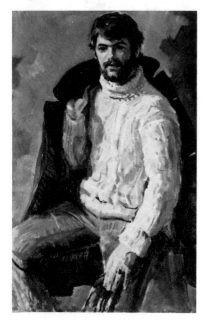

Eric *by William F. Draper, oil on canvas, 50" x 30" (127 x 76 cm). This informal portrait is a decided departure from the institutional portrait Draper is so often engaged to execute in his busy schedule. Painted as a demonstration for the Art Students League, it allowed the artist to be as free as he wanted; yet it's virtually indistinguishable in technique from his commissioned work. This represents a tribute to Draper's maturity and assurance as an artist. He feels no compulsion to tighten up when he paints for a fee, and he manages to have fun and to be inventive whether he's painting an archbishop or a young friend.*

good," when he gets there he is invariably disappointed. Those who aren't painters apparently don't see light through the eyes of an artist. However, Draper enjoys painting outdoor portraits. Since he was taught by the celebrated Charles Hawthorne, who insisted that his pupils paint subjects posed against the light and thus learn to read colors in shadow, Draper would never paint a simulated outdoor portrait inside. He feels this would raise havoc with the shadows and emerge all wrong.

Draper's portrait palette consists of the following colors in the Rembrandt line:

Ivory black
Ultramarine blue
Cerulean blue
Viridian
Permanent green light or
 (occasionally)
 chromium oxide green
Cadmium yellow light
Cadmium yellow deep
Cadmium orange
Yellow ochre
Cadmium red light
Burnt sienna
Alizarin crimson
Burnt umber or
 (occasionally) raw umber
Zinc white (by Winsor & Newton)
 He had an unfortunate experience
 with lead white and has used
 zinc white ever since.

Draper also suggests some possible color mixtures for various racial skin tones:

Caucasian skin: variations of yellow ochre, cadmium red, and white plus cool tones

Black skin: variations of alizarin crimson, ultramarine, burnt sienna, and white plus cool tones.

Oriental skin: variations of yellow ochre and white plus cool tones

Draper isn't inclined to select an overall color scheme for a portrait, but he might repeat the color of the costume in the background to attain a sense of color unity. He prefers bright, intense color—in his words, "lots of color" — in his paintings. His tonal key is normally high, and he doesn't fiddle with this natural proclivity. He won't consciously invent color, but he might exaggerate it by putting more in a particular area than actually exists. In his portrait backgrounds he will vary the color tonality by placing his darks next to the lighter parts of the face and vice versa.

Although he occasionally uses a rigid ground, his basic surface is a smooth Belgian canvas. He uses long, flat brushes, but isn't particular about sizes. He painted the entire demonstration portrait with one, or possibly two brushes which he selected at random. He also paints with the knife at times. Although he has used medium in the past, he has stopped because he found it darkened his canvases. Now he uses only turpentine, very sparingly, and retouch varnish frequently to bring up areas gone dead.

Although he usually pitches right in on a white, untoned canvas, he might occasionally do a preliminary sketch for design purposes; but this

would be only on a very large canvas. Lately it has been his practice to begin the portrait in acrylic paints, which set very quickly. Thus, if the second day's painting in oil is not successful, he can retain the good start with acrylic and wipe away the second day's errors. This isn't possible if he uses oils from the beginning.

Draper doesn't work from photographs and works only when the model is present. He employs a spontaneous *alla prima* technique which involves no glazing. He likes a juicy effect in his paintings with decided brushstrokes very evident here and there throughout the canvas. He is essentially a soft-edge painter and makes particularly certain to fuse hair into skin areas to achieve a soft, blended effect. He advises that an area lying just beneath a bone be shown somewhat more sharply to promote the illusion of a protruding form. He suggests that a sharp edge can sometimes be indicated by adjoining contrasts of color value. Also, Draper will scumble in selected areas (paint in broken light tones over dark areas) to indicate textures.

When the portrait is approaching completion, Draper will listen to comments from the sitter's relatives or associates. Occasionally such observers might sense something not quite right about the likeness without actually knowing where the problem lies. This will compel Draper to take a closer look and possibly spot the offending area. Another trick he employs, as he did in his demonstration portrait, is to consciously leave out one of the eyes until the very end. Thus if the likeness is there despite this omission, Draper knows that he is home free.

Draper's attitude concerning painting can be summed up in the following three quotes: "When in doubt—take it out." "It's wrong until it's right." "The love and enjoyment you have for painting shows in your work."

He has trained himself to finish a portrait in the allotted five days, and by Friday afternoon it is always complete. Draper himself is often amazed at the suddenness with which a portrait falls into place. It may have presented problems up until the last half hour, but suddenly everything comes together.

Step 1. *Working on an untoned canvas, Draper maps in the figure roughly with brush and paint. He is designing the portrait in this stage and is concerned mainly with the placement of the figure. He pays a little more attention to the drawing of the right hand, which is an important aspect of the foreground, but he has not even indicated the shape of the left arm. In subsequent stages changes are effected in the angle of the right arm. Freewheeling painters like Draper never lock themselves into a rigid posture; they always allow room for change.*

Step 2. *Now Draper masses in the tones in the figure to obtain a preliminary tonal relationship and a base upon which to paint. All the darks are placed more or less accurately, and several background tones are laid in to define the shape of the head. Note that the right elbow now juts out of the canvas—a decision Draper made as he was blocking in the tones. He has also accentuated the slight stoop of the shoulder that's so characteristic of the subject in the sitting position. Mr. Rathbone is quite tall, and tall men tend to slouch slightly when they sit for long periods.*

Step 3. *For the first time we see features in the face. The right eye is placed, as is the shadow side of the nose and the lines of the planes surrounding the mouth. There has been some modeling of the right cheek and chin, but the left side of the face has been smeared and fused with the background. Draper is trying to establish the forms inside the head and hasn't yet spent much time working out its external contours.*

Step 4. *Draper has placed most of the features now, with the exception of the left eye. This is a device he employs as a kind of safeguard. If everything appears correct without the inclusion of one eye, he knows that he's on the right track. He's done considerable modeling in the left side of the subject's head and a little corrective work on the suit. The left arm is still untouched, and no work has been done in the background or the right arm. Draper obviously likes to get the head fairly well finished before he turns to the other elements.*

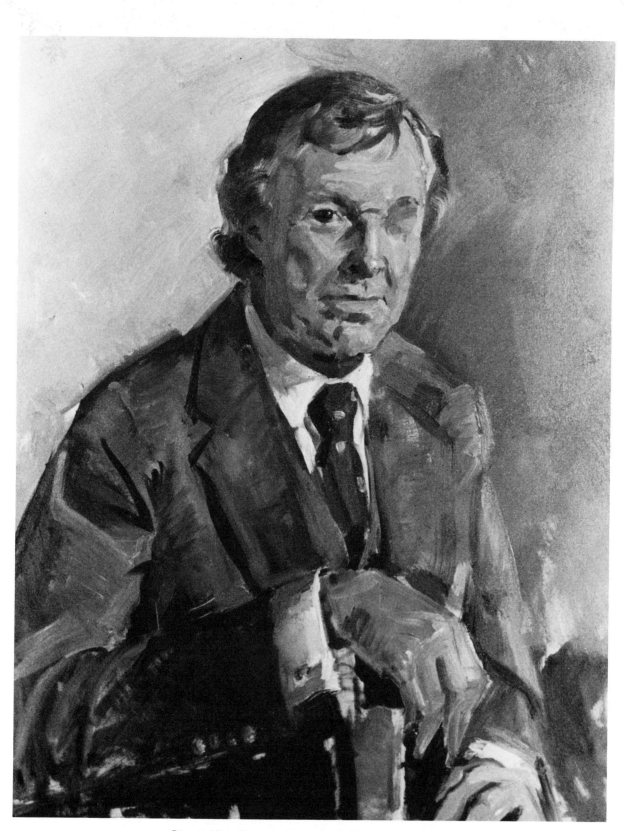

Step 5. *Now Draper places the folds in the suit and adds the shape of the left arm. He has fully brushed in the background and done considerable work on the tie, shirt collar, and hair. Also, he has put in the horizontal fold across the bridge of the nose. Draper is now fairly content with the placement of all his big masses and is looking for those smaller touches that identify the sitter. He will make additional corrections and refinements as the work progresses.*

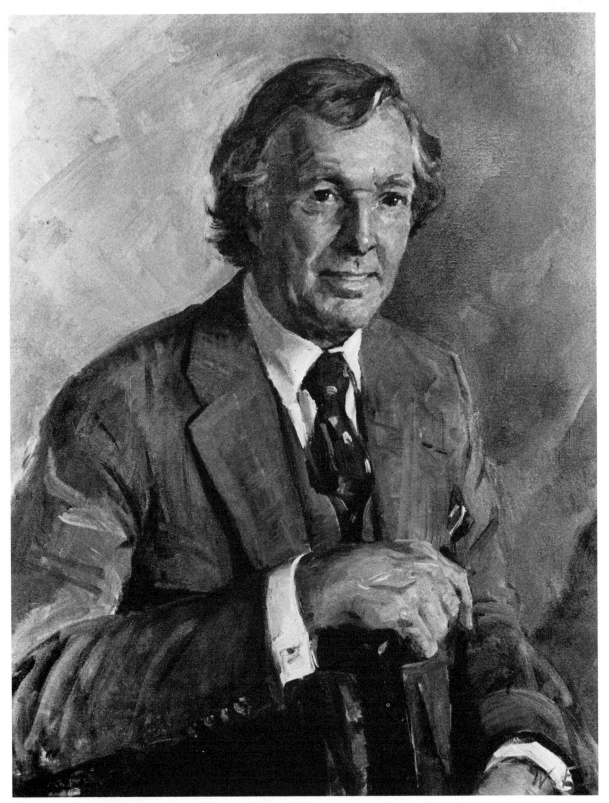

Step 6. Perry T. Rathbone, *oil on canvas, 30″ x 25″ (76 x 64 cm), collection the sitter. Draper has effected many changes. The right hand now lies horizontal instead of hanging over the arm of the chair. The left hand has been cut off just below the wrist. He has narrowed the chin and jaw and opened the mouth slightly in a smile. He has slimmed the face generally and raised the temples a touch at the hairline. He has also darkened some of the shadows in the face and added appropriate highlights in the forehead, on the bottom lip, and on the tip of the nose. Draper now paints in the left eye and shows a pocket handkerchief.*

CHAPTER TEN
Everett Raymond Kinstler at Work

Everett Raymond Kinstler is a native New Yorker who abandoned formal schooling at the age of sixteen to earn a living, first by drawing for comic books, then in various facets of illustration. He studied painting with Wayman Adams, Frank DuMond, Sidney Dickinson, and John C. Johansen. The transition from illustrator to portrait painter came naturally to Kinstler. He quickly established himself as one of America's foremost portrait artists. He has executed over 500 commissioned portraits of men and women including such well-known figures as publisher Charles Scribner, astronauts Scott Carpenter and Alan Shepard, Mrs. Irenée du Pont, Jr., and Roy Rogers and Dale Evans. For the past several years, Kinstler has been painting a series of official portraits of United States cabinet members.

Kinstler is an Academician of the National Academy of Design, Vice-president of the National Arts Club, and member of Audubon Artists, Allied Artists of America, and the Pastel Society. He taught at the Art Students League from 1969 to 1974 and is Director of the American Watercolor Society.

Kinstler is the author of Painting Portraits (Watson-Guptill 1971).

Everett Raymond Kinstler does not think of himself as primarily a portrait painter but rather as an artist who paints portraits. He considers himself involved in the "people business" and is delighted to earn his living doing something he enjoys doing so much. His only regret is that his activity has denied him the time to diversify and to tackle artistic challenges such as creating landscapes.

He is proud of his hard-won place in the field of portraiture and has no patience with those who regard it condescendingly as a purely commercial venture unworthy of artistic consideration. The most dangerous obstacle facing the busy portrait painter, Kinstler points out, is slipping into formula and routine. It's often too easy for the skilled craftsman to develop slick mannerisms and, instead of painting creative and imaginative portraits, to produce a commercial product guaranteed to offend no one.

Kinstler lists several prerequisites for aspiring professional portrait painters:

1. The person must want to do this above any other kind of painting. If he does it for the money alone, he will tire of it and turn into a hack.

2. He must be sensitive to people, and if he does not actually like them, he should at least understand and respond to them.

3. In Kinstler's words, he must also possess the "thick hide of a rhinocerous and a good set of bowels" that won't be disturbed by the many pressures, emotions, restrictions, and obligations imposed by the profession.

4. Above all, he must remain firmly dedicated to the principles of craft, discipline, and honesty in order to approach each portrait with sincerity and a fresh eye.

Kinstler feels that there is a distinct difference between painting commissioned portraits of men and women. Most men's portraits are of the institutional type, ordered when the subject has achieved a degree of success, which is usually when he is in his fifties or sixties. This generally dictates a formal, rather traditional approach as opposed to the woman's portrait in which the subject is usually younger and more casually dressed, with the painting designed to hang at home where a less conventional approach may be appropriate. Thus, Kinstler finds the man's portrait generally more challenging because it compels the artist to employ all his inventiveness and imagination to avoid turning out still another "boardroom" portrait. The answer lies in the artist's ability to conceive a lively, animated, and vital painting even though the subject, pose, and mood may be fairly restrictive.

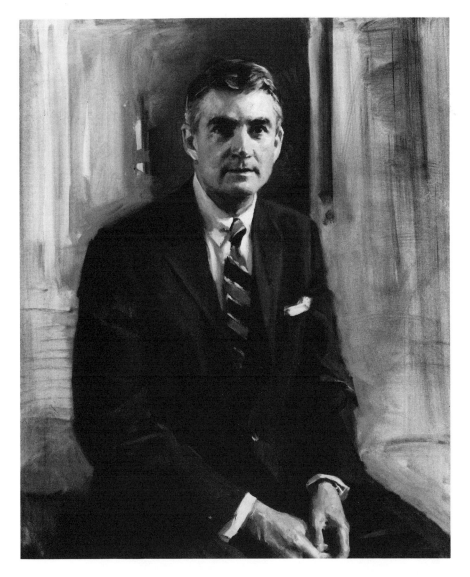

Louis Stanton, Jr. By Everett Raymond Kinstler, 44" x 34" (112 x 86 cm), collection the Union Club, New York City. To gain an illumination that departed from the usual "studio" look, Kinstler employed a screen to cast the shadow almost into the center of the head, with reflected light bathing the subject's right (darker) side. This approach represented a challenge to Kinstler and was made possible because the subject had a strong, symmetrical head that would appear to advantage under any illumination. The pose was selected to give an indication of the subject's height. Kinstler used a rag to lay in the background of almost abstract forms which vaguely follow the actual shapes of objects he saw behind the sitter.

The artist may soften some of these restrictions by urging the sitter to put on a less formal costume than the usual dark suit characteristic of the official portrait. Or he might attempt to vary the size and shape of the portrait from its prescribed dimensions. He may also try to pose and light the sitter in a way that will remove the portrait from the ordinary.

Failing all these devices, which are largely dependent upon the client's cooperation, the artist may (as Kinstler has done) subtly introduce objects or accents which will lend some tang and variety to the corporate portrait. Kinstler once did this by placing a hypodermic syringe on the desk of an executive who had been accused of "needling" his associates. At other times he has deliberately posed the sitter in some unconventional place such as an unoccupied dining room or an unfinished office building.

As is apparent to anyone familiar with Kinstler's output, he has painted dozens upon dozens of male subjects who, due to similarities of age and other attributes, possessed similar complexions and white hair. Yet, through measures similar to those already described, Kinstler has invested each painting with a flavor and individuality all its own. His biggest battle is against grinding out the repetitious, formula portrait, and he wages a constant struggle to avoid stagnation so that he can keep growing in outlook and ability and make every new portrait a thinking, feeling, viable, and exciting experience.

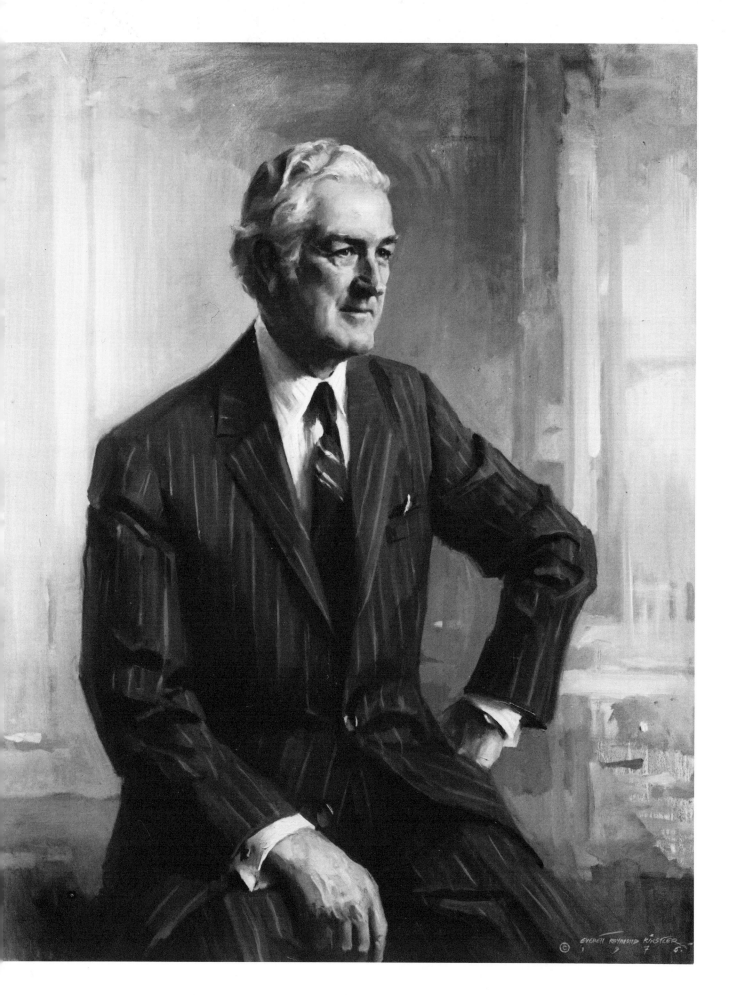

Lately Kinstler has been painting in a broader technique than ever before. He finds this approach particularly effective in depicting the rugged, masculine sitter and in achieving the sculptural effect that delineates a man's pronounced facial planes and hands.

He welcomes any distinctive factor within the subject that will, in his own words, "start my creative juices flowing." This might be a particularly vivid shirt or tie, a nubby-textured sport jacket, a uniform, academic robes, or an unusual beard or mustache. The artist must be wary, however, not to allow these features to so dominate the portrait that they negate its primary purpose, which is to depict "the essential character of the person."

Kinstler's biggest frustration is the limitation of size imposed upon the professional portraitist because of the contracted fee. He would like to be free to determine size based only upon the special considerations required by the individual sitter. Were it not for this factor, he might paint more male subjects standing, a pose he feels adapts rather well for men of certain physique and temperament.

Kinstler paints in basically a middle key. He finds that due to the propensity of men toward sports, outdoor activities, and alcohol, they are more likely to have a redder, warmer complexion than women. This, Kinstler points out, is particularly true in the South, where women traditionally avoid exposure to the sun. He advises the student painter to note this when painting men.

Kinstler tends to paint men's heads lifesize, but sometimes he'll vary this practice as he did in the demonstration painting of Alfred Drake, in which the head is quite large. He paints men a touch more sculpturally than he does women and emphasizes the individual facial planes rather than fusing or drifting them together as he would in the softer female portrait.

Kinstler sees much beauty in the elderly sitter and in the folds, wrinkles, and character lines the well-worn face presents. He says that from an artistic standpoint there is no such thing as a bad feature. He disputes the commonly held opinion that only symmetrical faces are handsome. His probing but sympathetic eye finds strength and character within the great divergence of types nature has created.

Kinstler's predominant ambition is to create a situation in which he can experiment in his portraiture. He constantly seeks to broaden his horizons as an artist and deeply admires those select painters who avoid shoring up safe reputations and strike out in new directions. This might entail executing two portraits of a single client—one in a more traditional style and a second in a totally fresh, daring vein. Hopefully the unconventional portrait would be the one chosen by the client. Another departure might be to paint or draw the portrait in new or different media or in a style that's not associated with the painter.

Such experimentation, of course, poses serious problems for the established artist. He has earned his reputation by creating a product which has attracted a certain amount of attention, and clients expect a similar type of painting when they contract for a portrait. Kinstler, who is thoroughly pragmatic, recognizes this contradiction and wrestles with the problem of how to resolve it. His goal is to enjoy the best of two worlds—to continue a successful career as a portraitist and, at the same time, to exercise his deepest urges to change, grow, and diversify his artistic interests so that each new portrait emerges as an exciting and fresh adventure, not just another job.

Kinstler paints his portraits with filbert brushes on single-primed Kent #125 canvas manufactured by Fredrix. His palette of colors, predominantly Winsor & Newton, includes the following:

John B. Connally (opposite page) by Everett Raymond Kinstler, oil on canvas, 50" x 40" (127 x 102 cm), collection United States Department of the Treasury. This is former Governor Connally's official portrait as Secretary of the Treasury. Here Kinstler faced the problem of time, since the governor was unable to give him all the time he needed. Kinstler therefore filled a sketchbook with countless pencil drawings from various angles and painted a head-and-shoulders study as a possible back-up in case the sitter couldn't return. The pose emerged from one the governor struck during a rest period. The head is painted rather large to convey the bigger-than-life impression the subject evoked to Kinstler. It's unusual to see the head turned so radically in an official portrait.

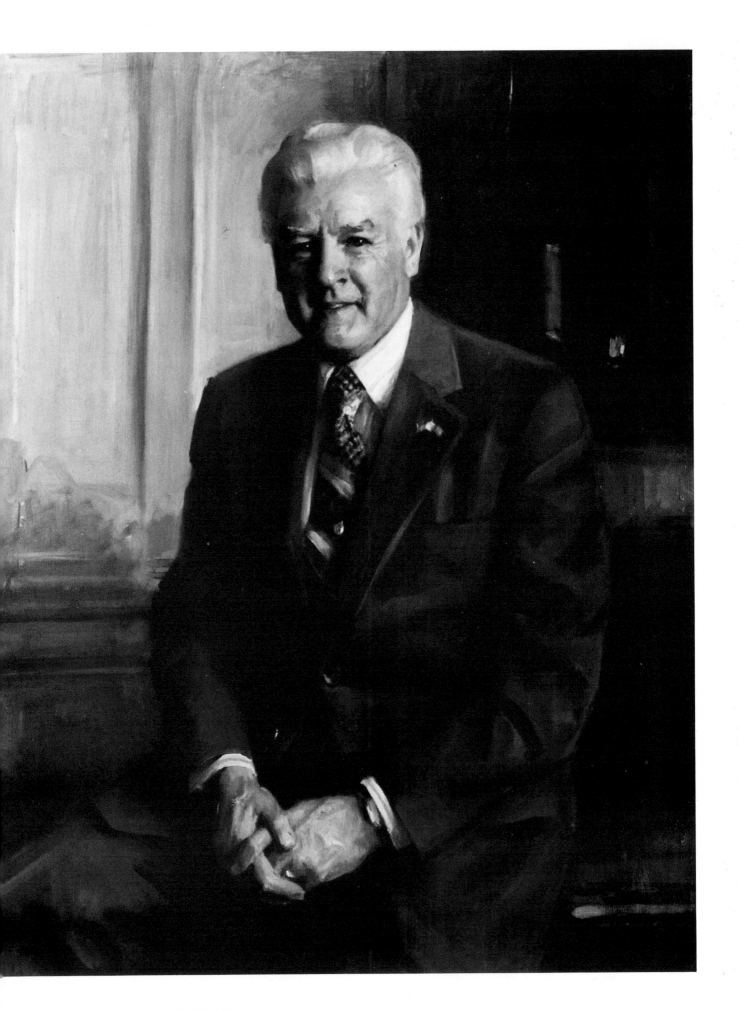

Permalba white (Weber)
 or Superba white (Grumbacher)
Cadmium yellow pale
Raw sienna
Cadmium orange
Cadmium red light
Light red

Alizarin crimson
Burnt sienna
Raw umber
Cerulean blue
Ultramarine blue
Chromium oxide green
Ivory black

Kinstler usually forms a first impression of a client and often maintains this impression right to the finish. He is likely to conclude the portrait in four sittings of two and one-half hours each, although as many as eighty hours might be spent finishing the work! He will work from sketches if the sitter isn't available throughout. Although he plans the design of the portrait fairly thoroughly, he leaves room for revision by stretching extra canvas all around. He prefers to paint in daylight but can function under artificial light if necessary.

He enjoys the vigorous give-and-take that develops between artist and sitter when the portrait is going well. He wants the subject alert, animated, and deeply involved in the excitement that should prevail throughout the experience.

He paints in an *alla prima* technique and works rather quickly, which is apparent from his broad, loose brushwork. His most recent paintings exhibit a pronounced plastic effect. The interplay of warm and cool colors is also more obvious than in his earlier works. Kinstler is probably approaching his peak in achieving a simple yet deeply effective form of expression. It's evident that Sargent is one of his idols.

Kinstler approaches portraiture in a practical, workmanlike fashion. He is constantly searching for new means to simplify the technical aspects of achieving his goal. By experimenting he has found that such a prosaic solvent as kerosene leaves a film on the painting which permits him to move his paint around to his liking. Accordingly, he has stopped using all other conventional painting mediums except on occasion copal varnish cut with turpentine.

Kinstler finds that making numerous drawings of the subject before deciding on a final pose is a very helpful device. It allows him to study the sitter from various angles and in various moods and to gain valuable insight into the person's physical and emotional being.

One principle that Kinstler has absorbed throughout his many years of drawing and painting — usually under heavy pressure — is that few, if any, rules prevail in art. Painting is basically an instinctive process, and the greatest obstacle for the beginner to overcome is the tendency to allow himself to become locked into precise, unvarying habits. Kinstler contends that the only way to overcome this tendency toward constriction is to paint and draw continuously — always remaining open to discovery — until the hand, the eye, and the brain function as a single cohesive unit, the first being merely an extension of the second and third.

Craft, which is the servant of art, can be learned through study, research, observation, and constant, repetitive practice. Kinstler contends that the student who finishes a painting and then feels the need for a three-month vacation before beginning the next will never become a competent portrait painter. Only by continuous trial and error is such a goal possible. Fortunately enough good art schools, private instructors, and manuals are available so that the person who sincerely seeks to develop his craft and to acquire discipline and devotion to art can certainly do so.

Peter J. Brennan (*opposite page*) *by Everett Raymond Kinstler, oil on canvas, 43" x 33" (109 x 84 cm), collection United States Department of Labor. Again, an official portrait of a former Secretary of Labor. Kinstler kept shepherding his subject from office to office, seeking the proper light. Finally, as they chatted in a private dining room, Mr. Brennan casually sat down on a rolling tray and Kinstler saw what he wanted. The powerful hands give evidence of the subject's past experience as a construction worker. Although the term "twinkling eyes" has been badly overworked, this portrait reveals a definite gleam in the eyes that gives life to this hackneyed phrase.*

Step 1. *Working on a lightly toned canvas, Kinstler departed from his usual procedure and executed a rather careful charcoal sketch of the subject. He usually executes this step in oil. Aware that the subject was a well-known actor and that this was to be a personal portrait in which he had freedom to do whatever he wanted, Kinstler used the charcoal as an experiment, as a welcome diversion from his usual procedure. This step was also prompted by the problem of time. Kinstler usually begins a portrait in the morning, but the day this was painted it was growing late. He therefore decided to settle the placement and drawing aspect quickly and with greater accuracy than usual. A light wash of brown-green shadow value was used to indicate certain areas.*

Step 2. *Determined to paint the portrait as a vignette, Kinstler is conscious of the need to establish a harmonious balance of shapes, since the forms in a vignetted painting retain all their contours. He loads his brush with more paint and begins to add volume. He lays in some darks with a mixture of burnt sienna and chromium oxide, and all the darks are massed in in the hair and the jacket, which are the major shadow areas. Then, using warm tones made up of burnt sienna, chromium oxide, and a touch of cerulean blue, he masses in some of the tones in the face, the beard, and the blue shirt. Until now, no lights have been introduced. The head is tilted slightly to characterize the sitter's attitude.*

Step 3. *Now Kinstler commences his second hour of painting. He is very conscious of the tone of the canvas, which represents the basic flesh values shown in the forehead, the nose, and the chin. He exploits this factor much as a pastelist employs the tone of a paper, making these areas advance by adroitly placing appropriate halftones around them. He now adds shadows, edges, and halftones to this basic tone, trying to hold it as much as possible. The necktie and pocket handkerchief form a color pattern that Kinstler will retain in the completed painting.*

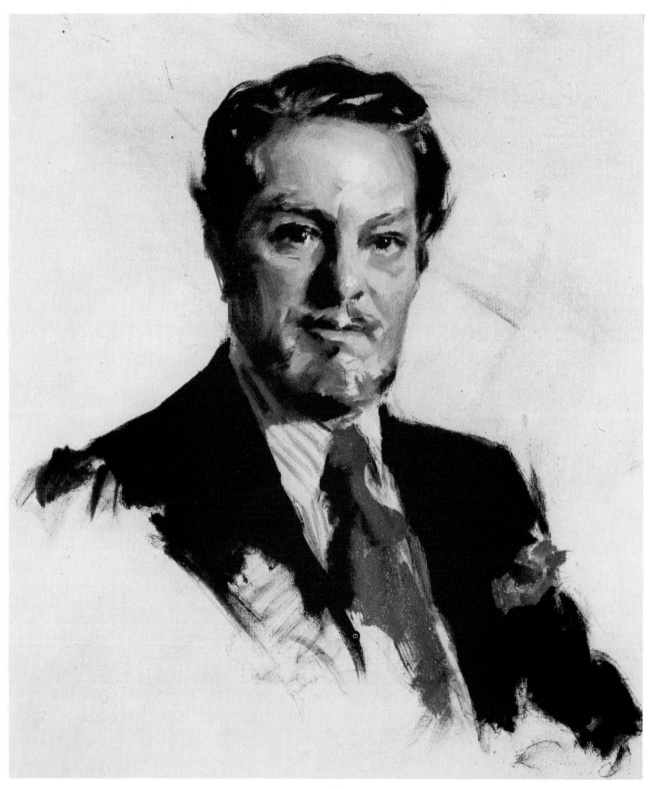

Step 4. *Now Kinstler turns his attention to the light areas of the portrait. He tries to be conscious of the overall pattern of color throughout the entire painting procedure. Therefore, had this not been a vignette, he would have already painted part of the background. Now Kinstler aims not for likeness but for expression—those aspects of the sitter that denote his individual personality. He looks for such characteristics as the two tufts of hair rising above each ear, the slight grin, and the glint in the eyes. He picks up the striped pattern of the shirt, and articulates some of the pocket kerchief.*

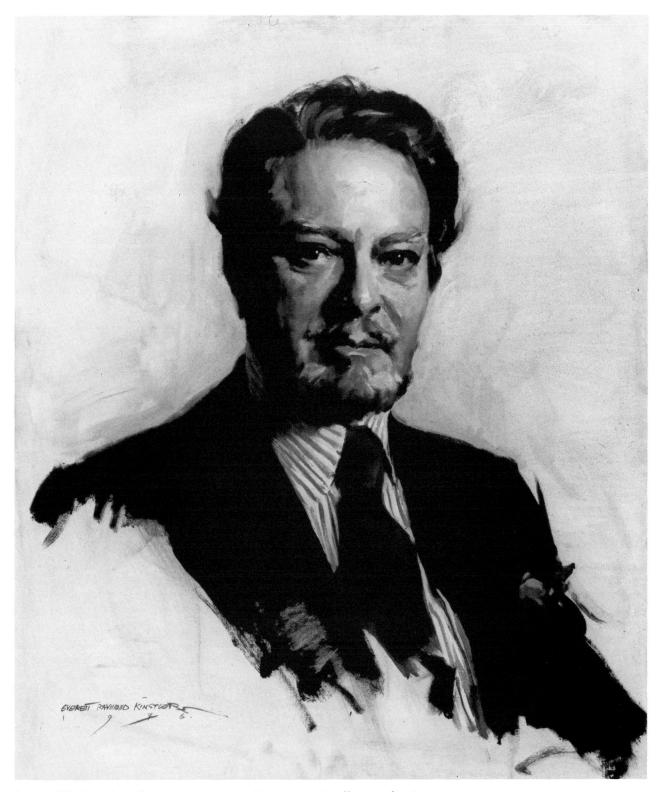

Step 5. Alfred Drake, oil on canvas, 30" x 25" (76 x 64 cm), collection the sitter. Kinstler still holds the grayish tone of the canvas, and the area above the lips and all the lights in the beard are pure tone. He captures the liquid quality of Mr. Drake's eyes, and uses alizarin crimson, burnt sienna, and white for the shadows in the subject's rather warm complexion. The size of the painted head is approximately three inches longer than its actual size, but this points up the subject's theatricality—his bigger-than-life dramatic presence. Kinstler's only concern was that the large size might become too apparent if the painting were hung next to another portrait. He was assured that it wouldn't be. As a final touch, Kinstler rubbed some blue into the background as a complementary accent. The immediate impact the portrait projects is: actor.

CHAPTER ELEVEN
Charles Pfahl at Work

Charles Pfahl was born in Akron, Ohio, and subsequently settled in New York City where he now maintains a large combination studio and living quarters in a West Side loft. He studied with American artists Jack Richard, Robert Brackman, and John Koch.

Pfahl has won a number of prestigious awards over the years, including the Stacey and Ford grants, the Greenshields; a Gold Medal presented by the Hudson Valley Artists; a grant from the National Institute of Arts and Letters; the Julius Hallgarten Award given by the National Academy of Design; and prizes awarded by the Salmagundi Club, the Knickerbocker Artists, and the National Arts Club.

Pfahl has exhibited at the National Academy of Design, the Childe Hassam Purchase Exhibition of the Institute of Arts and Letters, the New York Cultural Center, and the Harbor and Far Galleries. He is a member of the Allied Artists, the Hudson Valley Artists, and the Salmagundi Club.

He has been featured in the American Artist magazine and his book, Charles Pfahl: Artist at Work, *is being published by Watson-Guptill Publications.*

Charles Pfahl likes one or two preliminary sessions with the sitter during which he will chat about various things and try to gauge his feelings toward his subject and those of the subject toward him. In the meantime he will be studying the sitter to see what moods and attitudes he strikes, and he will be trying to ascertain the subject's expectations, thoughts, and ideas for the portrait. He forms an initial impression of his subject within the first half-hour of this preliminary encounter, and the subsequent meetings help him affirm and refine this impression.

Although Pfahl uses the initial encounter to consider how he might best pose and light his subject, he doesn't totally visualize the finished portrait the way some artists do. He has a general idea of what he's after, but he remains open and alert for changes, since, as the portrait progresses, some surprising, unanticipated element inevitably enters into the painting.

Pfahl finds it vital to the portrait's success to establish a constructive relationship between the artist and the sitter. So he reads and keeps up with what's happening in the world in order to find some common ground or interest with which to engage the sitter in conversation. If the subject isn't involved or entertained in some way, he is likely to grow stiff in his pose or even fall asleep while posing.

Pfahl works in a very realistic style and can't conceive of painting someone other than exactly as he appears. If the subject tried to impose restrictions upon him, Pfahl would probably refuse the commission. To Pfahl the portrait must not only look like the person, it must be the person; and he feels that it's the artist's job to probe and determine who and what this person is. Pfahl feels if there is depth and substance to the person the artist will discover it, assuming he is sensitive, alert, and talented. Pfahl believes that the absence of these attributes contributes to the plethora of unremarkable portraiture today, much of which he feels is superficial and bland.

Pfahl makes no distinction between his techniques for commissioned and noncommissioned work. He might, however, use a more extreme pose or lighting setup in a noncommissioned portrait, such as losing much of the subject's head in shadow—a ploy that would be impossible in the usual commissioned portrait.

Pfahl's goals are first, to achieve a good work of art, and second, to achieve a good portrait. He feels that the fact that the artist is working for a fee should only intensify his urge to create a good painting rather than make him consciously stress the portrait aspect. To him a portrait, whether commissioned or not, is primarily a means for the artist to use a person to create the best possible painting he can. Who is painting the portrait is more important than who is sitting for it.

The size of a picture is a very important consideration to Pfahl, who

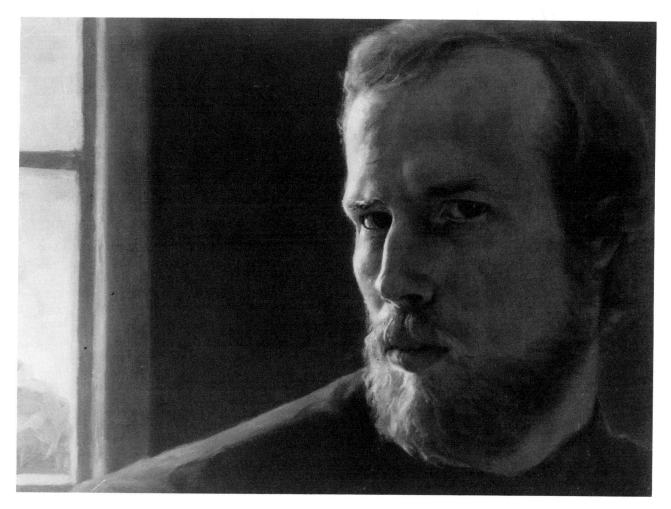

paints canvases ranging from very small to very large. He carefully plans the composition of the picture and makes many sketches and drawings prior to deciding which size and shape would best serve its concept. Pfahl's work tends toward the somber and reflective. In planning the mood of the portrait, however, he matches it to reflect his feelings about the subject. He feels that the ideal portrait situation is for the subject to leave all decisions regarding size, costume, mood, pose, and lighting to the artist. This allows him to shed all restrictions and to use the subject in the way he considers best, based on his knowledge and experience. Few clients, however, are that flexible, and the artist must accept certain compromises.

Pfahl tends to paint his subjects somewhat below lifesize. He tries to have the subject appear to sit within the canvas so that the atmosphere and space lying between the viewer and the subject appear natural and true-to-life. Were the head to be painted exactly lifesize, it would seem pushed flush against the canvas, thus diminishing the illusion of reality.

Pfahl never arranges artificial backgrounds. Instead, he seeks out a background against which the subject appears natural, and then paints it exactly as is. It is completely contrary to his nature to paint imaginary elements. However, he will seek out a background that won't detract attention from the subject.

Given his choice, Pfahl prefers an informal approach, with clothing and pose generally casual and relaxed. Since he wants his portrait subject as relaxed as possible, he will most likely paint him sitting. Since he works in a deliberate style in which every area of the canvas is finished and fully articulated, one might think he would rely heavily upon photography. However, Pfahl paints only from life, and the only conces-

Self-portrait by Charles Pfahl, oil on masonite, 10" x 14" (25 x 36 cm), collection Mr. Archie Slawsby. Pfahl frequently uses the device of showing the source of illumination—in this case, a window. With the lighting concentrated on just the edge of the face, the painter is hard put to make the rest of the head appear round and three-dimensional. The forms must be carefully developed in the darkened side of the head, and the transition from one receding plane to another requires utmost attention. Pfahl could have avoided all these problems by throwing more light onto the head, but he preferred to set a difficult challenge for himself and to find a creative solution to it.

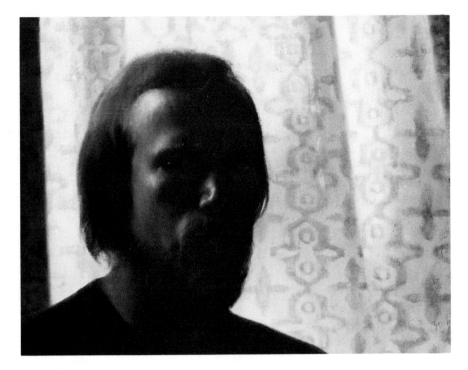

The Monk *by Charles Pfahl, oil on canvas, 12" x 14" (30 x 36 cm), collection Mr. and Mrs. Klein. Even less light illuminates the face in this haunting study in which the forms are barely indicated and the viewer must exercise his imagination vigorously. The effect is of an ominous, Rasputin-like figure glaring balefully out of a dark web. Obviously this couldn't work in a commissioned portrait, but it's an exercise one might pose for oneself in painting a friend or professional model. It's basically a study in silhouette—unless the contours are accurately defined, the whole thing falls apart. Also, the value relationships must be most carefully balanced within their narrow range inside the head.*

sion he might make if a subject couldn't be present would be to pose another person in the subject's clothes and work on the costume or the hair.

Since Pfahl prefers to be at eye level with his subject, he adjusts his painting position to the pose. Under extreme circumstances he might even paint while sitting on the floor. However, his objection to painting a subject while looking at him from above or below is that recognition may be a problem, since people are not normally viewed from such unusual angles. He has no hesitation, however, about painting a full-face portrait in which the lighting is somewhat flatter than in a three-quarter view.

Pfahl likes lots of air in his portraits and in his choice of clothing for the subject, he prefers some neutral shade or pattern that doesn't dominate the head. When painting eyeglasses he generally paints the subject with the glasses off and then has him put them on once the underlying areas are completed.

Pfahl has no compunctions about painting hands, but he insists that they be shown naturally, not added arbitrarily, since hands are as much an element of a person's personality as his other features.

Pfahl paints in an extremely wide tonal range running from very dark to very light and therefore cannot be designated as essentially a high-key or low-key painter. However, his work can be classified as basically low in value with a few very bright highlights included. At times he will glaze an area that's too high in key to bring it down.

The studio in which Pfahl works occupies an entire floor and offers banks of windows facing north and south. This affords him a wide range of illumination, and he takes advantage of it to select the proper lighting for each individual painting. Pfahl finds that a skylight offers an interesting pattern of light but one in which people are seldom seen today. The side lighting in his studio seems to him more natural for our times.

Although Pfahl prefers painting portraits in daylight, he doesn't object to electric light, assuming it's incandescent. It's only fluorescent light, which attempts to emulate daylight, that Pfahl considers "artificial," and, therefore, unacceptable.

Pfahl's palette of Winsor & Newton or Blockx colors includes the following:

Lead white	Cadmium orange
Naples yellow	Cadmium red light
Raw sienna	Cadmium red deep
Light red	Alizarin crimson
Indian red	Manganese violet (by Shiva)
Burnt sienna deep	Winsor violet
(a Blockx specialty)	Cerulean blue
Ivory black	Ultramarine blue deep
Lemon yellow	Sap green
(or cadmium yellow pale)	Viridian
Cadmium yellow medium	

Pfahl doesn't arrange an overall color scheme for the portrait. However, he will repeat certain hues in both the costume and the background to achieve color harmony. His deepest interest lies in his use of a variety of grays. He feels that this emphasis constitutes an essential aspect of his painting approach.

He never consciously invents color, but he does believe that the artist can force himself to see whatever colors he wishes in any given area. Then he merely decides which to put in, since obviously he cannot include them all. Pfahl wouldn't change the color of any object he saw; however, he might change its value.

Pfahl paints on panels and on #111 Frederix double-primed canvas, which he usually tones a gray shade mixed from black and Maroger medium—his only painting medium. He begins his portraits with bristle filbert brushes and concludes with sables for fine detail. He does no painting with a knife. Because of his use of the Maroger medium, Pfahl avoids retouch varnish in either the intermediary stages or at the conclusion of the portrait.

Pfahl always makes preliminary design sketches for composition and then does a number of actual drawings of the subject. He begins the portrait by making a drawing in charcoal—merely for placement, since he has resolved the other aspects earlier. After he has established the essential forms and masses he wipes away the excess charcoal. He might also execute a quick color sketch, perhaps in pastel, to help establish the main light and shadow areas.

Pfahl's technique is to build up the painting in thin layers of color. His paintings emerge essentially smooth, and he studiously avoids a distinct brushstroke which would stand out from the surface and catch unwanted light along its ridges. Although his technique leans essentially toward the tight, Pfahl varies his edges so that soft and sharp are interspersed. He enjoys the variety of textures that any subject presents and seeks to depict them as accurately as possible.

Pfahl acknowledges that in commissioned portraiture a certain amount of criticism may be encountered from those who have ordered the painting or who feel that their intimacy with the subject gives them insights into the sitter the artist may have overlooked. He accepts these conditions as one of the hazards of the profession, but he feels that the ultimate decision as to how the portrait will emerge must remain with the artist. Pfahl feels that if he has fulfilled his expectations and resolved the concept as planned, then the portrait is a success and he will do nothing more to carry it any farther. But he contends that only through experience can this sense of accomplishment be sustained regularly.

CHARLES PFAHL DEMONSTRATION

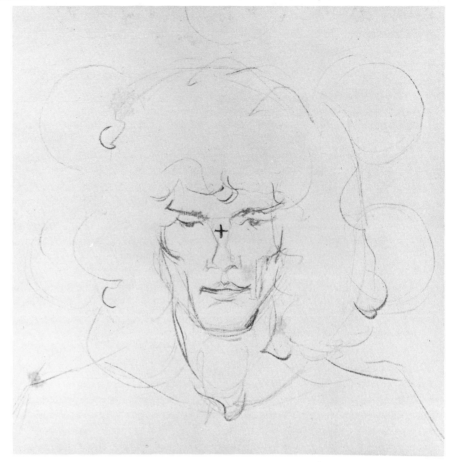

Step 1. *Working on an untoned surface, Pfahl places a small cross in the exact center of the canvas. This lets him know where the middle lies and allows him to place the subject accordingly. In this instance, the head is situated exactly dead center. Now Pfahl draws in a rough outline of the features with charcoal and indicates some of the larger areas of design in the tapestry behind the head. The concentration here is on placement rather than on drawing. Pfahl has resolved the drawing aspects in sketches he has executed prior to going on to the canvas.*

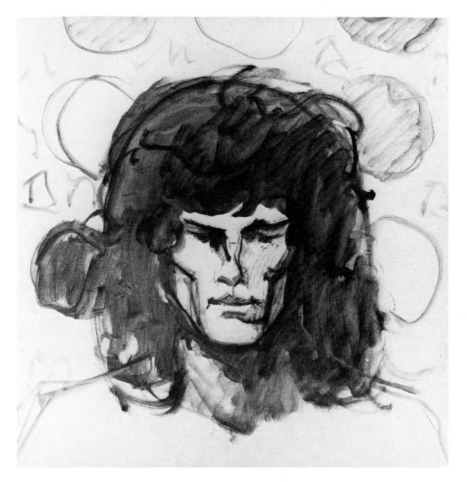

Step 2. *Now Pfahl brushes away the charcoal, leaving but a trace to serve as a guideline, and turns to brush and paint. Employing almost a dry-brush technique, he quickly maps out the head, concentrating on the darks. Only the hair area—the darkest part of the painting—is filled in to any extent, as is the shadow below the chin. Some of the larger patterns in the tapestry are roughly indicated too. So far the halftone and light areas are left unfinished.*

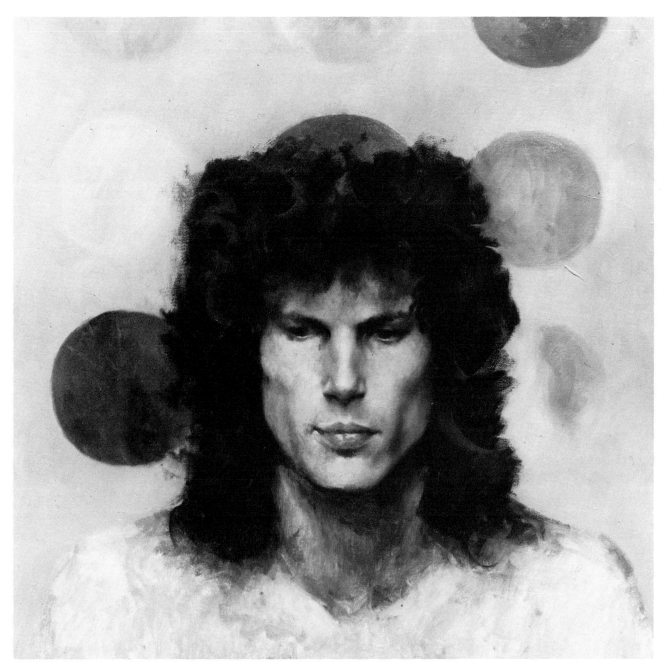

Step 3. *Having mapped in the forms, Pfahl loads his brush with Maroger medium, which renders the paint liquid. He quickly masses in all areas of the painting to provide a base upon which to lay additional paint. Once the massing is completed, Pfahl paints with little or no medium and proceeds to lay stroke after stroke without moving the paint around and seeking to build his portrait with successive layers of color. The massing stage is most evident in the neck, shoulders, background, and hair. Pfahl has begun to paint the head with small and precise strokes, aiming for the correct value and hue.*

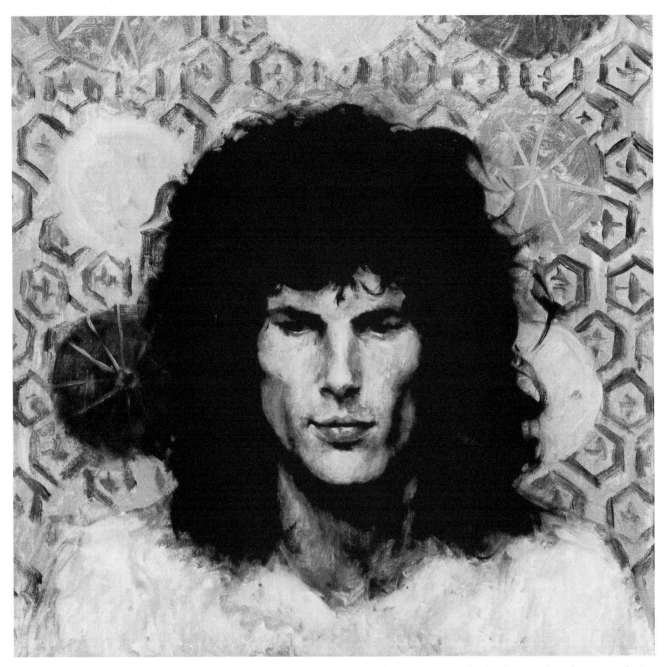

Step 4. *Pfahl now elaborates the elements in the background, at first articulating each element in the tapestry roughly but proceeding with additional refinements. He builds up the hair in back so that it assumes a rounder, fuller shape. In the process of building up the strokes in the face, he has lost some of the smoothness, but he will pull it all together again in the final stages. Pfahl describes his method of painting as consistently removing all mistakes until what's left is correct and right.*

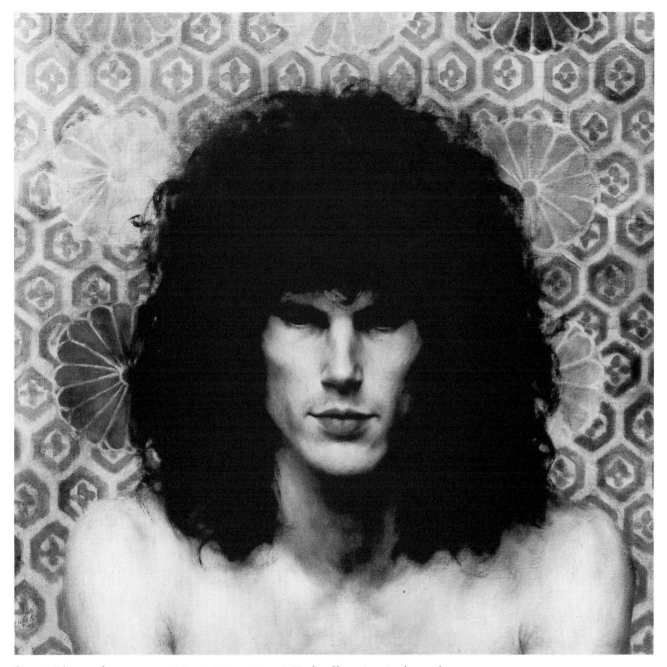

Step 5. Diego, oil on canvas, 20″ x 20″ (51 x 51 cm). He finally paints in the neck, shoulders, and upper chest, and smooths and softens the hair. He fuses the left side of the subject's face into the mass of hair and plays down the light accents in the hair itself so that it assumes its matte quality. He softens all edges except for the slash of the mouth, which he strengthens and intensifies. He leaves the eyes almost entirely in shadow. He rounds the nose, places a minor highlight on its tip, and brings the narrow area of the forehead down in value. He paints the texture of the skin so skillfully that it seems completely lifelike. Pfahl has here produced a most exciting portrait of an exotic youth.

CHAPTER TWELVE
John Howard Sanden at Work

John Howard Sanden started drawing as a youngster, painstakingly copying portraits of famous figures in history and religion. He attended the Minneapolis School of Art, then launched a career as an illustrator. He executed commissions for various church publications and completed over 65 portraits of prominent persons for the Reader's Digest. In 1968, Sanden gave up his flourishing illustrating career to try his luck in New York. His success was immediate, and he was engaged to teach a course at the Art Students League, taking over the classes of Samuel Edmund Oppenheim. He also became associated with Portraits Inc. and quickly became one of its most prolific portrait artists.

Sanden is also active in a company promoting artist materials and is president of The Portrait Club of America. He continues to teach, lecture, and demonstrate his skills to large groups between his portrait assignments. Sanden is the author of Painting the Head in Oil *and the forthcoming* The Portrait Painter's Problem Book, *both edited by Joe Singer and published by Watson-Guptill Publications.*

John Howard Sanden tries to arrange a meeting with the subject at least one week in advance of the actual portrait. During this initial meeting Sanden will chat casually and seek to learn all he can about the individual he's scheduled to paint. There is no conscious effort to probe—merely an attempt to see how the subject sits, walks, talks, and generally conducts himself. Sanden's concern is visual only, since he's not prone to dig for emotional characteristics. Essentially what he is seeking is some physical aspect of the person that will excite him artistically and serve as the basis for the concept of the portrait. This is such an important part of Sanden's approach that he may try for two such nonpainting encounters.

Sanden feels very strongly that the subject contributes much more to the success of the portrait than merely holding still and maintaining the pose. On several occasions a subject has inadvertently provided Sanden with the best possible pose for the portrait. For example, Dr. Robert Ray Parks (whose portrait appears in the color gallery on page 84) related to Sanden that his congregation was alert to the moment when he removed his eyeglasses. This always signified that something portentous was coming. Dr. Parks whipped off his glasses to demonstrate, and Sanden quickly seized the pose as the one appropriate for the portrait. Sanden considers this exchange a moment of inspiration and a perfect example of the kind of rapport between subject and artist that leads to the outstanding portrait.

In his entire career Sanden has never been asked to flatter a sitter. If anything, subjects have complained to Sanden that he has been too kind to them. This is at least one refutation of the commonly-held theory that people want or expect to be painted as other than they are. What they do want and expect is an honest re-creation of themselves at their very best. Sanden frankly says that he couldn't flatter a subject even if he wanted to. Unless the portrait is intended for specific journalistic purposes, Sanden aims for an upbeat, untroubled effect in which any negative qualities are played down.

Sanden is one of the few artists who visualizes a portrait down to its very last detail before he lays in a single brushstroke. Unless he sees it completely finished in his head, be cannot proceed. He might doodle about with a ballpoint pen on typing paper or merely stare out the window as he is contemplating the work; but all aspects of color, background, and composition must be worked out and clear in his mind before he can proceed.

Because of his extensive teaching demands Sanden executes a number of noncommissioned demonstration portraits between his commissioned assignments. Although the technique is similar in both instances, the noncommissioned paintings are executed much more quickly and are

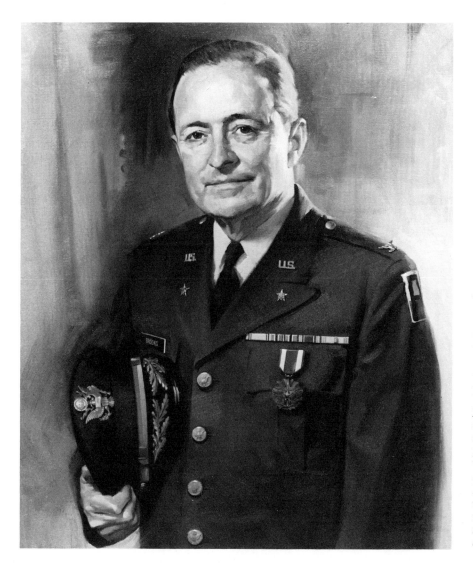

James Hall Brooks *by John Howard Sanden, oil on canvas, 30" x 25" (76 x 64 cm), collection Morgan Guaranty Trust, N.Y.C. Sanden is most particular about detail. Note how meticulously the ribbons, medal, cap insignia, and other accoutrements are painted. You can even read the subject's name on his nameplate! There is much controversy over this practice, and some artists and critics find this niggling. Nevertheless, subjects and viewers love these small details, and the painter who provides them is usually the one who is swamped with commissions. Masters such as Dürer, Brueghel, and Van Eyck offered a wealth of detail, so who can question it? Conversely, note how softly Sanden painted the other edges.*

more direct and less finished. However, Sanden maintains that the pressure to achieve a good painting and an exact likeness is equally intense in both circumstances.

Sanden has several goals in mind when he paints a portrait:

1. To render the portrait as real and lifelike as possible.

2. To achieve a perfect likeness.

3. To bring out the character of the sitter.

4. To render as close a re-creation of the sitter as is possible in terms of paint and canvas. Sanden claims that the meaning of the phrase "to create a good work of art" eludes him.

Although the size of his portraits is closely determined by the prearranged fee, Sanden will often give his sitter a bigger canvas than he is paying for in order to achieve a better painting. His favorite size is 36" x 30" (91 x 76 cm) and up, since he prefers to show more rather than less of the sitter. He might even choose a full-length portrait since, in his words, "It seems such a shame to leave anything out."

Sanden aims for the mood of serene optimism in his portraits. The somber, introspective portrait runs contrary to his approach to portraiture. He finds that initial reactions to the finished portrait are centered not on the subject's likeness but on his expression, and in Sanden's portraits the expression always conveys confidence and contentment.

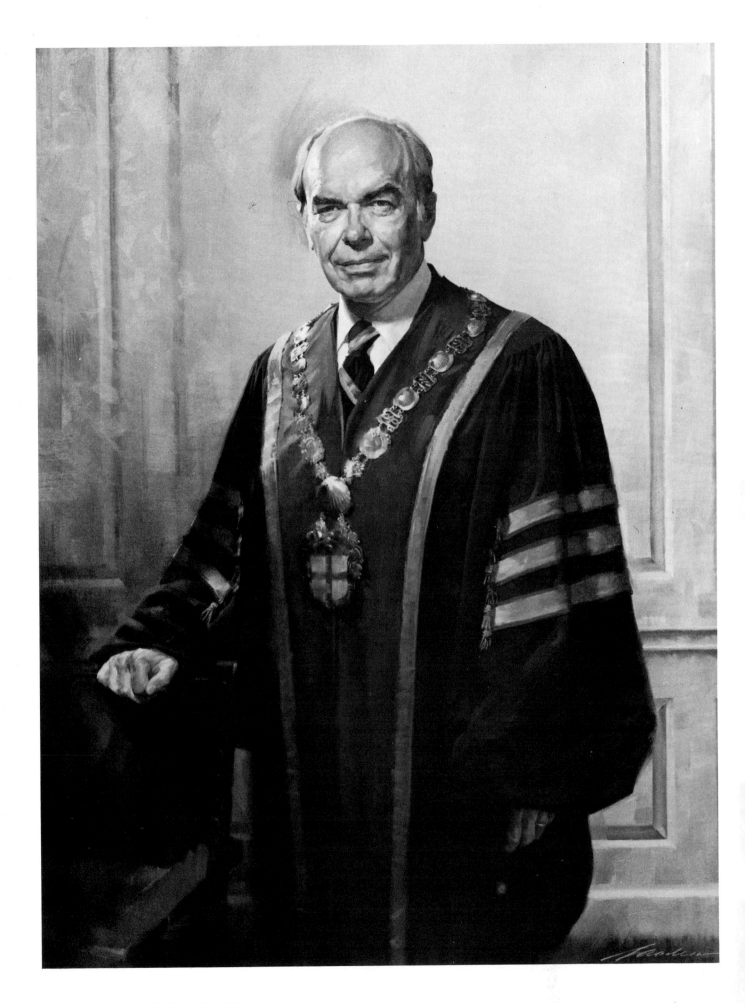

Sanden is very careful to paint in exact lifesize proportion. He will take a precise measurement of the subject's head with calipers and then transfer these readings to the canvas. However, if the sitter is depicted sitting at some distance or depth back from the picture plane, Sanden will pare perhaps 3/8″ from the actual size of the head. He will never paint a head larger than it actually is. He considers such a practice silly even if the portrait is to be viewed from some distance away.

Sanden finds that over the years his backgrounds have tended to grow more simple, and that he is leaving out the definite objects he may have included in the past. The only exception is if a background element is of an unusually attractive color, or if it somehow reinforces the sitter's personality.

He prefers light backgrounds to dark, since they strike him as more contemporary, and more fun to paint and view. His tendency, in fact, is to make his portrait backgrounds lighter in tone than any other value in the painting except the highest highlight. He seeks to contrast the temperature of the background against that of the sitter. Thus, if the sitter's costume and/or complexion tend to be warm, he would render his background cool, and vice versa. At one time Sanden painted in his backgrounds first and then added the head and figure. Now he reverses this procedure.

Since it's one of Sanden's primary goals to present his subject at his very best, he tries to suit the pose to this purpose. He would be more likely to paint his subject standing if he were wearing academic or clerical robes rather than ordinary street clothes. The same would apply for a large canvas designated to be displayed in a big room.

Sanden finds the three-quarter view of the face more attractive than the full frontal view which, in his opinion, doesn't show the subject at his best. However, he does like to have the eyes looking directly at the viewer, a pose he considers up-to-date as compared to the averted gaze of the pensive, reflective portraits of the past.

Since he paints standing, Sanden usually poses his subjects sitting on a model stand, which affords him the eye-level view he desires. He makes the interesting observation that while painted portraits look best from the eye-level view, photographic portraits are shown to best advantage when shot from somewhat below eye level.

Sanden likes to include as much air as possible around the sitter's head and figure. This, he contends, creates an expansive, spacious effect. Since he plans so meticulously from the very outset, he doesn't leave extra canvas around the stretchers and then reposition the portrait.

Because so many men are painted in the rather prosaic business suit, Sanden seeks to enliven such a costume with exciting illumination or background. He prefers suits of a light shade, which help create diversity between light and shadow and don't recede into the background. He also likes a patterned fabric, which lends interest to the garment.

Confronted with a subject who wears eyeglasses, Sanden will paint him with them on from the very beginning in order to incorporate the special shadows they cast. He will later have the subject remove the glasses in order to see the underlying areas. At the end the glasses go back on again. Sanden confesses, however, that he's apt to forget to have the subject put the glasses back on toward the end of the portrait.

Sanden enjoys painting hands, but, for the degree of finish he requires in his portraits, he must refer to photographs to paint them exactly. Even though he is a relatively rapid painter, Sanden allows one full day for each hand, so careful is he to get them just right.

A folding screen is one of Sanden's most useful props in the studio. He uses it with various colored draperies and cloths to arrange backgrounds and to cut off unwanted light.

President Donald F. Hornig (opposite page) by John Howard Sanden, oil on canvas, 48″ x 32″ (122 x 81 cm), collection Brown University. The light issues from high above the subject's right side, throwing a bright accent on his right temple and brow; the light diminishes as it travels down the figure. The standing pose here enhances the sweep of the academic robe, and, while Sanden never flatters, he manages to imbue his subject's faces with expressions that accent the positive. Whether this is due to his own optimistic view of life or to his concept of what a portrait's purpose should be, the results are invariably successful and satisfying to everyone.

Sanden paints essentially in high key but also with lots of contrast so that a full range of tones is present in nearly every portrait. He finds that high-key painting expresses a happy, positive mood and is representative of contemporary attitudes.

In one respect, Sanden differs sharply from nearly all portrait painters — he actually prefers to paint under artificial light, which he feels is easier to manipulate than the more arbitrary daylight. This control enables him to arrange precisely the kind of illumination he has visualized for the portrait. He usually arranges it so that it shines from the side and somewhat above, and maneuvers it around until the shadow cast by the nose falls halfway down the upper lip. He prefers light that is direct, clear, and strong—not diffused in any fashion. He also prefers the light to be cool, since he dislikes hot flesh colors. He is likely to use a more direct light for male subjects than for females, since it produces stronger shadows. For female sitters he might diffuse or soften the light with a photographer's umbrella. Because of this predilection for artificial light, Sanden carries two trunkfuls of assorted lights, stands, and other paraphernalia when he goes out to paint on location.

Sanden's palette includes a complement of regular paints manufactured by Weber plus an assortment of Pro Mix colors, which are ready-made flesh mixtures manufactured and distributed by Sanden's own company, S.E.E., Inc. of New York City.

The regular colors include:

Permalba white (by Weber)	Cadmium orange
Yellow ochre	Cadmium yellow light
Burnt sienna	Chromium oxide green
Burnt umber	Viridian
Venetian red	Cerulean blue
Alizarin crimson	Ultramarine blue
Cadmium red light	Ivory black

This, in addition to the ten Pro Mix colors, constitutes Sanden's portrait palette. Sanden also suggests the following mixtures for the three main racial skin tones:

Caucasian skin: white, yellow ochre, cadmium red light, plus a touch of cerulean blue.

Black skin: viridian, cadmium orange, and burnt sienna for the middle tones combined with cool highlights and warm shadows.

Oriental skin: white, yellow ochre, burnt umber, plus a touch of blue.

Sanden has never preselected an overall color scheme for a portrait. He considers such a practice an interesting but somewhat simple-minded approach. He prefers the interplay of warm and cool colors. His tendency lies toward sober, subdued as opposed to intense colors, which he considers crude. He might go so far as to mute some of the actual color in the background and costume to avoid a garish effect. However, he would never alter skin color or invent a color that wasn't present on the subject.

His preference is for single-primed canvas, since he likes its more distinct tooth. His favorite brushes for the bulk of his work are bristle filberts, bristle broads for backgrounds, bristle blenders for blending and fusing, and sable flats and rounds for fine detail. He never paints with the knife and no longer uses a painting medium, since the Pro Mix colors are loose enough to permit easy manipulation.

Sanden always prepares a very thorough color study which also serves as a *tonal* reference guide for the portrait. He does much of his actual

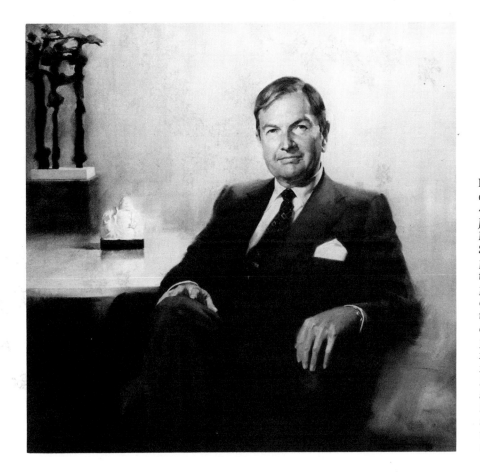

David Rockefeller by *John Howard Sanden, oil on canvas, 36″ x 42″ (91 x 107 cm), collection Joseph Verner Reed, Jr., Chase Manhattan Bank, New York City. Sanden is one of the most skilled painters of gracious portraits today. I have yet to see a Sanden portrait in which the subject doesn't appear amiable, attractive, and urbane. Part of this is due to the artist's healthy approach to portraiture. He assumes no pious airs but is determined to make his sitter appear at his best. In this context, Sanden doesn't seek to impose his own personality but rather to ascertain what the sitter wants, then to give it to him without sacrificing truth, honesty, or integrity.*

painting from photographic reference material, since he frequently finds the presence of the sitter to be a distraction! Sanden is quite frank and open about this, which is a most refreshing change from the frequently snide attitude painters adopt toward photography. Sanden's response is quite reasonable. If Holbein could paint a portrait from a charcoal sketch, why can't the modern painter do the same, except that he uses a photograph?

Sanden works in the *alla prima* technique, seeking to achieve the right color, tone, and drawing from the very first brushstroke. He never glazes or isolates the paint layers but aims for instant perfection. Although he varies the sharpness of his edges, he prefers soft edges and observes that they never emerge quite as soft as he would like them. He avoids excessive texture in his portraits, since he feels most clients would be averse to them. He likes his paint surface flowing — not too thick and not too thin.

Sanden often does a very careful drawing of the entire portrait right on the canvas in a graphite or pastel pencil. He then proceeds to finish it one section at a time rather than working all over the canvas at once. He used to place the head from one-third to one-half its length from the top of the canvas, but lately this space has been increasing.

Sanden knows instinctively when he has captured the likeness. This is such a definite sensation that it's unmistakable when it occurs, and it leaves no doubt in his mind that he has succeeded. He stops painting when the likeness and the character are both evident in the face, and the rest of the painting is up to the level achieved in the head. Sanden is so disciplined a worker that he can set a schedule for himself and meet it without fail. This is the result of years of struggle and the product of a resolute, determined will.

Step 1. *Using a #7 filbert brush and his premixed color Neutral 5, Sanden first draws the head in the following sequence: the top of the hair and the bottom of the beard, to establish the length of the head; the contour of the right side of the face; the contour of the hair on the left; the left and then the right contours of the neck. He then establishes the hairline and the angle of the jaw, and marks the shoulders, the collar, and the neckline. Finally he indicates the irises, the nostrils, the division between the lips, and the shape of the beard. Sanden usually devotes about 10 percent of his total painting time to this "mapping" step—in this case seven minutes.*

Step 2. *Sanden indicates the background with a few strokes of a greenish-gray mixed with Neutral 5 and a touch of slightly lightened chromium oxide green. He then mixes a deep dark—burnt umber, alizarin crimson, and ultramarine blue—for the darkest areas in the hair. At this point he is painting with a large #10 filbert brush.*

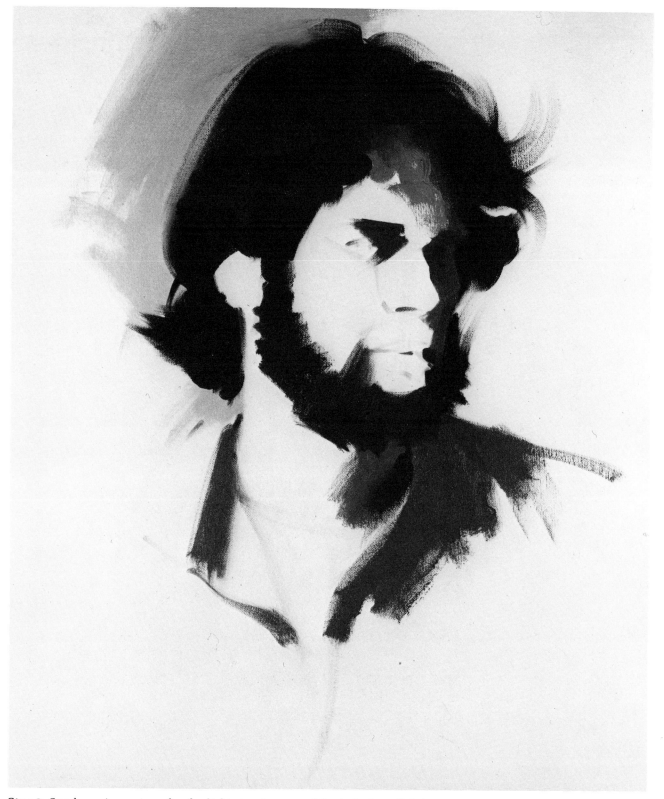

Step 3. Sanden mixes a tone for the light-struck areas of the hair, just slightly lighter in value than that in the preceding step: umber, sienna, and a touch of ultramarine blue. He is working mainly on the silhouette of the hair—its mass in correct value and color, with some attention to edges. He brushes in the beard in two values, adding Venetian red for warmth, and mixes a tone for the shadows on the face, using his premixed Dark 1 with chromium oxide. He adds burnt sienna to the darkest accents, those in the eye sockets and near the mouth. A shadow tone is stroked onto the collar.

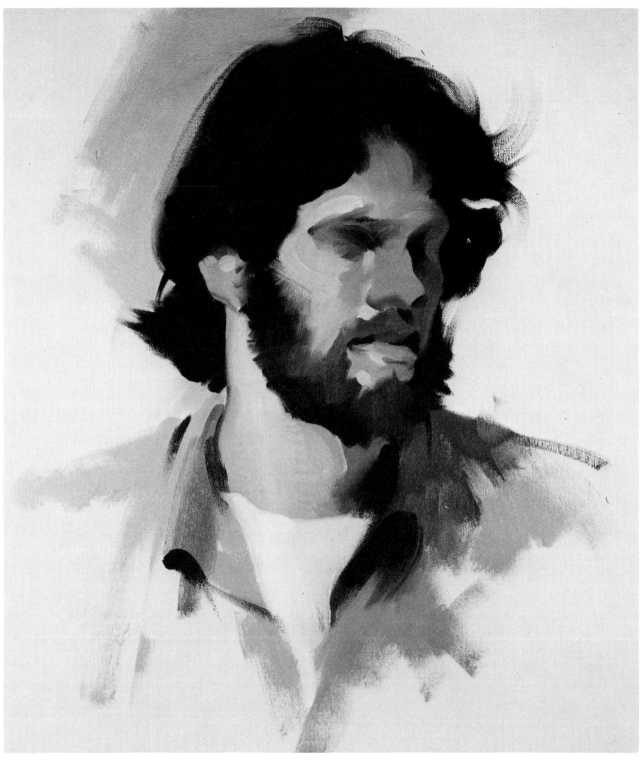

Step 4. First he indicates some cool bluish reflected lights in the shadows along the right contours of the face, and then he goes to work on the halftones: first those below the mouth, and then the dark tones on the cheek below the eye and the nose. He then paints in the shadow and halftone areas of the forehead. The neck has three basic halftone mixtures, and the ear is a mixture of Light 3 with Venetian red. He paints in the lips and darkens the eye sockets with a grayish neutral composed of Neutral 5 and alizarin crimson. He places in a light tone on the shirt, and finally paints in the lights on the forehead, the cheek bone, and near the beard. He puts in a very neutralized Light 2 on the upper lip and on the chin just above the beard.

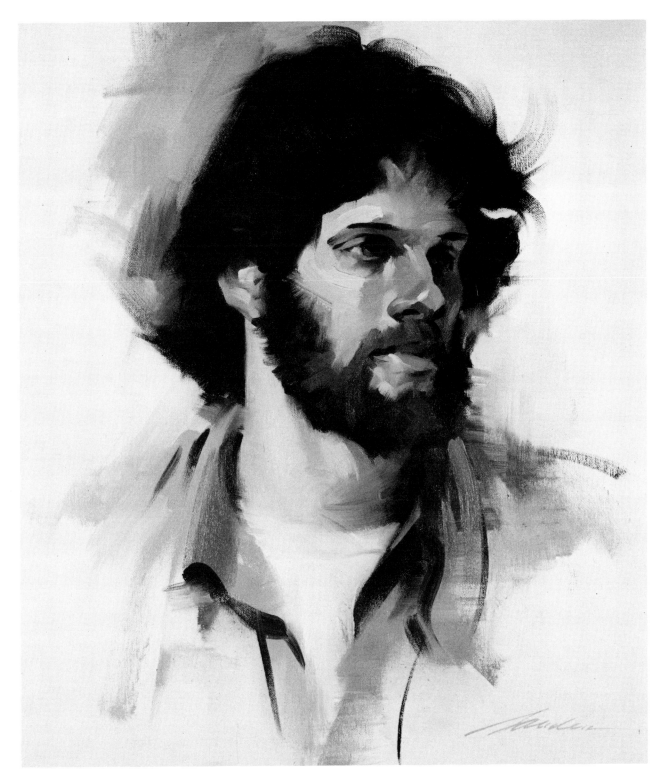

Step 5. Steve, *oil on canvas, 24" x 20" (61 x 51 cm). Sanden begins this final step by redrawing, merging tones, and softening edges. Up to this time he has been preoccupied with color and value; now he's concerned with form. When this is as fully developed as possible, he begins to indicate the features. The iris color goes in, and the eyebrows are a single stroke each. The nose requires very little work: first a slight separation of the front plane from the side plane, then the placing of the nostril openings, and finally the addition of a crisp highlight. A highlight on the lower lip plus a slight strengthening of the dark below the lower lip completes the mouth. Now Sanden restates the edges of the hair and beard, adds some warm touches to the background behind the head, and does a little back-and-forth stroking between positive shapes and the background. Finally, he takes a towel and clear turpentine, dissolves a little of the color in the shirt and background, and softens the edges of the vignette.*

CHAPTER THIRTEEN
Richard L. Seyffert at Work

Richard Seyffert is a native Philadelphian and the son of the noted portrait painter, Leopold Seyffert. Educated in Switzerland, he studied art in Italy and with Leon Kroll and Gifford Beal at New York's National Academy of Design. In 1950, Seyffert moved to New York City and established a connection with Portraits Inc. Some of his better-known portrait subjects have been Nobel Prize Winner Dr. George H. Whipple, Fannie Hurst, Patrice Munsel, and Edward R. Murrow. Seyffert's works are included in collections of the Pentagon; the U.S. Air Force Academy; the University of Chicago, and Cornell and Rutgers universities; and the Chicago Museum of Science and Industry.

Seyffert belongs to the Century Association, the Allied Artists of America, and the Hudson Valley Art Association. He is a member of the board of governors of the National Arts Club and is currently an instructor at the Art Students League in New York City. His prizes include: The Century Association's Art Committee Medal, the Lockman Prize of the American Artists Professional League, the Reilly Memorial Award of the Allied Artists of America.

Seyffert's portrait commissions are most often arranged by an agent, and he usually meets the subject for the first time when he shows up for the initial sitting. Seyffert takes this opportunity to sit and chat while he carefully observes the subject's mannerisms — what he does with his hands and legs, and what poses he seems to strike most naturally.

After a while Seyffert asks the subject to mount the model stand. Seyffert then selects the chair in which the subject will feel most relaxed and comfortable. Various poses are tested until both sitter and artist agree on one that's pleasing to both. In this, as in all other phases of the portrait, Seyffert actively solicits the participation of the sitter as a constructive contribution to the whole effort.

Seyffert doesn't garner an instant, definitive first impression of the subject unless there is something particularly startling or unusual about him. Instead, he allows this to become an evolving process that continues throughout the duration of the portrait. Nor does Seyffert make a conscious effort to probe the subject's emotional character. He prefers to rely on his intuition to supply this data, which becomes apparent to him through consistent observation and perception.

Few male subjects ask Seyffert to flatter them, but he does take their comments and observations into consideration and tries to be sympathetic to their feelings and suggestions regarding their portrait. He does this by posing the subject in the light and angle that will best bring out his features and by painting him as honestly and as competently as possible.

Elderly subjects are particularly intriguing to Seyffert, and he loves the lines and creases that bring out the character of a person's age, his past joys, his sorrows, and his disappointments.

Seyffert doesn't visualize the portrait down to its last detail. Rather, he begins with a concept but remains receptive to changes and revisions that might occur during the painting. In the demonstration portrait of Frank Williams, Seyffert changed the position of the right arm, which he ultimately felt would be best shown hidden.

Seyffert concedes that his noncommissioned portraits may emerge somewhat looser and more sketchy in technique, but this isn't an absolute rule, since he tries to keep all his portraits looking fresh and not overly finished.

These are his goals for a portrait:

1. To produce a competent painting, a good work of art.

2. To gain a respectable likeness.

3. To achieve a blend and harmonization of color.

Seyffert has no particular preferences for any specific sizes for the portrait. He enjoys painting a three-quarter-length portrait which includes

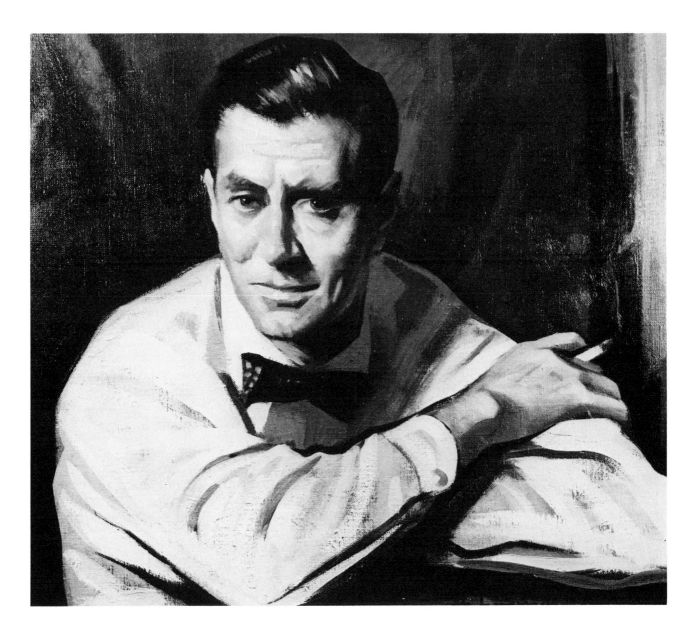

the hands in a natural and comfortable position. This might mean a canvas of approximately 40″ x 34″ (102 x 86 cm).

Seyffert does not plan the mood for his portraits. Rather, he strives instinctively to bring out the best in the sitter and thus unconsciously works to suit the mood to the subject. His portraits do emerge generally happy and pleasant, but not due to any special effort on Seyffert's part. His primary goal is to infuse his portraits with a sense of life and animation.

The sitter pretty much dictates the degree of formality or informality of the portrait. If he is executing a boardroom portrait, Seyffert will try to mitigate some of the formal air by possibly proposing a blue shirt instead of the traditional white.

Seyffert tends to paint his men's heads a touch over lifesize, particularly if the subject projects an imposing, forceful image. Also, many of the institutional portraits Seyffert paints are hung fairly high, and he feels the slight exaggeration of size lends a sense of reality to the painting. In Seyffert's opinion painting men's portraits under lifesize tends to rob the subjects of some of their masculinity in the painting.

The artist selects his backgrounds mostly by instinct. He often arranges the background to harmonize in color with the sitter's costume. He also employs the background to repeat, complement, or emphasize

Barty Leahy by Richard L. Seyffert, oil on canvas, 20″ x 24″ (51 x 61 cm). Here is an intimate type of portrait which most artists would welcome after one boardroom portrait commission after another. Particularly interesting is the manner in which Seyffert used darks to outline the right forearm and the folds in the shirt. He was after the quick effect here, and he used the line as a visual shortcut to show the action of the folded arms. In the portrait of Mr. Patterson (page 149), he resorted to a more subdued style.

the movements of the pose. He might do this through the use of drapery folds. Note in his demonstration portrait the strong diagonal formed by the subject's left arm and the counterdiagonal created by the drapery behind it.

The backgrounds for Seyffert's male portraits are usually of medium tone, with color used deliberately to create attractive harmonies and contrasts. In the portrait of Ben Sonz (color gallery, page 85), the background changed from a neutral greenish umber to a more vivid yellow, which served to set off the blue suit and tie. The sitter is president of the Lotus Club and wanted the club's emblem shown. Seyffert complied and added the globe to balance the composition. This occurred well after the picture was started and demonstrates Seyffert's flexibility in making appropriate changes during any phase of a portrait.

Seyffert picks the pose to fit the occasion. For an exceptionally tall man he might choose a standing pose. However, because of the limitations of canvas size imposed upon him and the fact that most subjects feel more comfortable seated, his tendency is to paint most portraits with the subject sitting down.

Although he prefers to paint his subject posed at a three-quarter angle —turned slightly away from a full frontal view—he concedes that many men look better facing directly ahead. This pose seems to lend the portrait a sense of immediacy. But Seyffert insists that it all depends on the subject. Some men are best shown looking pensive; others are better shown looking you straight in the eye.

The height from which the artist views the subject is a value judgment Seyffert makes depending on whom he is painting. In the past he would have hesitated to paint a person from an elevated angle, but it's a prejudice he has overcome. Usually he is at eye level with the subject and paints in a standing position situated about eight to ten feet from the model. He prefers to stand when he paints, since this allows him to roam back and forth to study his work from a distance and to wield the brush with more vigor than if he were seated.

Seyffert tries to avoid a cramped, crowded look in a portrait and consequently leaves plenty of air around the head and figure. He also makes sure there are no lines in the background that lead into or out of the head or that compete with the importance of the main attraction, the subject. If he must paint the sitter in dark clothing, he will lighten the background somewhat for contrast. But, given his choice, he will select a light-toned suit which will allow for more color and which adds a touch of informality.

If the sitter wears eyeglasses consistently, Seyffert will paint him with them on, since they are a vital part of the man's image. If they are black-rimmed, Seyffert will stress this factor. If they are not, he might merely suggest their presence through the use of reflections, some slight magnification of lenses, shadows cast on the cheeks, highlights, or any touch that will *hint* at the appearance of glasses. He will not ask the sitter to remove the glasses at any time but will paint him wearing them throughout the painting of the portrait.

Seyffert considers hands to be very expressive of the subject's character, nearly as much as the head itself. He likes the shape and musculature of men's hands and tends to exaggerate their size in order to represent strength and masculinity. He also enjoys the various subtleties of color hands present — the greenish veins and the red accents of the knuckles.

Seyffert generally paints in medium key, but he will adjust the key to suit the individual sitter — consciously heightening it to attain a dramatic effect or lowering it to convey a more placid, sober type of individual.

Robby Seyffert (*opposite page*) by *Richard L. Seyffert, oil on canvas. In an informal study of the artist's nephew dressed in the style of today's youth, this long, narrow canvas accentuates the subject's angularity. In this painting Seyffert eliminated most of the air and almost filled the canvas with the figure. Crowding a canvas this way is a device occasionally used by artists to lend additional impact to the figure. The eye has nowhere to roam and must settle immediately on the subject. The eyeglasses are indicated with only a few telling accents reflecting the glint of the lenses.*

The light in Seyffert's studio is a high, cold north light. He uses no secondary light sources; even though lights reflected from other than the main source help bring out the form and introduce color in the shadows, they also tend to be tricky and look photographic. A skylight, Seyffert feels, would confine him too much to a limited type of illumination. He prefers light that is somewhat diffused, since an absolutely clean and clear glass introduces reflections from the outside that can be harsh and distracting.

Seyffert doesn't care for artificial light and uses a fluorescent lamp only on those rare occasions when the daylight is too dark and he must keep on painting. He hasn't painted too many outdoor portraits except for several watercolors, which he does quickly. The problem of painting outdoors is the inconstancy of light. In addition, if the subject poses in the sun, there is too much contrast of tone; if he poses in the shade, there is too little. There is also the problem of glare in sunlight and the difficulty of concocting accurate color mixtures. Actually, Seyffert prefers the cool light of the studio, which allows him to see the tones and colors in their total accuracy and under unvarying conditions.

Seyffert paints with Rembrandt or Winsor & Newton colors. His palette consists of the following:

Primary Palette	*Secondary Palette*
Permalba white (Weber)	Cadmium red dark
Venetian (or light) red	Cadmium red light
Mars violet dark	Cadmium yellow pale
(mixed with chromium	Viridian
oxide green for shadows)	Cobalt blue
Alizarin crimson	Burnt sienna
Yellow ochre	
Chromium oxide green	
Ultramarine blue	
Raw umber	

Seyffert also suggests some color mixtures for various skin types.

Caucasian skin: a mixture of yellow ochre, light red, and white—with green, mars violet, and possibly raw umber for the shadow areas.

Black skin: He calls attention to the blue character of the lighter areas caused by the shiny quality of the dark skin.

Seyffert is inclined to select an overall color scheme for the portrait. He prefers intense color to dull and looks for those exaggerations of hue which will permit him to paint the color more vividly than it actually appears. However, he will not consciously invent or introduce colors into skin areas where none exist.

For male subjects he prefers a single-primed canvas of a somewhat rough tooth. His chief brushes are oval filberts, and he seldom uses a knife for painting portraits, although he may make extensive use of it in landscapes.

His only painting medium is turpentine, and he makes preliminary sketches only when he is forced to work from photographs rather than from the model. He might, however, do some preliminary sketches for design purposes.

Although he has glazed and underpainted in the past, he now works in a direct *alla prima* technique. He likes to vary sharp and soft edges and to lose some edges altogether. He does try to depict the various textures presented by the subject's skin, costume, and by elements in the background. He tends to paint thicker in the lights and thinner in the

shadows, in traditional fashion. The thickest strokes are reserved for the highlights.

He uses retouch varnish between sittings to bring up color areas gone dead and sprays the canvas with it at the portrait's conclusion.

When he begins, he maps in the masses and contours in a cool green or blue. He has found that if these marks show through, they will tend to turn an edge rather than bring it forward, as a red outline would do.

Instinct tells him when he has captured the sitter's likeness and when to lay down his brushes. He would rather leave a painting underfinished than overdone.

Seyffert defines all painting as a blend of feeling and intelligence. A man of deep spiritual conviction, he senses the presence of some undefined inner spirit which propels the painting along, monitored by the artist's intellect. This inner force, he feels, has to be present in quantity in every great artist.

At times Seyffert looks at a painting he has completed in sheer amazement, for he cannot explain what he did consciously to move it along. He feels that the most valuable advice he can impart to his students and to all aspiring artists is to allow their inner intuitive feelings to emerge and guide their artistic efforts.

Mr. Patterson by Richard L. Seyffert, oil on canvas, 40″ x 30″ (102 x 26 cm), collection the sitter. The light here seems to issue from below, which is unusual in portraiture but perfect for the spiritual quality of the subject's profession. It almost appears as if the subject were in the process of some religious ceremony. The two black stripes of the robe guide our eye to the head. Seyffert obviously enjoyed the contrasts offered by the darks and lights of the costume and exploited them to fullest pictorial advantage. Painters of men's portraits dearly love robes, uniforms, cassocks, and habits — anything that is different from the conventional business suit.

Step 1. *Working on a toned canvas, Seyffert draws in the figure with brush and paint, using a neutral shade of cool green that won't obtrude in the paint layers which will ultimately be laid in. In this step Seyffert works primarily to place the figure properly so that the design of the portrait is essentially resolved. You will note in forthcoming steps that changes will be effected in the location of both of the subject's hands. Seyffert remains flexible and open to improvements at all times throughout the duration of the painting.*

Step 2. *Now Seyffert blocks in some of the major darks and a number of the halftones, still trying to resolve the relationship of the various masses and capture the subject's characteristic postures and general attitude. There is something of the Western plainsman about Mr. Williams that comes across in his slouch and a rather studied indolence. Seyffert, who knows the subject rather well and has a trained artist's eye, is aware of these traits, and will express them. A few strategic lights are placed in the shirt, forehead, and cheeks.*

Step 3. *Seyffert begins to model the head. In a series of receding planes, the forehead is made to turn. Halftones break up the edge between the darks and lights of the face. The nose is modeled to some degree, and the hair is beginning to assume its flowing character. The pupils are placed roughly, and the mustache is shaped to some degree. From the original rough forms, the image of the subject begins to emerge as the artist sharpens his focus and begins delineating those features that lead toward likeness. The left hand has been raised somewhat, but the right is still unresolved.*

Step 4. *Seyffert does considerable work on the background, sharpening the strong diagonal on the left of the canvas which acts as a counterpoint to the sharp angle of the crooked left arm. Additional darks are added below the left arm, giving the hand form and direction. The hair falling over the collar is fused with the dark of the collar. The right arm is still vague, but some shapes have been established there. This will change in subsequent steps as Seyffert makes a final decision as to the arm's placement.*

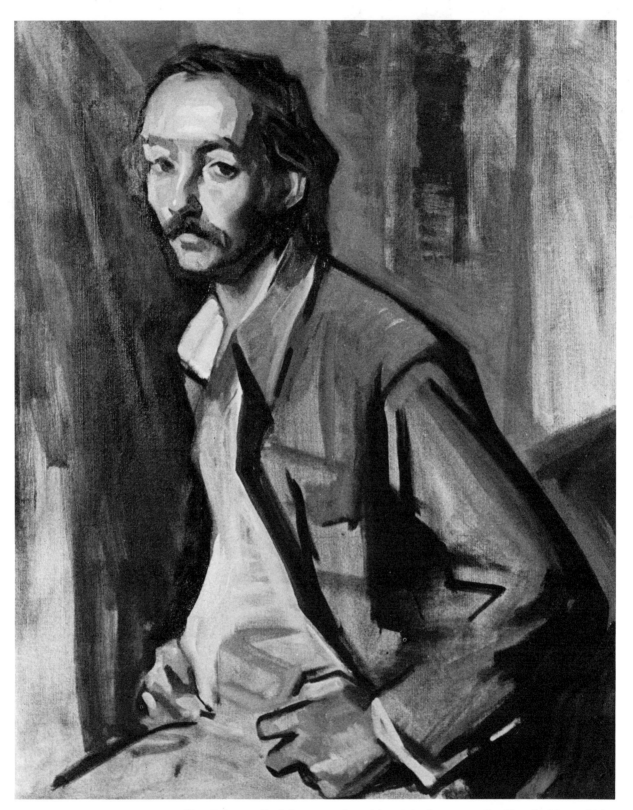

Step 5. *In a radical departure from his original concept, Seyffert decides to hide the right arm completely and to show only the hand holding the waist. Such last-minute revisions are a mark of a dedicated artist who won't let anything deter him from improving a painting. The subject's stooping torso now makes a much better design and is also more characteristic of the way he sits and arranges his body. The extreme dark edge in the left background is painted in, and the shadow is extended further down alongside the figure.*

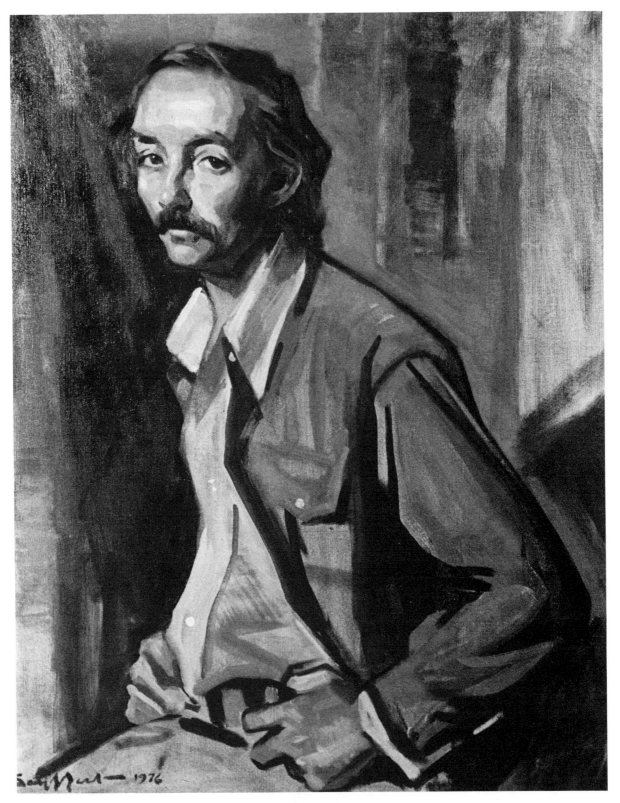

Step 6. Frank Williams, *oil on canvas, 36″ x 30″ (91 x 76 cm). In the final stage of the portrait, Seyffert has decided to hook the left thumb around the belt, lending greater impact to the hand. The hair is indicated in a few strokes to show its straight, flowing character, and some light accents have been placed there. He has thrown some additional darks against the right edge of the subject's face to bring it forward and has accented the nose, forehead, right cheek, and lower lip with highlights. He has added the buttons on the jacket and shirt and heightened the value of the shirt cuff. He has cut down the light on the ear but has brought up the light in the shirt collar. A dark outline is placed around the contour of the jacket.*

CHAPTER FOURTEEN
Clyde Smith at Work

Clyde Smith graduated from Dartmouth College and studied painting and drawing at the Art Center School in Los Angeles. With his wife and two teen-age sons, he maintains a home and studio in Cos Cob, overlooking Connecticut's Mianus River.

In addition to his portrait career, which often takes him on trips around the country, Smith paints landscapes, still lifes, and likes to paint houses and gardens with figures included.

An additional facet of his career is designing theater posters. He has executed commissions for such Broadway productions as Subways Are for Sleeping, Cactus Flower, Applause, and Gingerbread Lady.

Smith's work is in the permanent collection at the Walter Chrysler Museum in Norfolk, Virginia, and at the Museum of the City of New York as well as in numerous private collections. The artist is represented by Portraits Inc. of New York, and is an instructor at New York's School of Visual Arts.

To Clyde Smith the most important aspect of the entire portrait experience is the initial impact, the first instant visual impression gained when artist meets sitter. He tries to arrange this initial meeting with the subject as much as a month before actually beginning the portrait. During the intervening weeks he evaluates and plays with the person's image in his mind, selecting those forms and patterns that will contribute to a meaningful arrangement of shapes. Another reason for the advance meeting, which Smith tries to hold at the subject's home, is to observe him in his natural surroundings where he is most relaxed.

Smith realizes that portrait subjects are often tense and anxious in what is for them an unnatural situation. Therefore he endeavors to set up a sympathetic current. He contends that a light touch is best in all dealings with the sitter. He makes light conversation or plays music to entertain the sitter and to keep him from growing bored or brooding. However, a degree of pensiveness is something Smith might welcome in place of the artificial, pasted-on smile seen all too often.

Having selected an appropriate pose and launched the portrait, Smith rejects any negative factors the sitter may project and instead accents the positive. He paints his male subjects just as they are, regardless of age or physical condition. Although he might paint fewer wrinkles than a female subject actually presents, he will paint a man with a compassionate, but totally accurate, eye. He will employ the pose to depict the subject's personality such as having the subject incline his head forward to represent an aggressive, driving person.

His male sitters haven't asked him to flatter them, but he does try to sense the role in which the subject sees himself and tries to accommodate it. He finds men most concerned about their clothing — whether their ties are straight and their suits fresh and crisp, or whether the proper amount of shirt cuff is showing.

Although Smith visualizes the portrait completely in his mind prior to laying in the first brushstroke, he is open to any changes and flashes of insight that might arise during the course of the painting and may even cancel out what he has already done and launch a completely fresh start. Because of his strong inclination toward design, Smith looks for those aspects of the sitter that will contribute most to the portrait's composition. Since this concept of abstract design figures so strongly in his work, Smith is constantly searching for new compositional approaches and would go so far as to cut a bit of the top of the sitter's head from the canvas if it served his design purposes.

He doesn't vary his technique from commissioned to noncommissioned painting, and he considers himself a loose, untrammeled painter whose uninhibited technique is manifested in the abandon of his strokes. Often those who seek him out for portraits are themselves artists

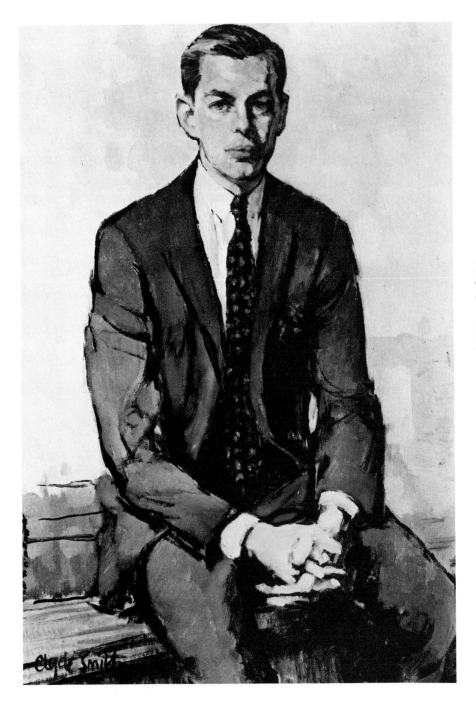

Ronald Jones by Clyde Smith, oil on canvas, 36″ x 23″ (91 x 58 cm), collection the sitter. Smith paints in an economical style that's completely attuned to the modern concept of art. He doesn't waste a stroke and makes his statements boldly and simply, telling all with nothing extraneous. Note how the seat is indicated in a few telling lines, and the background is left nearly bare; yet there's no mistaking who the subject is both physically and emotionally. What's most intriguing is the contrast of the rather conventional pose set against the nervous, slashing, almost expressionistic painting style.

or collectors who revel in his unconventional methods.

These are the goals Smith lists for a portrait:

1. To provide a likeness, to which the sitter—particularly in a commissioned work—is entitled.

2. To achieve a good work of art which will be appreciated even by those who don't know the subject.

3. To enable the viewer to recognize and acknowledge the feelings that the artist has invested in the effort. He considers painting a kind of intellectual love affair and strives to reveal this spirit in the finished works.

He is deeply enamored of and dedicated to this genre of painting and would go on painting portraits even if they no longer provided him financial renumeration. He would consider two commissions a month the ideal situation.

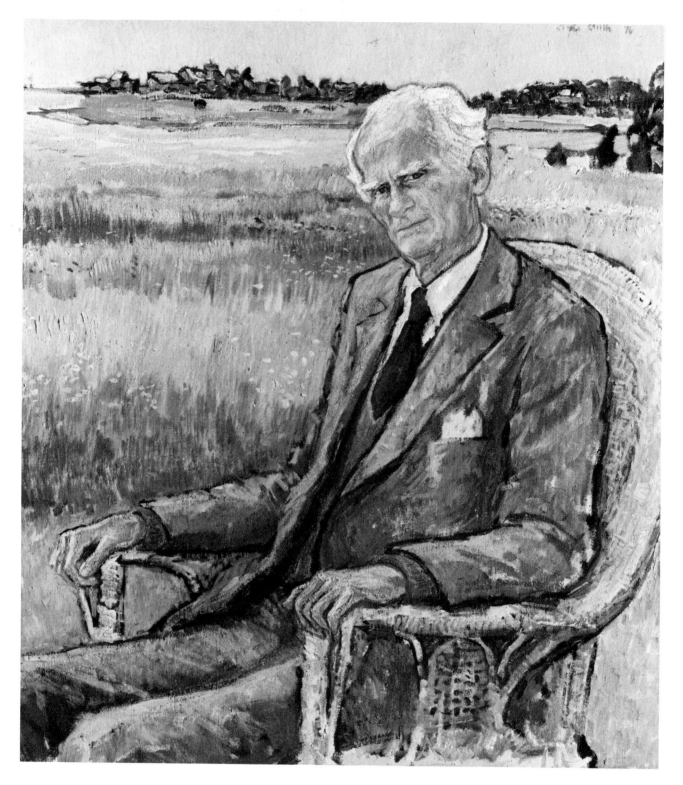

He finds a larger canvas most fun to paint on and leans toward a horizontal shape for a man's portrait, since it provides a scope and expansiveness which complement the subject's masculinity. He tends to paint the head and figure a touch under lifesize, perhaps four-fifths its actual size. This, it seems to Smith, allows the figure to sit more pleasingly and comfortably within the confines of the frame. Painting over lifesize, on the other hand, strikes Smith as awkward and disturbing, even though it may appear more monumental. He does find that the head and body occasionally tend to expand a bit if he is really painting with excite-

ment, and he then takes deliberate measures to bring them down to manageable size once more.

Smith contends that every painting should evoke a swift first reading in which the viewer sees its dominating element first. In a portrait this is (or should be) the subject's head. He therefore plans his backgrounds so they will not interfere with this initial reaction. He makes sure the background isn't so busy or prominent that it robs attention from the subject. His tendency is toward light, high-key, neutral-colored backgrounds. Rather than arranging and painting the background as is, Smith often invents his own abstract backgrounds to suit his requirements.

When it comes to posing, Smith looks for the unusual and the expressive—for anything that will release the portrait from its staid, traditional formula. Smith will employ devices to jolt himself out of the ordinary and to force himself to look with a fresh eye at each new portrait experience. Thus he will vary the pose as well as the angle from which he views the subject in order to avoid the banal and to accommodate the individual characteristics projected by the sitter. He prefers an eye-level view of the sitter and so uses a model stand, since he paints standing. He owns a portable model stand that he takes with him when painting on location.

Smith likes a high-key palette. He feels it adds elegance to both the formal and informal portrait. He enjoys painting patterned fabric and would welcome the chance to do a uniform. Whatever costume is worn, however, Smith emphasizes that it must be painted so that it's clear there is a person, not a mannequin, inside it.

If the subject habitually wears glasses, Smith will paint him with them on from the beginning and will even suggest the distortion produced by the lenses, if it exists. Smith also likes to include hands, but not if they are posed in any set, mannered way. They have to be characteristic of the sitter. He feels a portrait should be immediately recognizable even if the subject's head were covered up.

Smith paints in a consistently high key so that his portrait subjects emerge warm and lighthearted. High key also allows him to use lots of color—an integral part of his approach and technique. Since he equates light with color, he wants as much illumination as he can get. If he could, he would paint all his portraits outdoors where the light is clearest and most direct. He might pose his subject in dappled sun and station himself in the shade. In his studio he employs strong side lighting on the subject, aided when necessary by small fill-in artificial lamps.

Although his experience as an illustrator and theatrical poster designer has acquainted him with working under artificial light, he would prefer not to paint portraits under such illumination. He likes both warm and cool light to play against each other in all of his paintings.

Smith uses a palette of Winsor & Newton colors consisting of the following shades:

Permalba white (by Weber)	Rose madder
Cadmium yellow pale	Permanent rose
Lemon yellow	Mauve, blue shade
Yellow ochre	Chrome green light
Raw sienna	Cadmium green pale
Cadmium orange	Permanent green
Scarlet vermilion	Manganese blue
(Smith's favorite color)	Cobalt blue
Cadmium red deep	French ultramarine

Smith is vehemently against the use of any browns in flesh tones, preferring to use subtle blues and greens for the cooler, darker areas in the

Dr. John Baker (opposite page) by Clyde Smith, oil on canvas, 42″ x 36″ (107 x 91 cm), collection Juniata College. The outdoor portrait is always great fun for artists who enjoy the challenge of an illumination that can present a host of problems. It's likely to change from moment to moment as the sun ducks in and out of clouds, and it's seldom the same from sitting to sitting. It throws reflected light into shadows, robbing them of their strength and consistency. For this reason, most artists prefer studio conditions where such factors can be more easily controlled. I don't believe an artist can ever really learn about color unless he paints portraits outdoors over and over again. The Impressionists were absolute masters of the outdoor portrait.

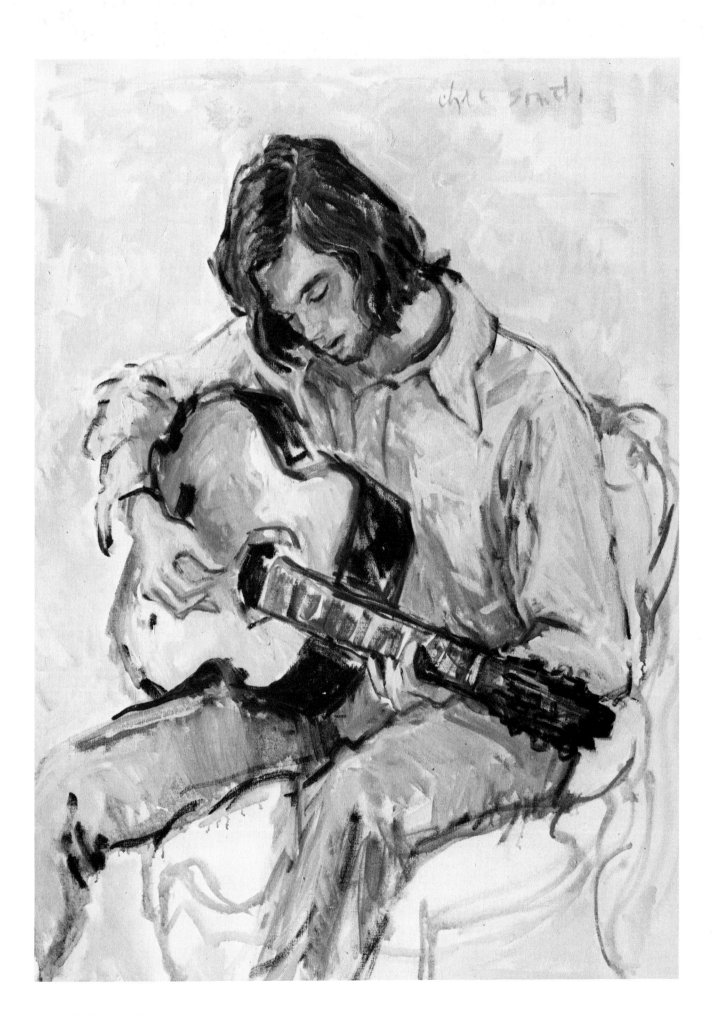

portrait. He urges his students to train themselves to see color in the shadows and to mix and appropriately cool shade related to colors in the warm areas, instead of mechanically filling them in with muddy browns.

While respecting the client's preferences, Smith may not preselect a rigid color scheme for the portrait, since he feels it should emerge with the multiplicity of sensations as the work progresses. His way of attaining meaningful color is to consciously think of the *noncolor* areas — the grays — and how they can best be used to bring out and enhance the sections where bright color predominates. Smith likes passages of intense color played against the more subtle areas for greater contrast and emphasis. He feels free to subdue or exaggerate colors to achieve this balance, but he puts in only those he sees — even if more vividly than they might appear to the untrained eye.

Smith prefers a single-primed Belgian linen canvas which offers a measure of tooth. He likes the spring and bounce of canvas which turn the painting experience into a kind of fencing bout in which interaction and rhythm flow between painter and surface. His brushes include various bristles, but none below a size 5, which is about one-half inch wide. He doesn't go in for picky, precise brushwork and never uses a knife for painting since he enjoys the visible and pronounced brushstroke. His medium is the traditional one-third linseed oil, one-third damar varnish, and one-third turpentine.

Smith isn't one to do preliminary sketches. His feverish temperament dictates that he pitch right in and commence drawing directly on the canvas. His approach is totally uncalculated and intuitive, and he attacks the portrait in a high state of excitement and urgency. He seldom, if ever, refers to photographic reference material and only works on the painting with the sitter in front of him.

Smith consciously aims for a dry effect in most of his textures. Following the first rough lay-in, he avoids the use of medium and thus achieves the painterly quality he is after. Some areas of the canvas emerge thick, and in others the bare canvas shows through. He likes to paint areas such as hair very thin and almost transparent and then load up the paint in the highlights. He also likes the white of the canvas and never tones it beforehand.

He never uses retouch varnish during the in-between stages and doesn't believe the portrait requires any final varnish. He wishes to avoid future yellowing. In this he differs from some painters who consider varnishing an absolute necessity. The fact that he likes his picture without a shiny finish is a definite factor influencing this opinion. However, when the painting is finished, he may consider glazing some passage that needs to be varied a bit.

A gregarious, bubbly individual, Smith enjoys company when he paints and welcomes any comments those present care to volunteer regarding the portrait. So eager is he to continue painting once he begins that he squeezes out three palettes charged with paint in order not to be forced to stop when he runs out of any color.

Smith is determined not to linger too long on the portrait. He feels this will subdue the spontaneity he wants it to project, and he is anxious that it not look over-finished.

Teaching painting has made Smith aware that too many beginners tend to stress features as the most important aspect of a portrait. He argues fervently that it's the *design* that's of paramount importance. If the overall structure and the planes of the head are essentially correct, the features will fall into place naturally. Smith contends that there is no right or wrong way of painting. If one's talent finds spontaneous and intuitive expression, the style will take care of itself.

Christopher Heaton (opposite page) by Clyde Smith, oil on canvas, 42″ x 36″ (107 x 91 cm), collection Mr. Jack Heaton. I am most intrigued by this striking painting of a young man absorbed in his music, since I feel this is the direction in which portrait painting will be going in the future. Plucked from the musty atmosphere of the studio, it represents a dynamic departure from the conventional. The Impressionists used this open, direct, and fresh approach freely, but in the years following them, the forces of convention again closed ranks to force the portrait back into its old, stuffy framework. Smith represents a new breed of portrait painter, and the client who commissioned this work is to be congratulated for his flexibility and open-mindedness.

Step 1. *In a series of swift, swirling strokes, Smith quickly places the figure on the untoned canvas with a large brush. Essentially this will remain close to the final portrait, and no major changes will be effected. The characteristic tilt of the subject's head is already evident, as is the shape of his leonine head. In this initial placement and in all the subsequent stages, Smith invariably aims for the general statement and disregards the minor and insignificant aspects. He is primarily a painter of large forms.*

Step 2. *Now Smith blocks in the head, again working with great speed. Despite his impulsive, almost nervous, technique, the placement of the elements is unerring—he has trained himself to be accurate in his statements, even though at first glance the strokes appear random and uncalculated. Smith paints essentially in color, placing dabs of bright hue in almost mosaic fashion. This rough, expressionistic method results in a portrait that's removed from the traditional concept but is bright, vivid, and arresting to the eye.*

Step 3. *Now Smith masses in the jacket and tie. His strokes seem to go in all directions, but a definite pattern emerges from this seeming frenzy. Smith manages to achieve accurate proportions by employing several carefully placed lines which serve to control the rhythm and thrust of the main elements of the figure. Note the dark slash across the right hand, which delineates the knuckles. This lets Smith know where the fingers bend, and he maintains such guidelines until he strokes additional colors over them.*

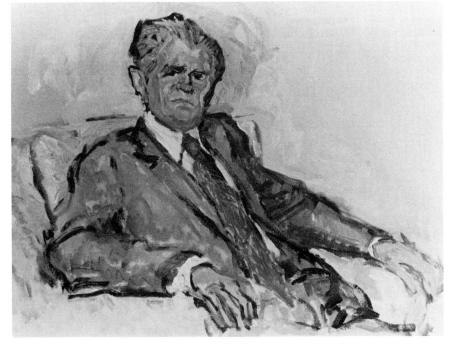

Step 4. *The first work has begun in and around the hands. There are no longer aimless lines but definite fingers, sleeves, and shirt cuffs. Smith builds his forms in this fashion. He doesn't require careful outlines underneath but relies on a few strategic marks to guide him in his overpainting. Each new stage represents a slight refinement and correction of the previous one. The back and arms of the chair are beginning to emerge, the outline of the hair has been adjusted and corrected, and many of the original dark guidelines have been obliterated.*

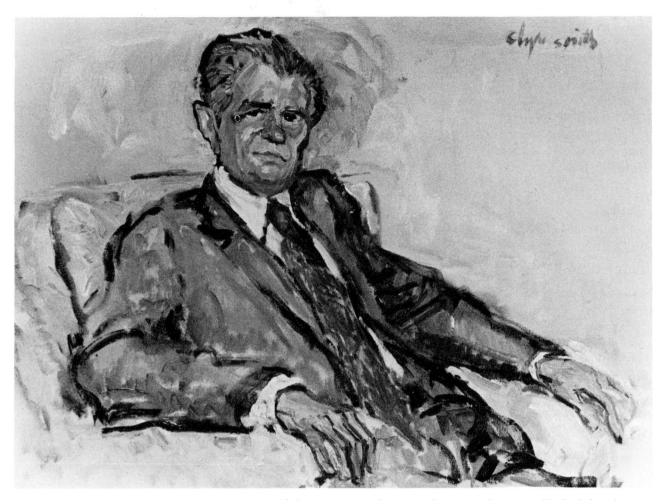

Step 5. Smith has gone over the entire figure. He has reestablished the placement of the facial features. The nose is refined, the mouth is more accurately delineated, and the planes around the mouth and chin are placed with additional concern for fidelity. The individual characteristics of the subject's face are now fairly well defined. Many of the external outlines still remain dark and intense, such as around the left side of the face, but these too will be softened in the final stage. The left hand is still in a very rough stage and will be refined.

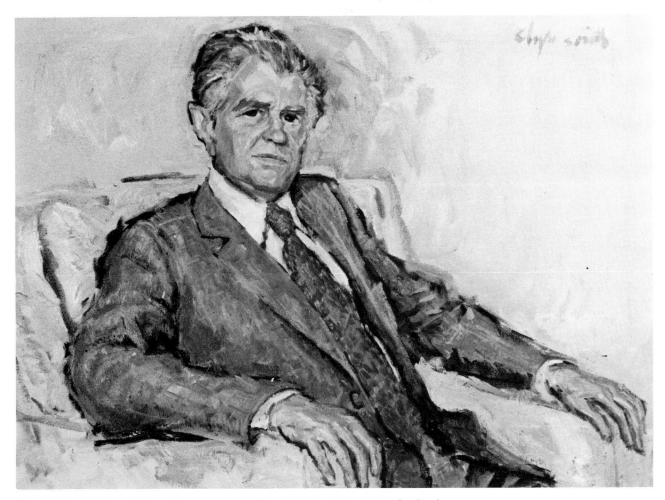

Step 6. Francis Hunsicker, *oil on canvas, 27" x 40" (69 x 102 cm). In the final stage of this painting, Smith demonstrates his ability to create an arresting portrait from a series of whirls and splashes. He finishes by doing considerable work on the left arm and hand, refining the fingers, and adding appropriate folds in the crook of the arm to make the arm appear to lie naturally on the chair. Also, the right hand is painted with care. The hard outline along the left side of the subject's face is modified, the lines inside the face are softened and subdued, and the hair is softened all over. He extends the backrest of the chair on the right, and the texture of the jacket material is indicated.*

Bibliography

Birren, Faber. *The History of Color in Painting.* New York and London: Van Nostrand Reinhold, 1965.

Blake, Wendon. *Creative Color: A Practical Guide for Oil Painters.* New York: Watson-Guptill, and London: Pitman, 1972.

Bridgeman, George B. *The Book of a Hundred Hands.* New York: Dover, 1962.

Fabri, Ralph. *Artist's Guide to Composition.* New York: Watson-Guptill, 1970.

Henri, Robert. *Art Spirit.* New York: J. B. Lippincott, 1930.

Hogarth, Burne. *Drawing the Human Head.* New York: Watson-Guptill, 1965.

Hogarth, Burne. *Drawing Dynamic Hands.* New York: Watson-Guptill, 1977.

Kinstler, Everett Raymond. *Painting Portraits.* New York: Watson-Guptill, 1971.

Massey, Robert. *Formulas for Painters.* New York: Watson-Guptill, 1967.

Mayer, Ralph. *The Artist's Handbook of Materials and Techniques.* New York: Viking, 1970.

Ormond, Richard. *John Singer Sargent: Paintings, Drawing, Watercolors.* New York: Harper and Row, 1971; London: Phaidon Press, 1970.

Sanden, John Howard. *Painting the Head in Oil.* Edited by Joe Singer. New York: Watson-Guptill, and London: Pitman, 1976.

Singer, Joe. *How to Paint Portraits in Pastel.* New York: Watson-Guptill, and London: Pitman, 1972.

———. *Painting Women's Portraits.* New York: Watson-Guptill, 1977.

———. *Charles Pfahl: Artist at Work.* New York: Watson-Guptill, 1977.

Taubes, Frederic. *The Painter's Dictionary of Materials and Methods.* New York: Watson-Guptill, 1971.

———. *The Technique of Portrait Painting,* New York: Watson-Guptill, 1967.

Index

Edited by Connie Buckley
Designed by Robert Fillie
Set in 10 point Melior by Gerard Associates
Printed by Halliday Lithograph Corp.
Bound by A. Horowitz and Son, New York